TRAVEL

ROUTE 66

A Guide to the History, Sights, and Destinations Along the Main Street of America

Jim Hinckley

Voyageur
Press

First published in 2014 by Voyageur Press, a member of Quarto Publishing Group USA Inc., 400 First Avenue North, Suite 400, Minneapolis, MN 55401 USA

Voyageur Press titles are also available at discounts in bulk quantity for industrial or sales-promotional use. For details write to Special Sales Manager at Quarto Publishing Group USA Inc., 400 First Avenue North, Suite 400, Minneapolis, MN 55401 USA.

To find out more about our books, visit us online at www.voyageurpress.com.

Library of Congress Cataloging-in-Publication Data

Hinckley, James, 1958-
 Travel Route 66 : a guide to the history, sights, and destinations along the main street of america / Jim Hinckley.
 pages cm.
 Summary: "A guide to destinations and sights along historic Route 66, with historical background and travel tips"– Provided by publisher.
 ISBN 978-0-7603-4430-9 (pbk.)
 1. United States Highway 66–Guidebooks. 2. Automobile travel–United States–Guidebooks. 3. United States–Guidebooks. I. Title.
 HE365.U55H56 2014
 917.304'932–dc23

 2013033158

On page: Photo by Tom Grundy/Shutterstock.com.
On pages 2–3: Photo by Alan Copson/AWL Images/Getty Images; postcard from the
 Voyageur Press collection.
On the facing page: Brochure courtesy Steve Rider.

Editor: Josh Leventhal
Design Manager: James Kegley
Design and Layout: Kim Winscher

Printed in China

10 9 8 7 6 5 4 3 2

TABLE OF CONTENTS

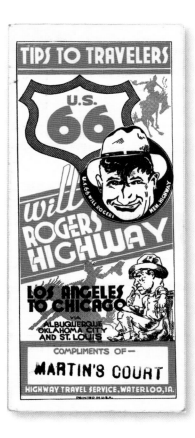

PREFACE

A FEW QUICK TIPS FOR YOUR JOURNEY

ENTER WITH CARE ✓

Along with your adventurous spirit and this guide, I recommend that you bring on your Route 66 odyssey two essentials for such a trip: the *Route 66 Dining and Lodging Guide* and Jerry McClanahan's *EZ 66 Guide for Travelers*, both published by the nonprofit National Historic Route 66 Federation.

Updated often to ensure accuracy, the dining and lodging guide is a handy resource to help you find fresh apple pie in a six-stool diner—and many other delights—at the end of a long day exploring the wonders of Route 66. The *EZ 66 Guide* is a simple flipbook atlas. It will help you find and follow the various alignments of Route 66 that are now signed as county or state highways, graded as gravel farm roads, or truncated. Also, it is an excellent resource for deciphering the evolutionary realignments of Route 66 between 1926 and 1984.

If this is your first journey on America's longest attraction, cast aside your preconceived ideas. Yes, Route 66 is a dusty repository of physical artifacts from more than a century of societal evolution. But it is also a living icon where myth and reality collide, offering a sensory kaleidoscope that starkly contrasts with the modern generic world.

If you are a seasoned Route 66 explorer, you know that no two journeys are the same. This asphalt string signed with two sixes knits together endless opportunities for adventure. You also know that Route 66 is a community filled with old friends and friends yet to be made.

In either case, thank you for choosing me as your guide. I promise you will have an unforgettable adventure, as any exploration of Route 66 is more than a mere drive across America.

Ready to roll?

(Opposite page) The author at Pecos National Historic Park, New Mexico. *Judy Hinckley*

CHAPTER 1

ILLINOIS

Shortly after the last community on Route 66 was bypassed by the interstate highway on October 13, 1984, a groundswell of interest in the old road and the places that made it special arose. Soon there were Route 66 associations in each of the eight states through which the highway passed and in more than a dozen countries.

Illinois was one of the first states to grasp the tourism potential of the resurgent interest in Route 66. Illinois has been a leader in developing innovative, cooperative projects that preserve and promote the many facets of this American icon. As a result of Illinois' leadership, ample signage makes it easy to follow the various alignments of Route 66 from the shore of Lake Michigan in Chicago to the Mississippi River at St. Louis, Missouri, a drive of about 300 miles.

The start of Route 66 in Chicago. *Bruce Leighty/Photolibrary/ Getty Images*

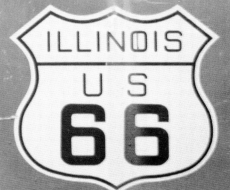

THE BIG CITY

Traditionally, travelers follow Route 66 from east to west, from Chicago to Santa Monica, California, where an ocean breeze will lure you those last few blocks to legendary Santa Monica Pier and Palisades Park. Because tradition is a great way to ignite a sense of time travel, you'll begin your adventure in Chicago's Grant Park at Jackson Drive and Lake Shore Drive, the eastern terminus of Route 66 since 1933.

Grant Park is Chicago's answer to New York's Central Park. The centerpiece is Buckingham Fountain, a replica of the legendary Latona Fountain at Versailles. Buckingham Fountain was installed in 1927, one year after certification of Route 66.

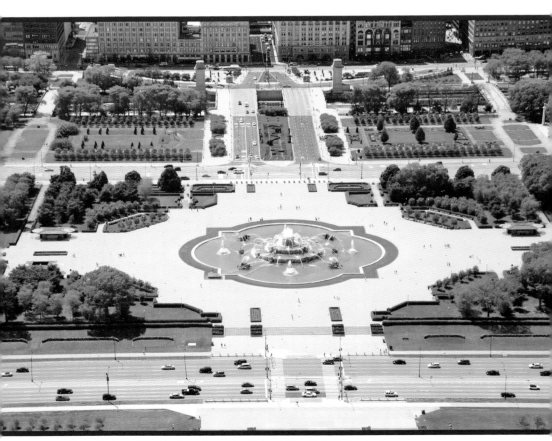

Grant Park and Buckingham Fountain. *Richard Cavalleri/Shutterstock.com*

To experience Grant Park and the surrounding attractions, it may be best to leave your vehicle behind and either walk or use Chicago's vast public transportation system rather than negotiating the crowded streets. The Grant Park South Parking Garage is located on Michigan Avenue just south of Jackson, and metered parking can be found on Columbus Drive as well.

GRANT PARK, CHICAGO

Grant Park is one of Chicago's cornerstones. It dates to an 1835 citizen's movement to preserve a segment of land along Lake Michigan from commercial development. In 1871, after the Great Chicago Fire, much of the debris from that calamity served as fill in Lake Michigan, creating more real estate for what was then called Lake Park (established in 1844). Additional fill came from excavations of the Chicago Tunnel Company.

In honor of President Ulysses S. Grant, the park became Grant Park on October 9, 1901. Oddly enough, a short time later, a statue of Abraham Lincoln was unveiled in Grant Park, but a statue of President Grant was erected in nearby Lincoln Park.

The first variance to allow development in the park was an 1892 ordinance that allowed for construction of the Art Institute of Chicago. Today museums in the park include the Shedd Aquarium, the Adler Planetarium, and the Field Museum.

DON'T MISS

Among the many notable attractions near **Grant Park** are the following:

- Navy Pier, an entertainment complex of more than fifty acres with parks, shops, restaurants, an IMAX theater, a Ferris wheel, a carousel, and a miniature golf course;

- The Art Institute of Chicago (111 South Michigan Avenue), one of the world's greatest museums, boasting a diverse collection ranging from photography and textiles to Bronze Age and Neolithic art and impressionist paintings;

- The Field Museum (1400 South Lake Shore Drive), offering a wide array of interactive exhibits that range from a re-created Egyptian tomb to a bug's-eye view of the world to the largest and most complete Tyrannosaurus Rex skeleton;

- Shedd Aquarium (1200 South Lake Shore Drive), one of the world's largest aquariums, with more than 22,000 animals in carefully crafted ecosystems;

- The Museum of Science and Industry (at the intersection of Lake Shore Drive and 57th Street), the largest science museum in the Western Hemisphere, with exhibits ranging from a German submarine captured during World War II to a replica of an Illinois coal mine;

- Millennium Park, a favored escape from the hustle and bustle of the big city for residents and visitors alike.

Cloud Gate sculpture at Millennium Park, Chicago. *Shutterstock.com*

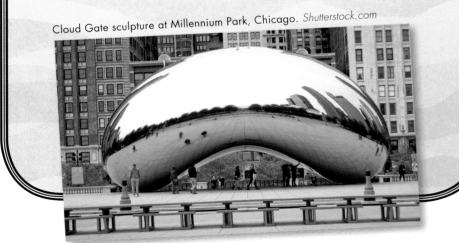

As you begin your westward journey across this historic route, it is rather fitting that the old Atchison, Topeka and Santa Fe Railway building (now with a big Motorola sign having replaced the old rooftop Santa Fe sign) casts its shadow across the urban landscape here. Working in conjunction with Fred Harvey and his chain of restaurants and hotels known as Harvey Houses, this railroad company pioneered tourism in the American Southwest. As the main rail line across western New Mexico, Arizona, and California's Mojave Desert, the Atchison, Topeka and Santa Fe Railway ran close to the Grand Canyon and many other natural wonders.

At the National Old Trails Road convention in 1913, the proximity of the railroad to these attractions were instrumental in the decision to plan routing of the road parallel to it in the Southwest. The initial course of the National Old Trails Road (predecessor to Route 66) followed the Trail to Sunset that began at the corner of Jackson Drive and Michigan Avenue in Chicago and met with the Ocean-to-Ocean Highway at Yuma, Arizona, after tracking south from Albuquerque through Springerville and Globe in Arizona.

Beginning in the 1950s, Route 66 utilized two primary roads as one-way arteries to traverse Chicago: Adams Street running westbound and Jackson

Santa Fe Railway Building, Michigan Avenue, Chicago. *Shutterstock.com*

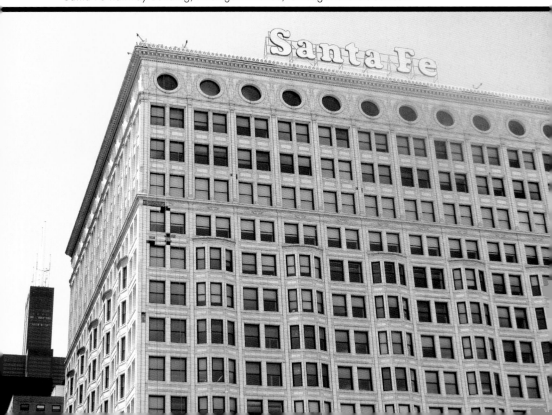

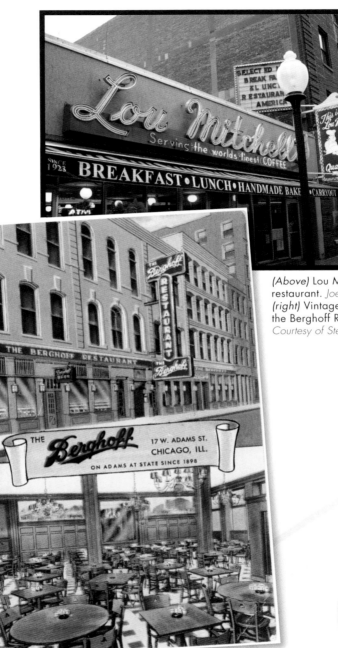

(Above) Lou Mitchell's restaurant. *Joe Sonderman; (right)* Vintage postcard for the Berghoff Restaurant. *Courtesy of Steve Rider*

Boulevard (the original alignment of Route 66) running eastbound. While a westbound adventure on the Double Six begins on Jackson at Lake Shore Drive, when you reach Michigan Avenue, you will need to jog one block north to Adams Street in order to continue west. In order to discover all that Route 66 has to offer in Chicago, follow Adams Street to Ogden Avenue (just under three miles) and then loop back toward Grant Park on Jackson Boulevard.

Towering attractions abound along both corridors of the route, creating a shadowy, manmade canyon. Notable among these towers of glass, steel, and brick are the Willis Tower (formerly the Sears Tower), tallest building on Route 66, and the John Hancock Building, both with incredible observation platforms that provide panoramic views of the city and lake.

Food of many kinds—from regional specialties to blue-plate specials, from gourmet desserts to five-course dinners—is key to the Route 66 experience. Setting the stage for this gastronomical odyssey is Lou Mitchell's Restaurant at 565 West Jackson Boulevard, a Route 66 landmark and a favorite of locals as well as travelers. Opened in 1923, the restaurant has operated at its current location since 1926, the year of certification for US 66, and has provided a free box of Milk Duds to all women who enter for just about as long.

At the corner of State Street and Adams Street, there is another landmark eatery, the Berghoff Restaurant, housed in some of the oldest buildings in the Chicago Loop, dating to 1872. Owned and operated by the same family since opening in 1898, the restaurant began as a saloon offering simple fare: a free sandwich with the purchase of a nickel beer. Today the Berghoff's reputation for delectable specialties, such as sauerbraten, apple strudel, Dortmunder style beer, and fourteen-year-old private label bourbon, makes this a destination for visitors as well as citizens of the Windy City.

Another Chicago culinary treat can be had with a short detour along Halstead Street and into the heart of the city's Greek Town district. Two restaurants in particular stand out where you can you can savor the delicacies of Greece. The Parthenon Restaurant and Banquets, at 314 South Halstead Street, is the district's oldest restaurant—be sure to try the roasted lamb dishes. Athena Greek Restaurant, a block north at 212 South Halstead, specializes in traditional dishes and offers outdoor dining and wonderful views of the city.

For more information about the array of attractions awaiting discovery in Chicago, contact the Chicago Office of Tourism at 77 East Randolph Street, Chicago, IL 60602; by phone at 312-744-2400; or on the web at www.choosechicago.com.

THE ROAD WEST

As you continue west, the towering skyscrapers of the Chicago skyline will not have faded from the rearview mirror when you turn southwest onto Ogden Avenue. The roadside landscapes through west Chicago and the old North Lawndale neighborhood, once part of the Al Capone crime syndicate empire, are littered with vestiges of the area's gritty industrial past, as well as a handful of surprising little gems such as the uniquely styled Castle Car Wash, originally a service station that opened in 1925, at 3801 West Ogden Avenue.

Chicago gives way to Cicero with little hint that you have crossed from one town to another. For the Route 66 enthusiast, Cicero is the home of Henry's (6031 West Ogden Avenue), with its giant hot dog–dominated, neon-trimmed sign proclaiming, "It's a meal in itself!" What started as a small stand with a walk-up window in the mid-1950s is today a full-service restaurant with a faithful contingent of customers. Even if you're still full after sampling the fare at Lou Mitchell's or one of the restaurants in Greek Town, it's tough to resist Cicero's specialty: a Chicago-style hot dog served with French fries and pickle spear.

Continuing west on Ogden Avenue, you see Cicero give way to Berwyn, a community that proudly proclaims its Route 66 association with illuminated glass-block entry signs and banners. Then, where Berwyn meets Lyons, you have two Route 66 options: continue west on Ogden Avenue before turning

Castle Car Wash, Chicago

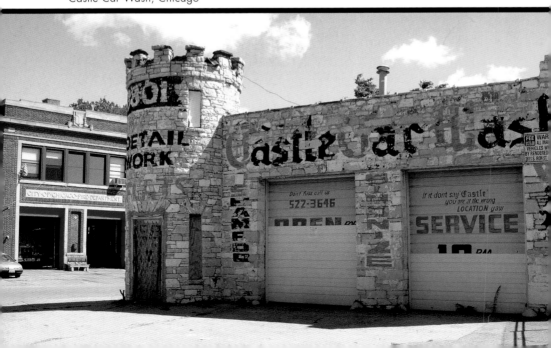

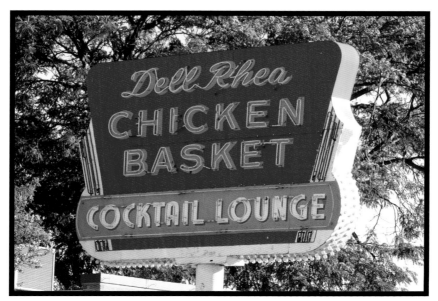

Dell Rhea's Chicken Basket and Cocktail Lounge, Willowbrook

south on Lawndale (the later alignment), or turn south on Harlem (the 1926 to 1928 alignment). On the Harlem alignment, you will traverse 43rd Street before joining Joliet Road.

On Joliet Road, Historic 66, in the area of Lyons and the Des Plaines River, you will find the Forest Preserve District, a relatively rare urban treat. The classic Route 66 roadside eatery Snuffy's 24-Hour Grill, which opened in 1930, is now a Steak N Egger franchise.

Because a quarry has undermined the old highway at Hodgkins, you will need to detour onto I-55 for a short distance rather than continuing southwest on Joliet Road. In spite of this abrupt intrusion by the modern era, it is still possible to maintain the Route 66 state of mind, especially with a detour to Dell Rhea's Chicken Basket in Willowbrook, accessed via exit 274. This roadside classic featured on the Food Network's *Diners, Drive-Ins, and Dives* has origins in a small café that served as a Blue Bird bus stop and service station complex established in 1946. It evolved in response to the rising tide of traffic that flowed past its door through the 1950s, but the current establishment has changed little since the early 1960s, and the fried chicken is now world-famous.

With the interchange at exit 268, you will again have two options. Fortunately in Illinois, Route 66 is well marked. Continue south on I-55, which roughly follows the course of Route 66 after 1938, or turn south on State Highway 53 (Joliet Road), the earliest alignment of Route 66 and Alternate 66 after 1938. My preference is the latter.

The first attraction of note is the White Fence Farm near Romeoville, which dates to the 1920s. Since 1954, the Hastert family has operated the facility, providing travelers with excellent, simple meals at reasonable prices. They added various attractions over the years, and today there is a free zoo and museum consisting of vintage cars and machines, which makes this a near-perfect roadside time capsule from the era of the Edsel and tail fin.

The next attraction of interest, a few miles south, is the Isle a La Cache museum, housed in a former restaurant that, legend claims, was a favored haunt of Al Capone. Located on an island in the Des Plaines River and dedicated to the French fur trade of the 1700s, the museum serves as the centerpiece of a complex that includes trails, picnic areas, and canoe launch sites. Here you can savor a summer afternoon, but if you have a photographic bent, I suggest visiting in mid- to late October, when the fall color is at its peak.

Lockport, the next town to the south, also has a few sites of interest, perhaps most notably the historic Illinois and Michigan Canal complex, which includes the Illinois State Museum Lockport Gallery and a canal museum. The Illinois and Michigan Canal played a pivotal role in transforming the area into a trade corridor connecting Chicago, La Salle, and Peru before completion of the Chicago, Rock Island and Pacific Railroad in 1853.

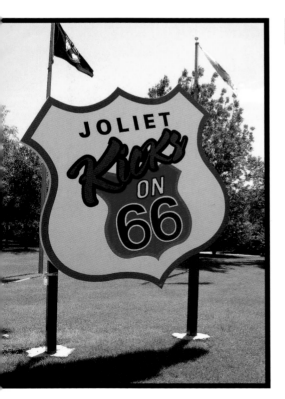

GET YOUR KICKS

Your next stop is Joliet, where there are enough attractions to ensure memorable vacations and several excellent places to satisfy your appetite. The numerous historic sites, attractions, museums, and recommendable restaurants mirror the community's rich history.

The Joliet Iron Works site (1869) and trail system require a detour of less than two miles from Route 66. As State Highway 53 (formerly Alternate 66) enters the city, it passes beautiful Route 66 Park and an oversize sign proclaiming, "Joliet Kicks on 66." Highlights of a stop here, especially on a warm summer day, include a fully refurbished Rich and Creamy ice cream stand

Route 66 sign, Joliet. *Steve Rider*

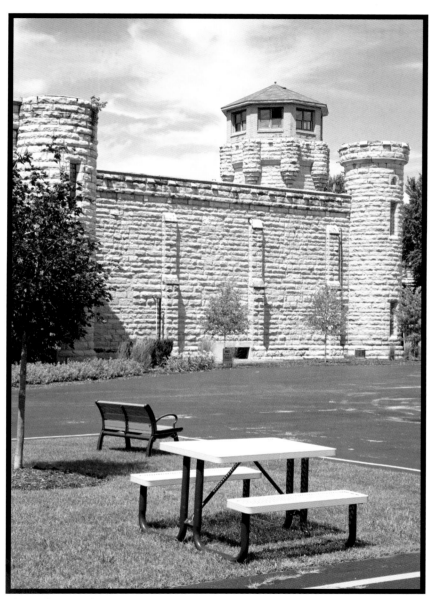

Joliet Correctional Center. *Henryk Sadura/Shutterstock.com*

DON'T MISS

Other interesting attractions in **Joliet** include the following:

- Union Station (50 East Jefferson Street), built in 1912, with 45-foot ceilings and crystal chandeliers;

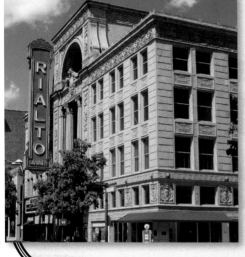

- Jacob Henry Mansion (20 South Eastern Avenue), built in 1873;
- The Rialto Square Theater (102 North Chicago Street, the original alignment of Route 66), dating to 1926—on Tuesday afternoons, guided tours are available through one of the nation's most beautiful theaters, with more than 100 hand-cut crystal chandeliers and light fixtures.

The Rialto Square Theater, Joliet.
Steve Rider

and a shade-dappled trail that leads to an overlook where you can see Joliet Correctional Center. Built in 1858, the prison was used as a setting in the movie *Blues Brothers* and the television show *Prison Break*.

If you favor obscure trivia, I suggest the building at 501 Chicago Street as a photo opportunity. It was here on June 22, 1940, that the first Dairy Queen opened.

Since this is a Route 66 adventure, set your sights (or your GPS) on 204 North Ottawa Street for an interactive experience at the Route 66 Visitor and Information Center and Route 66 Experience, a portion of the Joliet Area Historical Museum. This complex is at the center of a one-mile walking tour and provides a wealth of information about the many attractions in the area. The museum is located at the intersection of Cass and Ottawa Streets, where Route 66 and the Lincoln Highway intersect.

From Joliet, State Highway 53 follows the 1940s four-lane alignment of Route 66 south to Elwood. You can also follow the original alignment: two-lane Chicago Road south to Mississippi Road and then through Elwood on Douglas and Elwood Roads.

From Elwood, Historic Route 66 (State Highway 53) courses through the expansive site of the former Joliet Arsenal, a segment that many Route 66 enthusiasts feel is where the essence of the storied road begins. Today, 982 acres of the grounds are set aside as the Abraham Lincoln National Cemetery. The remaining 19,000 acres make up the Midewin National Tallgrass Prairie. Heralded as a model of land reclamation, this prairie reflects an Illinois landscape during the era of French exploration in the seventeenth century. The free information center includes informative and fascinating displays that ensure a memorable visit.

The next stop is the quaint village of Wilmington, on the banks of the Kankakee River. Unique shops and pleasant restaurants housed in structures built half a century or more before the dawn of Route 66 are only part of the charm. There are two landmarks of particular note here: the Launching Pad Drive-In and the Eagle Hotel. The Launching Pad Drive-In, with its towering Gemini Giant, has cast its shadow across Route 66 since the early 1960s. Built by International Fiberglass—a company famous for its so-called Muffler Men statues—the Spaceman is a favored stop for fans of the Double Six.

Gemini Spaceman at the Launching Pad Drive-In, Wilmington

The Eagle Hotel (closed as of this writing) initially opened in 1836 at the intersection of Water and Baltimore Streets to meet the needs of travelers on the road between Chicago and St. Louis. The oldest commercial building along Route 66 in Illinois offers evidence of Route 66's ancient roots in this state, as well as a great photo opportunity.

For movie buffs, a must-see attraction is the charming Mar Theater at 121 South Main Street. This 300-seat theater, with original marquee, dates to 1937.

From Wilmington, it is a short and pleasant drive to Braidwood. A mining boomtown a century ago, Braidwood is now famous among Route 66 enthusiasts for the Polk-a-Dot Drive-In, which opened in 1962. Originating in the 1950s as a gaily painted school bus that served as a burger stand, this little roadside gem serves up healthy portions of traditional fare with a touch of whimsy.

Godley and Braceville are next, but both are mere shadows of their former selves. In 1946, Jack Rittenhouse published *A Guide Book to Highway 66*, in which he noted that Godley was "once a booming mining community. Now

BRAIDWOOD

Braidwood, Illinois, was not always a quiet spot. In 1883, a disaster here that played an integral part in the rise of labor unions and child labor laws. The disaster placed this mining boomtown in the international spotlight.

February 16, 1883, was an unseasonably warm day. Heavy rains coupled with melting snow and ice collapsed the east tunnels of the Diamond Mine, owned by the Wilmington Coal Mining and Manufacturing Company. The main passage quickly flooded, and the water pressure sealed ventilation doors.

Area mines suspended operation as miners worked desperately to build a dam, pump water from the mine, and launch rescue teams. But it took thirty-eight days to reach the main shaft and recover the dead.

Deemed unsafe for further use, the mine was sealed two days later, entombing forty-six miners. Two of the miners were thirteen years old, and two were fourteen.

only a few homes remain." For Braceville, the Rittenhouse notes are a bit more expansive: "few gas stations; cafés; small garage. Like Godley, this town is but a remnant of a once thriving coal town."

Gardner, with its intriguing two-cell jail built in 1906, follows. Shady streets and the Gardner Restaurant, an eatery where the past and present blend seamlessly, exude old-fashioned charm. Adjacent to the jail, a simple memorial honoring Reverend Christian Christiansen was dedicated in August 2004. Christiansen, a Norwegian-born Lutheran pastor who lived in Gardner, provided the Allied forces with crucial intelligence during World War II. This information helped Allied commandos raid a German heavy water production facility, resulting in a major setback to the Nazis' atomic bomb development program.

Another intriguing attraction dating to the infancy of Route 66 is the former Streetcar Diner. Restored by the Illinois Route 66 Association, the diner began as a Kankakee streetcar but was relocated to Gardner and converted into a restaurant in 1932.

Route 66 twists its way through the heart of town on Washington Street, Depot Street, Jefferson Street, and Jackson Street. Then, shortly after crossing the railroad tracks, State Highway 53 gives way to State Highway 129, the modern incarnation of Route 66.

In the seven miles between Gardner and Dwight, Route 66 gently flows through a serene pastoral landscape. Then, two choices abruptly confront you: follow the original alignment of Route 66 into Dwight on Macnamara Street, or swing wide and follow Bypass 66.

During the 1940s, construction of a series of bypass routes to alleviate traffic congestion severed Route 66 from its historical roots along State Highway 4. State Highway 4, which predated the federal highway system, was an improved version of the original coach road built in the 1830s to link Chicago with St. Louis. In his 1946 guidebook, Rittenhouse made a prophetic notation about the construction of bypass alignments: "The new freeway, by skirting these smaller towns, is affecting the portion of their income formerly received from tourists."

Route 66 originally curved around the town of Dwight on Waupansie Street and then connected with Odell Road, which joined the bypass alignment south of town. The Becker Marathon gas station, located at the intersection of State Highway 17, is a Route 66 treasure dating to 1933. Fully refurbished, the station remained in operation for sixty-six years. It now serves as a visitor center, providing information about Route 66 as well as other sites in the community. It is also a favored photo stop. Meeting travelers from the four corners of the earth is a common experience here.

If your visit coincides with breakfast or lunch, the Old Route 66 Family Restaurant is less than a block away. Just look for the crowded parking lot

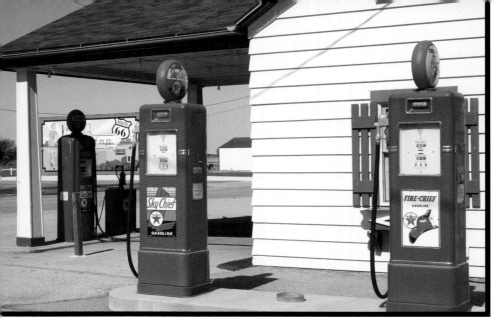
Becker Marathon gas station, Dwight

and the colorful mural that decorates the outside of this wonderful old-fashioned café.

Before continuing with your Route 66 adventure, I recommend a slight detour. Take a left turn on State Highway 17 and drive into the historic heart of Dwight. I also suggest parking at the beautiful train depot, built in 1891, and exploring the charming downtown district on foot.

Designed by renowned Chicago architect Henry Ives Cobb, the Chicago and Alton Railroad Depot received recognition with its addition to the National Register of Historic Places in 1982. Today the depot serves as an Amtrak station as well as the Dwight Historical Society Museum.

Surprising treasures await discovery at every turn in downtown Dwight. There is the stylish First National Bank building (1905) designed by Frank Lloyd Wright, the Bank of Dwight building (1910) with its gorgeous dome mural, and the former Keeley Institute, now the Fox Developmental Center, with five beautiful Tiffany-style stained-glass windows that depict the five senses affected by alcoholism.

Nearby is the delightful 1891 Oughton House, now the Country Mansion Restaurant. Dominating the grounds is an octagonal five-story building built in 1896. The building is an odd blend of vintage lighthouse and windmill.

From Dwight the old road, now State Highway 129, resumes its leisurely course through bucolic landscapes before arriving at Odell. Again, you have the option of taking the bypass or coursing through town. I recommend the latter.

Even in towns as small as Odell, there are hints of the important role that Route 66 played in these communities and of the crush of traffic that once

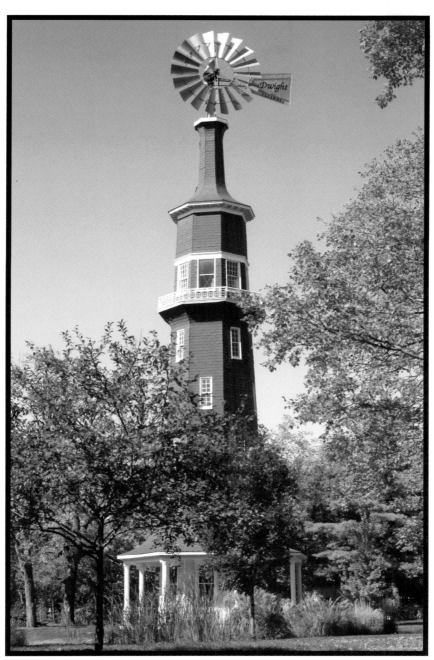

Windmill at Keeley Institute, Dwight

flowed through them. In Odell, such hints take the form of the subway—an underground walkway built in 1937, when traffic was so heavy it was almost impossible to cross the road—and the refurbished Odell Standard Oil Station.

The latter, listed in the National Register of Historic Places on November 9, 1997, dates to 1932. It now serves as a visitor center. The refurbished station is a classic example of how the cooperative efforts of the state of Illinois, the Route 66 Association of Illinois, and individual communities have helped revitalize and transform the Route 66 corridor into one of the state's top tourist destinations.

Standard Oil Station, Odell. *Judy Hinckley*

THE LAND OF LINCOLN

After driving a few short miles through pastoral landscapes, your next stop is Pontiac, a jewel of Route 66 preservation. A hint of what awaits you in this treasure chest of a community is found at the intersection of Bypass 66 and the original alignment, or Pontiac Road.

The Old Log Cabin Restaurant, at 18700 Old Route 66, was built in 1926 facing the original alignment. When construction of the new four-lane highway was completed in the 1940s, the entire building was rotated 180 degrees to front the new highway!

Route 66 intersects with history here at the Pontiac Trail, a path used by Native Americans before the arrival of European explorers. The trail later became Pontiac Road to meet the needs of an evolving nation. Pontiac also boasts State Highway 4 (predecessor to US 66) and the pre-1930 alignment of Route 66, as well as the 1940s four-lane bypass.

The town of Pontiac has masterfully used interest in Route 66 to transform and revitalize itself, becoming a destination for international travelers as well as weekend adventurers from Chicago, St. Louis, Springfield, and other cities. At every turn, you'll see colorful murals—even in the alleys! The town's centerpiece is the beautiful Livingston County Courthouse. Built in 1875, the courthouse is surrounded by monuments in the shaded town square,

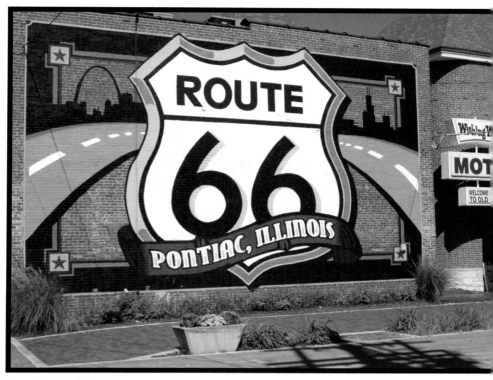

Route 66 mural, Pontiac

which includes a Civil War soldiers and sailors monument dedicated by President Theodore Roosevelt in 1903.

Unique and fascinating museums abound in Pontiac, including the Route 66 Hall of Fame and Museum and the Livingston County War Museum, both housed in the massive old city hall and firehouse built in 1900. You can also visit the International Walldog Mural and Sign Art Museum, which preserves the history of outdoor wall signs and murals.

For the automotive enthusiast, the Pontiac-Oakland Automobile Museum and Resource Center opened in the summer of 2011. The facility preserves the largest collection of materials related to these brands, including original design sketches, promotional material, and a full library of original research material in addition to a significant number of automobiles.

Additionally, Pontiac contains numerous historic sites and homes, several with direct connections to Abraham Lincoln, and the charming Three Roses Bed and Breakfast on Howard Street. A beautiful park features three swinging bridges built more than a century ago to span the Vermilion River. Incredibly, this community filled with so many attractions has a population of less than fifteen thousand!

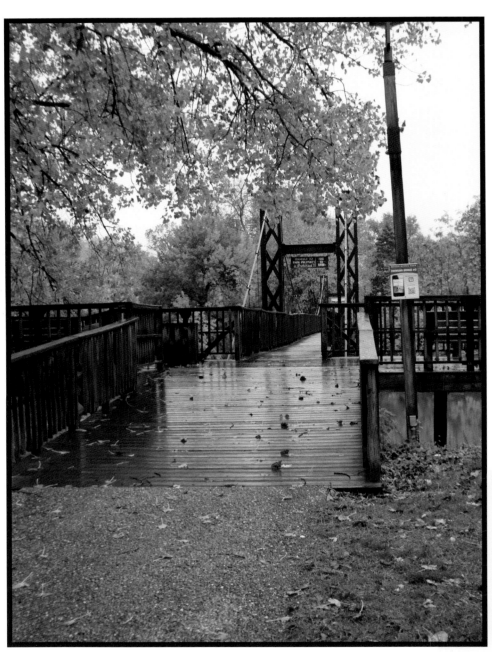

Swinging bridge across the Vermilion River, Pontiac

DON'T MISS

When visiting **Pontiac**, these sites are worth a look:

- Illinois State Police District 6 Headquarters, built in the shape of a pistol in 1941;

- North Creek Bridge, the only original bridge abutments with the State Highway 4 (Route 66 predecessor) designation;

- Humiston Woods Nature Center (2100 North Street), a 400-acre nature preserve with a restored Illinois prairie and a series of trails;

- Catherine V. Yost House Museum (298 West Water Street), built in 1898, which houses an extensive collection of Yost's paintings from her travels in Europe and the United States.

Continuing south from Pontiac, old Route 66 resumes its leisurely course through farmlands and woodlots. Not much bigger than the dots that represent them on maps are the communities of Ocoya and Chenoa. However, this is Route 66 in Illinois, so no town is too small for a surprise or two. Old Route 66 followed Morehead Street into Chenoa through a nineteenth-century business district that has survived into the modern era with little change.

The centerpiece of Chenoa is the Chenoa Pharmacy at 209 Green Street, originally Schuirman's Drug Store, built in 1889. Now a museum as well as a drug store, it retains its original custom-built cabinetry with ceramic knobs.

In Lexington, the next stop on your journey west, the primary attraction is the road itself even though the historic district is a wonderland of architectural gems. A short segment of the original alignment, anchored with Lexington Route 66 Park at one end and the town at the other, now serves as a bicycle and walking trail signed aptly as Memory Lane. Reproduction billboards enhance the sense of a journey into the past. As you explore this trail, enjoy a rest on one of the shaded benches.

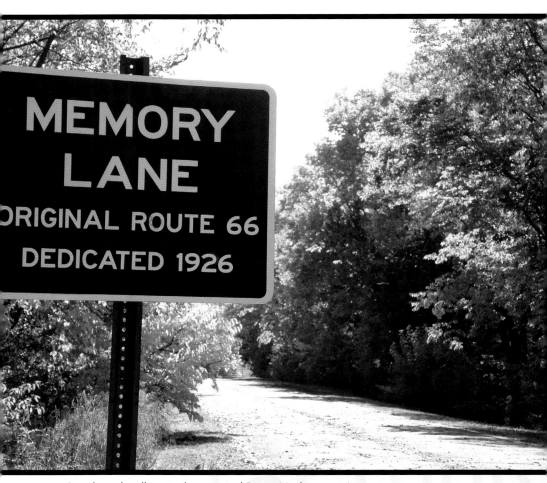

Bicycle and walking trail on original Route 66 alignment, Lexington

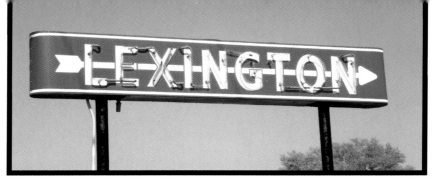

Lexington neon sign. *Judy Hinckley*

A Lexington landmark easily overlooked is a recently refurbished neon arrow emblazoned with the word *Lexington*. With completion of the bypass alignments in the 1940s, the city erected the sign to direct people into the Lexington business district.

Towanda, the next town on your westward odyssey, has taken the concept of Route 66 as informative walking or bicycle path a step further. Towanda's trail, named Historic Route 66: A Geographic Journey, was created utilizing a 1.6-mile segment of the old four-lane Bypass 66. Burma-Shave signs, displays representing all eight states through which Route 66 passes, flyers printed in eight languages, and Boyd Wesley Park with its fishing hole make this trail an ideal place to stop and stretch your legs.

P. J. KELLER PARK DETOUR

Listed on the National Register of Historic Places, the Patton Cabin located in Lexington's P. J. Keller Park dates back to 1829.

The cabin is open for exploration on Sunday afternoons in June, July, and August.

Patton Cabin in P. J. Keller Park, Lexington. *Shutterstock.com*

Suburbia intertwined with pastoral landscapes dominates the roadside on the short drive from Towanda to Normal and Bloomington. These two towns seem to blend into one large community, the largest encountered since leaving Joliet. To avoid the crush of traffic, take Veteran's Parkway, the I-55 business loop that is the modern incarnation of the Route 66 alignment after 1941.

Historic Route 66 is well marked through both communities. And as with each town along the highway in Illinois, this area boasts a wide array of attractions, important sites, and interesting museums. For example, at 1219 South Main Street in Normal is the site of the first Steak 'n Shake franchise, which opened in 1934.

Another intriguing stop is the McLean County Museum of History, located in the old county courthouse at 200 North Main Street. Built in 1900, the monumental building now houses a variety of award-winning exhibits that chronicle the county's colorful history. It is also home to one of the top five genealogical reference libraries in the nation.

BICYCLING DETOUR

Exploring Route 66 by bicycle is fast becoming a favored way to enjoy the iconic highway. Many states and communities are using old alignments as bicycle corridors and are establishing bicycle-specific services. A number of organizations and companies can help you plan a bicycle adventure on the Double Six. The Adventure Cycling Association (www.adventurecycling.org) is one of the oldest. It is currently spearheading an effort to create a guide to Route 66, to develop urban corridors, and ultimately, to incorporate the old highway into the U.S. Bicycle Route System. You can find more information about bicycling Route 66, especially in Illinois, at www.bikelib.org/maps-and-rides/route-guides/route-66-trail.

McLean County Museum of History, Bloomington. *Henryk Sadura/Shutterstock.com*

And because food is an integral part of our adventure, be sure to stop at the world's only Beer Nut factory, at 103 North Robinson Street in Bloomington. The factory has a gift shop and offers tours and, of course, samples.

West of Bloomington, a brief detour into the modern era is required between exit 157 and exit 154 on I-55. Then you can resume your Route 66 adventure at Shirley.

COUNTRY ROADS TO THE CAPITOL

The next stop on our voyage of discovery requires a slight detour, but it is a true gem. Funks Grove is one of those places that makes a journey along Route 66 special. From Shirley drive 4.2 miles to Funks Grove Road, turn right, cross the tracks, and slip into an era far removed from that of cell phones, the Internet, and television.

Immediately to the left is the weathered old country store, now closed. Across the road is the railroad depot relocated from Shirley. However, to find the real treasure here, follow the signs for about one and a half miles to the 1845 Funks Grove Church, the historic cemetery, and Sugar Grove Nature Center. The nature center is designated a National Natural Landmark by the U.S. Department of the Interior, with trails that twist through the thick stands of native maple trees. If you make this drive or walk these trails during mid-October, when the leaves are changing color, just try to take a poor photograph. It is almost impossible.

Shortly after resuming the drive southwest on Route 66, on the south side of the road, you'll find a shaded driveway and a sign that reads "Funks Grove Pure Maple Sirup." Here are a small country store, open from spring to late summer, and production facilities for the various Funk family maple products.

The Funk family settled here in 1824. Issac Funk was an Illinois state senator in the 1840s and a con-temporary of Abraham Lincoln. In

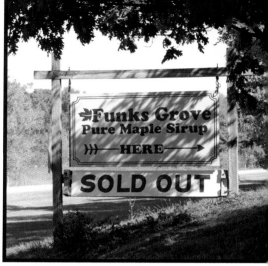

Sign for Funks Grove Pure Maple Sirup

1891, Arthur Funk initiated commercial production of maple syrup, a tradition that continues to this day with Debbie and Mike Funk.

About 4.5 miles south you'll find the Dixie Travel Plaza, which opened in 1928 as the Dixie Truckers Home. It is the oldest continuously operated truck stop on Route 66. The route follows a twisted course through McLean, one of two communities with this name on Route 66. It enters as the frontage road, follows Carlisle and Main Streets, and then tracks with US 136 before resuming its southwestern course.

Before leaving McLean, take a break at the Arcadia: America's Playable Arcade Museum (107 South Hamilton Street). Preserved circa 1984, the museum is free to enter, but be sure to bring lots of coins for the games.

Vintage postcard for Dixie Truckers Home, McLean. *Courtesy of Steve Rider*

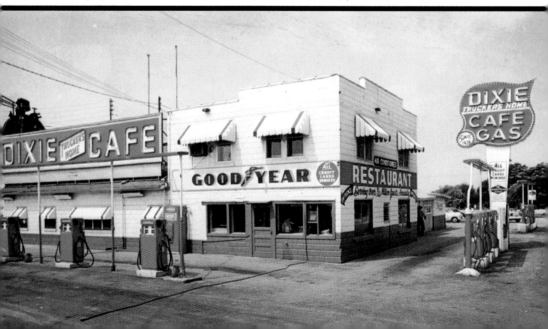

In Atlanta, about four miles from McLean, you will have the option of following the 1940s-era bypass or Northeast Arch Street into town. Again, I recommend the latter, since this unassuming little town holds a wealth of surprises. They range from the silly—namely the nineteen-foot fiberglass statue of Paul Bunyan holding a giant hot dog, relocated from Bunyon's Restaurant in Cicero—to the fascinating. In the latter category, you have the J. H. Hawes Grain Elevator Museum at the corner of Race and 2nd Streets, the octagonal library built in 1908, and a 1909 clock in a tower that has a viewing window into the internal working mechanism, which is wound by hand every eight days.

Restored wall signs add a period feel to the central block, which consists of a row of sturdy brick buildings dating to the 1860s. Here you will find the Palm Grill Café—an authentically refurbished 1930s café known internationally for its pies—as well as the community's surprisingly in-depth museum.

The attention to detail in the café's restoration immerses you into the world of 1940 as soon as you step through the door. Music of the era playing ever so softly sets the mood. The 75-year-old baseball-themed pinball machine is operational. The day's blue-plate specials are displayed on a board near the door. A mid-1930s refrigerator is still used, and a cash register of similar vintage adorns the counter.

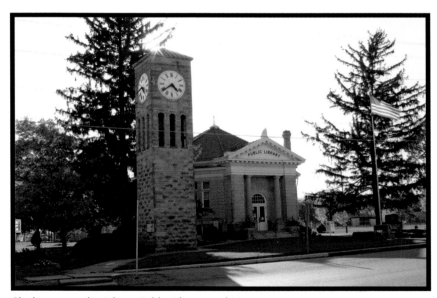

Clock tower at the Atlanta Public Library and Museum

Next door at 112 Southwest Arch Street, the Atlanta Museum houses a staggering collection that includes materials pertaining to Abraham Lincoln, the community's role in his presidential election, and Route 66, as well as the area's colorful history. In addition, an extensive genealogy materials collection is open to the public. Before you can blink or settle into a pleasant drive through Illinois prairies and farmland, the little town of Lincoln requires a slowdown and another decision: the Lincoln Parkway that was Bypass 66, or the route into town via Kickapoo Street? Since Lincoln has numerous notable attractions, you'll want to pass through the town.

THE LAWNDALE THUNDERBIRD

Just southwest of Atlanta lies Lawndale, a town so small you might miss it even if you're looking for it. In 1946, Jack Rittenhouse described it as "really not a town at all, since it consists of a couple of red railroad shacks, a few homes, and a pair of grain elevators."

It is difficult to imagine anything earthshaking ever happening here. But this diminutive community is legendary for a story that began on the evening of July 25, 1977.

The Lowe family had gathered family and friends that evening for a barbecue, and young Marlon Lowe was playing with the other children in the yard. Just after 8:00, a huge black bird swooped down over the crowd, lifted the 56-pound child from the ground, and began to fly away. Only the intervention of the boy's mother, Ruth Lowe, saved him.

For a brief time the Lawndale Thunderbird provided fodder for late-night comedians and was used as filler for news shows and newspapers. The publicity proved to be a curse for the Lowe family, however, and they left town and tried to put the event behind them.

With the passing of years, the event became an obscure footnote. Then, in 1997, the Thunderbird story resurfaced when Marlon Lowe told his incredible story on the Discovery Channel's program *Into the Unknown*.

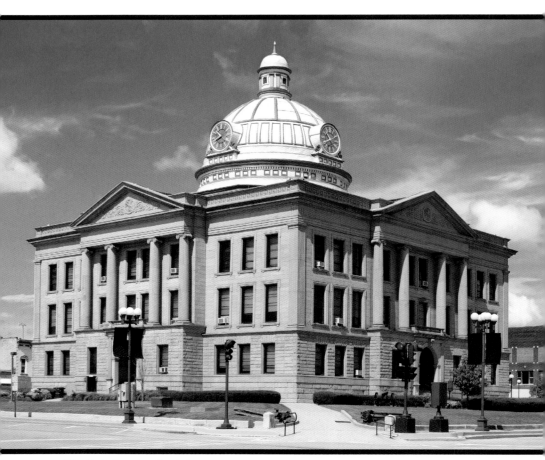

City Hall, Lincoln. *iStockphoto*

Lincoln has the distinction of being the only town named for Abraham Lincoln before he became president. Legend has it that Lincoln attended the dedication, cut a watermelon, and christened the community with the juice. A plaque and monument at 101 North Chicago Street attests to this story.

These associations with the sixteenth president of the United States were a determining factor in the decision to hold the premiere of the Steven Spielberg movie *Lincoln* here in November 2012. The venue for the showing was the aptly named Lincoln Theater, a charming old facility built in 1923. Counted among other notable attractions in Lincoln are an exact replica of the Pottsville Courthouse built in 1841 (the original was relocated to the Greenfield Village complex in Dearborn, Michigan) and the current courthouse built in 1905. Lincoln is also home to two museums: the Lincoln College Museum at 300 Keokuk Street and the Heritage in Flight Museum located at the Logan County Airport.

On the list of the top ten strangest attractions found anywhere on Route 66 is a telephone booth on the roof of the Lincoln City Hall (built in 1895). Installed for the use of weather spotters, it remains as a curiosity.

From Lincoln to Springfield, Route 66 is often squeezed between the railroad tracks and I-55 as it cuts through farmlands and twists its way through the small towns of Broadwell, Elkhart, Williamsville, and Sherman. Each offers a little something unique.

Broadwell was home to the Pig Hip restaurant, a roadside classic operated by Ernest Edwards from 1937 to 1991. A fire in 2007 leveled the venerable old diner-turned-museum, and a monument marks the site today.

In Elkhart, the treasures are the Wild Hare Café, an eatery that comes highly recommended by John Weiss, historian and author of *Traveling the New, Historic Route 66 of Illinois*; and the Gillett Memorial Arch Bridge on County Road 10, commissioned by Emma Gillett Oglesby, a former Illinois first lady, in 1915.

Sherman retains historic architecture that makes for interesting photo opportunities. For the Route 66 enthusiast the primary attraction is Carpenter Park, the eastern border of which is formed by a segment of the original alignment of the highway, including concrete curbing.

In Springfield, signage indicates Historic 66 as well as Business Loop 55. The pre-1930 alignment followed State Highway 4 through the city using Capital, 2nd, Macarthur, and Wabash Streets and Chatham and Woodside Roads.

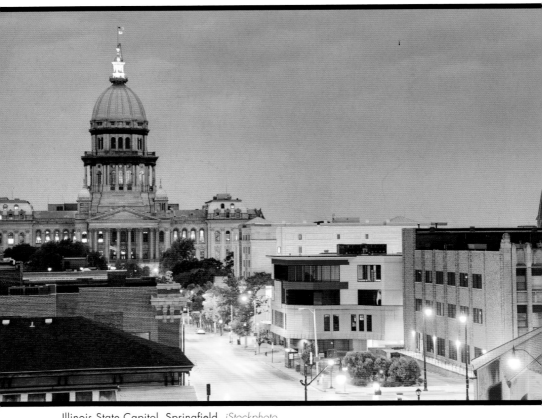

Illinois State Capitol, Springfield. *iStockphoto*

Between Springfield and Staunton are two distinct alignments of Route 66: the pre-1930 alignment, which follows State Highway 4, and the later alignment, which is now largely a frontage road for I-55. With a little planning, you can have your cake and eat it too by enjoying the best of both alignments. First, let's explore Springfield.

If you are in a Route 66 frame of mind, start with Shea's Gas Station Museum at 2075 Peoria Road, just south of the Illinois State Fairgrounds and its thirty-foot statue depicting Abraham Lincoln during his years as a rail-splitter. There is a fee to tour this private museum, but it offers a rare opportunity to see a staggering collection of oil company memorabilia that runs the gamut from refurbished gas pumps to original signage, as well as ample Route 66–related material.

DON'T MISS

In **Springfield**, you can add some depth and context to the Route 66 experience by visiting these sites:

- The Old State Capitol, a reconstruction of Springfield's first state house (1839–1876);

- Camp Butler National Cemetery, once the site of a Confederate prison camp and training center for Union soldiers;

- Illinois State Police Heritage Foundation and Museum (4000 North Peoria Road), with a fascinating collection that highlights the history of the highway patrol since 1922;

- Washington Park Botanical Garden, featuring a conservatory, greenhouse, and a variety of outdoor garden plantings on 20 acres.

Located on the south side of the city is a Route 66 attraction of epic proportions: the Cozy Dog Drive-In. This unassuming little restaurant provides a link to the immediate post–World War II era of Route 66. However, what really sets this establishment apart is its association with members of the Waldmire family, who still manage the property today.

The restaurant's signature dish is the batter-dipped Cozy Dog, created by Edwin Waldmire and debuted at the Amarillo (Texas) Army Airfield Post Exchange during World War II. Edwin was the father of iconic artist Bob Waldmire, a fixture on Route 66 for many years as he traveled in his Volkswagen bus and painted murals and crafted pen-and-ink drawings, as well as postcards, with stunning attention to detail.

Bob Waldmire was the inspiration for the character Fillmore in the animated film *Cars*. His VW bus and handcrafted motor home on a school bus chassis are major attractions at the Route 66 Hall of Fame Museum in Pontiac.

DON'T MISS

When you're in Springfield, don't forget these **Abraham Lincoln**–related spots:

- Lincoln Home National Historic Site (426 South 7th Street), which includes Abraham and Mary Todd Lincoln's home and a four-block neighborhood of twelve original or restored homes that enable immersion into the world of 1860;

- Abraham Lincoln Presidential Library and Museum (112 North Sixth Street), which houses more than 1,500 original letters and manuscripts, artifacts ranging from the president's signature stovepipe hat to a bloodstained glove from the night of his assassination, and original items and materials belonging to Mary Todd Lincoln and John Wilkes Booth;

- The Lincoln-Herndon Law Offices, a state historical site at Sixth and Adams Street, preserved as it was when Abraham Lincoln practiced law there with William Herndon from 1843 to 1852;

- The Lincoln Tomb State Historical Site at Oak Ridge Cemetery (1500 Monument Avenue), dominated by a beautifully detailed 117-foot high obelisk built in 1874;

- Daughters of Union Veterans of the Civil War Museum (503 South Walnut Street), with a museum of Civil War artifacts, a library and research center, a gift shop, and a memorial brick garden honoring DUV founders and war veterans;

- Grand Army of the Republic Memorial Museum (629 South 7th Street).

Lincoln Home National Historic Site, Springfield.

ALTERNATE ALIGNMENTS

Now let's discuss the sixty-five mile drive from Springfield to Staunton, an ideal segment of Route 66 for enjoying a leisurely drive in your car or a day trip on your bicycle. I recommend following the old alignment, State Highway 4, also signed as historic 66. Since only a few miles separate the two alignments, and other state and county roads link them, it is quite easy to enjoy the high points of both alignments.

Found almost immediately after leaving the town of Chatham is a highlight of the earliest alignment. Listed on the National Register of Historic Places, a 1.4-mile section of roadway boasts a surface of hand-laid bricks placed over the original Portland cement in 1931.

COVERED BRIDGE DETOUR

The Sugar Creek Covered Bridge is one of five remaining historic covered bridges in the state. Accessed from Covered Bridge Road, which connects with the early alignment of Route 66 (State Highway 4 near Chatham), or from the later alignment and I-55 via Ponyshoe Lane and Pullman Road, a trip to the bridge requires less than a three-mile detour from either alignment.

Sugar Creek Covered Bridge

The restored sixty-foot span across Sugar Creek dates to 1880. It is the centerpiece of Pioneer Park. It was at this site that Robert Pulliam established his homestead in 1817.

During mid-October the fall leaves make this a photographer's paradise. In summer, it is an ideal picnic stop as well as a refreshing place to stretch your legs.

Each of the little towns along this early alignment—Chatham, Auburn, Thayer, Virden, Girard, Carlinville, and Gillespie—has something to offer. A traveler only needs to take time to search for the little gems and to savor them.

In Auburn, the gems are a pleasant little square with an unusual two-story gazebo and Becky's Barn, an eclectic shop offering everything from fine antiques to birdhouses. Thayer has no business district aside from a few shuttered buildings that hint of better times in the distant past. But these present wonderful photo opportunities, especially during the months of fall with the changing color of the leaves.

In the serene central park of Virden, a memorial honoring those who served in World War I contrasts with another memorial to a tumultuous time when this community was the frontline for bitter labor struggles. The latter monument is a series of bronze bas-relief panels that offers silent testimony to the bloody Battle of Virden, when coal miners, union organizers, and strike-breakers clashed in 1898.

In Girard, the special treasure is Doc's Soda Fountain. Traditional treats and an intriguing, free drug store museum with items chronicling more than a century of history ensure that a stop here bestows plenty of fond memories.

If you prefer your ice cream treats in a more modern atmosphere, try the Whirla-Whip (309 South 3rd Street) one block south of Route 66/State Highway 4. Virtually unchanged since its opening in 1957, from April through September this roadside wonder offers soft-serve ice cream, traditional fare, and an opportunity to try your hand at a game of horseshoes.

West of Nilwood, on a section of Route 66 signed as Donaldson Road, you'll find a few modern fossils: turkey tracks that date to when this roadbed was laid in the 1920s and the turkeys traversed the still-wet concrete. As with most attractions of note along Route 66 in Illinois, this, too, is well marked.

Carlinville town square

Despite its diminutive size, Carlinville is a treasure trove of historical curiosities and photo opportunities. With a post office in operation since 1830, historic Carlinville offers a wealth of late nineteenth-century and early twentieth-century architecture surrounding a beautiful town square.

Less than two blocks away is the stunning "Million-Dollar" Macoupin Courthouse. This is an architectural gem completed in 1870 that stands as a towering monument to the high price of cronyism and political scandal. In 1867, the projected cost was $50,000 but the actual price ended up being $1.3 million. Another interesting attraction is the ornate jail built across the street in 1869.

CARLINVILLE

Historic Carlinville, with a post office in operation since 1830, was once synonymous with greed, cronyism, and political corruption of epic proportions. The ornate jail (built in 1869) and the towering courthouse, which was the largest outside New York City at the time of construction in 1870, remain as mute testimony.

The "million-dollar courthouse" is but one of the unique sites with an obscure historic association. In 1918, as Standard Oil expanded its mining operations nearby, a housing crisis ensued. To resolve the issue, the oil company ordered 156 mail-order kit houses from Sears, Roebuck, and Company. Built in what is now platted as the Standard Addition, 152 of the houses remain, making this the largest concentration of Sears catalog homes in the nation.

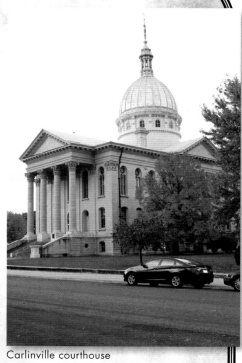

Carlinville courthouse

Then, those seeking a place to lay their heads at the end of a long day exploring the wonders of Route 66 need look no further than the Carlinville Motel, another time capsule from the pre–interstate highway era. Simplicity, cleanliness, and quiet have been this place's hallmarks for more than a half-century.

After twisting and turning through the old streets of Gillespie and Benld—lined with picturesque homes—you come to Staunton, where the original and later alignments of Route 66 merge less than two miles south of town. A variety of artifacts remain from the era of Route 66, but only one attraction perfectly bridges the gap between the past and present: Henry's Rabbit Ranch at 1107 Historic Old 66.

The collection at Henry's ranges from vintage tractor-trailer rigs emblazoned with *Snortin' Nortin* and the slogan *Humpin' to Please*—links to the now-defunct Campbell's 66 Express—to both Volkswagen Rabbits and giant fiberglass rabbits. In the yard, a pile of historic neon signs await restoration, and vintage gas pumps guard the entrance. In the gift shop, where all things rabbit-related are for sale, live rabbits have free rein.

Now, let's consider the other alignment of Route 66 from Springfield to Staunton. With the exception of a 1930s segment that runs from Lake Springfield to Glenarm, here we follow the 1940s alignment used as a frontage road for I-55. As a result, the generic offerings of the modern era often outnumber the vintage treasures, but those that have survived are extraordinary, as are the little treasures found with slight detours.

Henry's Rabbit Ranch, Staunton. *Judy Hinckley*

LAKE SPRINGFIELD DETOUR

At exit 90 on I-55, turn left on Toronto Road, travel about three-quarters of a mile to North Cotton Hill Road, and turn right. You can follow this road—the original Route 66 alignment—for about one mile until you come to gates that block the old highway. From here to Lake Springfield, the remnants of the old road make for a short but wonderful walking trail.

Lost under the waters of the lake created in the 1930s is a forgotten chapter in Illinois and Route 66 history. The exact date of origin for the small town of Cotton Hill is unknown. However, historical records indicate John Ebey was manufacturing "Illinois redware pottery" at this site between 1826 and 1828.

A post office operated under the name Cotton Hill from 1862 to 1908, indicating the community was in a period of decline during the first decades of the 20th century. By 1933, as the rising waters of manmade Lake Springfield inundated the site, Cotton Hill faded into obscurity.

After leaving Springfield on I-55, I suggest you take exit 88 (Lake Shore Drive) to Old Carriage Drive. This road, followed by Old Route 66 and Glenarm Road, is a circa 1930 alignment of the highway.

Glenarm qualifies as little more than the proverbial wide spot in the road, but Divernon is a pleasant little town with a beautiful old train depot and a cluster of shops and restaurants nestled around a parklike square.

Farmersville is home to Art's Restaurant and Motel, a survivor from the pre-interstate era. It began life in 1937 as a gas station, a restaurant, and eight cabins. It still consistently garners favorable reviews. Its original signage, recently restored with assistance and partial funding from the Illinois Route 66 Preservation Committee, is a favorite photo stop.

Near Waggoner, there is the Our Lady of the Highways shrine. Established by the Francis Marten family (whose members still maintain the site) in 1959, the shrine hints at the dangers associated with driving Route 66 during an era when traffic flow had exceeded what design engineers had envisioned.

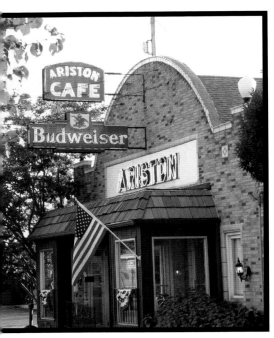
Ariston Café, Litchfield

This takes you to Litchfield, a treasure trove of attractions and sites. Topping that list has to be the timeless Ariston Café, owned and operated by the same Adams family that established the restaurant in 1924 and relocated it to the current site in 1935. Good food, excellent service, and a remarkably well-preserved interior ensure a stop here will be quite memorable, and your appetite will be satisfied.

Across the street from the Ariston Café, the Litchfield Museum & Route 66 Welcome Center opened in the summer 2013. The museum offers exhibits and displays outlining the history of the community and the historic highway.

If your schedule allows, plan on spending the night, because this little town is home to the Skyview

LITCHFIELD

Today Litchfield, Illinois, is recognized internationally, thanks to the Ariston Café. However, in 1904 tragedy put the community in international headlines.

On July 5, 1904, the Exposition Limited train was making good time on the run to St. Louis when it hit an open switch one mile from the Litchfield, Illinois, station. The resulting collision was horrendous. The passenger train was mangled almost beyond recognition.

Rescuers combed the wreckage throughout the night and into the next day. The death toll of twenty-two, and severe injury toll of thirty-seven, made this one of the worst train wrecks at the dawn of a new century.

Drive-In Theater. In operation since 1951, it's the last of its kind along Route 66 in Illinois.

Mount Olive is the last community on this alignment, since the various incarnations of Route 66 converge near Staunton. Here the fully refurbished Russell Soulsby Shell Station appears as it did in the early 1930s after the addition of the garage. The station itself dates to 1926. It remained a family-owned business for sixty-five years.

The second attraction here is a bit more somber, since it commemorates a dark period in our nation's history, the labor strife of the 1890s. The Union Miners Cemetery, dominated by a towering obelisk honoring labor organizer Mary "Mother" Jones, was established in 1899 after the men killed in the Virden Riot in October 1898 were disinterred at the request of the cemetery owner and the families were barred from using the Lutheran cemetery.

MOUNT OLIVE

The Union Miners Cemetery in Mount Olive has its origins in the labor strife of the late nineteenth century. It is the final resting place for a number of pioneering labor organizers.

On March 10, 1898, at Virden, Illinois, striking miners led by "General" Alexander Bradley, a flamboyant figure and self-appointed organizer for the United Mine Workers of America, confronted armed mine guards while attempting to stop a train carrying 180 African-American "scabs." Who initiated the gun battle is unknown, but by the time National Guard arrived to restore order in the late afternoon, seven miners and four guards were dead, and forty miners and four guards were severely wounded.

Initially the dead miners from Mount Olive were interred in the town cemetery, but upon complaints from the owner, an order was given that the bodies were to be moved. Since the local Lutheran minister denounced the miners as murders and anarchists, the families were barred from burying the miners in the Lutheran cemetery.

The local union purchased a picturesque one-acre site, and the Union Miners Cemetery was established in 1899. Expansion occurred in 1902, 1918, and 1931.

TO THE GREAT RIVER

The last segment of Route 66 in Illinois from Staunton to the Mississippi River is a maze of alignments littered with a dizzying array of attractions. As an example, during the 1950s, the highway was rerouted south from Mount Olive along what is now I-55 to Collinsville, famous for its giant catsup bottle water tower. This bypassed the junction of the earliest alignment and the 1940s alignment near Staunton.

Portions of earlier alignments in Mitchell and Granite City and the Chain of Rocks Bridge became Alternate 66 or Bypass 66, depending on the year, for those hoping to avoid the crush of traffic in St. Louis. There were major adjustments to the highway's alignment on the east bank of the river in 1929, 1936, the mid-1940s, and the early 1950s.

EDWARDSVILLE

In 1890, industrialist N. O. Nelson selected a wooded tract of land immediately south of Edwardsville, Illinois, to establish a plumbing supply manufacturing company and a community he called Leclaire. The operational procedure for the company was revolutionary and visionary.

First, all employees shared in the company's success through a profit-sharing program. Second, employees could avail themselves of low-interest home loans in the planned community of Leclaire with its free schools, wide expanses of parks, and educational seminars designed to ensure workers were well educated.

Today, the former Leclaire Academy houses the Edwardsville Children's Museum. Lewis and Clark Community College has taken over the former factory.

Each October the village, listed on the National Register of Historic Places in 1979, hosts the Friends of Leclaire Festival. The event captures the essence of the original community with parades, music, family-oriented activities, guest speakers, and a book sale.

Fortunately, most of Route 66 is well marked and relatively easy to follow. Still, many segments lie buried under a freeway or flow through areas that are not tourist-friendly. Inquire at the tourist information center on I-55 near Hamel for more information.

Attractions abound all along the various alignments of Route 66 in this area. For example, in Hamel, there is Weezy's, an old roadhouse with a dining room that has been serving travelers since the 1930s. In Mitchell, the Luna Café (1924) is another classic roadhouse but with restored neon signage. Persistent urban legends claim that the establishment had ties to Al Capone and illicit activity.

Cahokia Mounds State Park near Collinsville is a fascinating attraction and a UNESCO World Heritage Site. Here a small segment of what was once a thriving pre-Columbian city-state is preserved. A museum and trails with markers provide details on an often-overlooked chapter in American history.

However, for the Route 66 devotee, the 5,353-foot Chain of Rocks Bridge is the must-see attraction here. Incorporated into the Route 66 corridor in 1936, the bridge was originally built in 1926 and served as a river crossing for the highway until 1966. It is now the nation's longest pedestrian and bicycle bridge, connecting the MCT Confluence Trail in Illinois with Riverfront Trail in Missouri.

For more information about Route 66 in Illinois, visit www.illinoisroute66. org or read *Traveling the New, Historic Route 66 of Illinois*, a self-published book by historian and Route 66 preservationist John Weiss. For more information, visit www.il66authority.com.

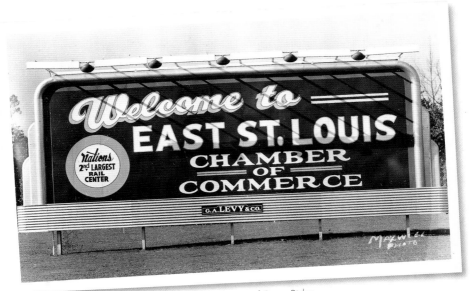

Postcard of East St. Louis welcome sign. *Courtesy of Steve Rider*

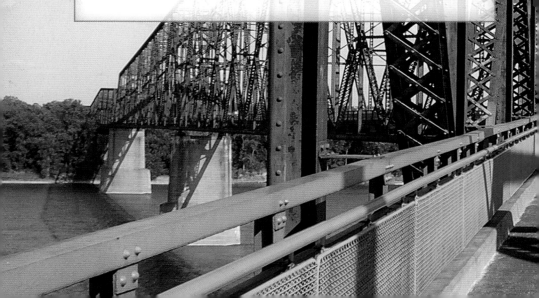

CHAPTER 2

MISSOURI

Following Route 66 across the Show-Me state can be a truly delightful adventure, especially during late October when the fall colors transform the Ozark Mountains into a sea of bright red, yellow, and orange. Attractions along the highway in Missouri range from natural wonders to Civil War sites to the world's tallest rocking chair, but you can't see any of them until you make it through St. Louis.

Chain of Rocks Bridge. *Shutterstock.com*

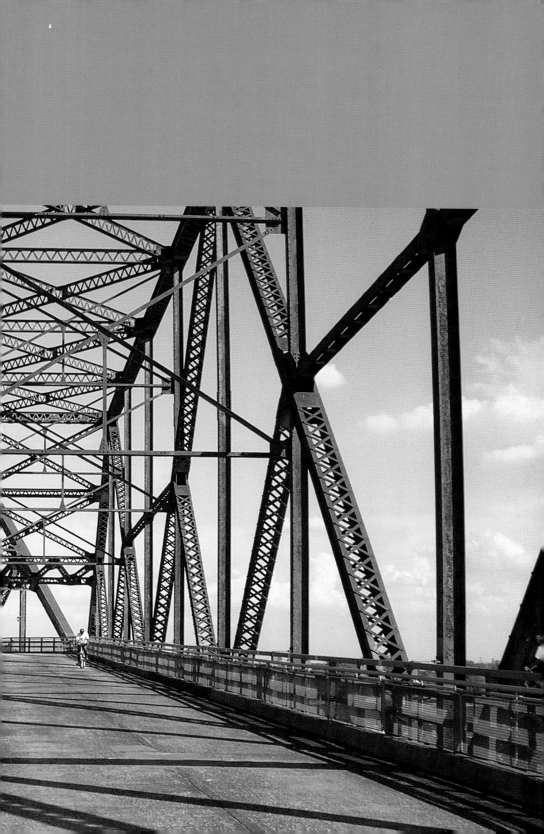

GATEWAY TO THE WEST

Jerry McClanahan, author of the *EZ 66 Guide for Travelers* and perhaps the ultimate authority on the course of this highway, has this to say about St. Louis: "Saint Louis, gateway to the west, nests in a tangled web of roads and freeways. Over the decades, US 66 used a bewildering variety of streets thru the region: main, city, truck, bypass, and optional routes made worse by later road building and one-way streets."

With this in mind, I suggest you focus on attractions in the proximity of Route 66 within the city and its surrounding communities, enjoy yourself, and then head for the hills—the Ozarks to the west of the city. You'll start by crossing the Mississippi River.

Gateway Arch and downtown St. Louis. *Chad Palmer/Shutterstock.com*

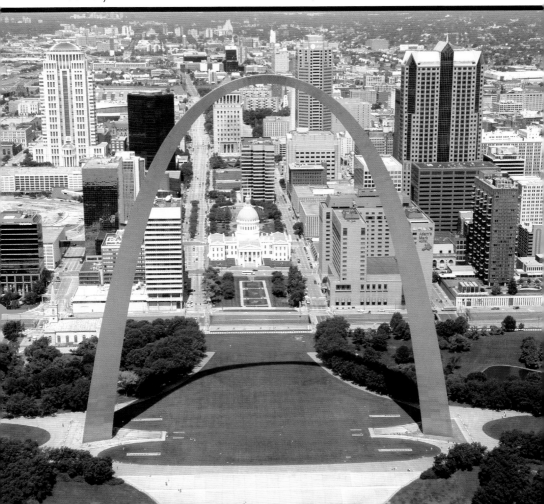

ST. LOUIS

For the daring urban adventurer, St. Louis is a wonderland of historic sites, architectural wonders, and charming restaurants. The odyssey begins with the various Mississippi River crossings into the city.

In my humble opinion, the most delightful of these is the Chain of Rocks Bridge, built in 1929, now a key component in the extensive Trailnet bicycle-hiking trail system. A wide array of Route 66 related remnants, including historic motel signs and whimsical benches enhance the stroll across the Mississippi River, with its view of the city skyline to the south.

A walk across the river is sure to ignite your appetite, which you can satisfy quite nicely at Bevo Mill, at the intersection of Gravois and Chippewa Street. This enterprise has an interesting history that dates to the Prohibition era. Built by Anheuser-Busch to resemble a Dutch windmill, the company used the eatery as an outlet for non-alcohol products, and it now serves as a renowned German restaurant.

It won't surprise you to learn that a city the size of St. Louis boasts a wide variety of museums. However, a museum that I think is one of the best in the nation is nestled underground beneath the world-famous Gateway Arch.

The Museum of Westward Expansion is extraordinary. Dioramas, exhibits, and state-of-the-art electronic displays immerse you in the experience of traveling west during the era of Manifest Destiny. From the expedition of Lewis and Clark to Native American life, encapsulated here is the entire history of American westward expansion.

Option one is to bypass the city by following the I-270 loop from Mitchell, Illinois, and resuming the Route 66 odyssey at Des Peres (the pre-1932 alignment that follows Manchester Road) or near Crestwood, where Route 66 and I-44 run together toward the town of Pacific on the course of the post-1932 alignment. If you choose this course, you should take a brief detour at exit 4 on the Illinois side of the river and enjoy an excursion across the Chain of Rocks Bridge.

DON'T MISS

For your further enjoyment, here are some interesting facts about the **Chain of Rocks Bridge**:

- The Chain of Rocks Bridge opened in 1929. It was used as a primary river crossing for Route 66 from 1936 to 1955, and for the Bypass 66 alignment from 1955 to 1965.

- At 5,353 feet, it is the longest pedestrian-bicycle bridge in the United States.

- The bridge has a unique 22-degree bend at the middle of the river crossing.

- Scenes for the 1981 movie *Escape from New York* were filmed at the bridge.

- Access from exit 34 on the Missouri side of the river is also an option, but escalating vehicle vandalism there has resulted in the advice that visitors park on the Illinois side of the river. Regardless of your access point, before leaving your vehicle, place all valuables securely in your trunk.

Chain of Rocks Bridge

If you choose the first option, Riverview Drive, which connects with Broadway, also served as an alignment of Route 66. However, the south end of this segment runs through some very tired, ghost town–like neighborhoods.

A second option is to take exit 3 from I-270 and follow Illinois State Highway 3 south to Venice, and then cross the river on the McKinley Bridge, which carried Route 66 traffic in 1926. My preference is to follow I-55 and I-70, since this is the direct route to the city's most famous attraction: Gateway Arch on the riverfront in Jefferson National Expansion Memorial, a site maintained by the National Park Service.

In my humble opinion, this is the highlight of a trip to St. Louis. The park setting, the views from the 630-foot arch, and the Museum of Westward Expansion are world-class attractions that should not be overlooked.

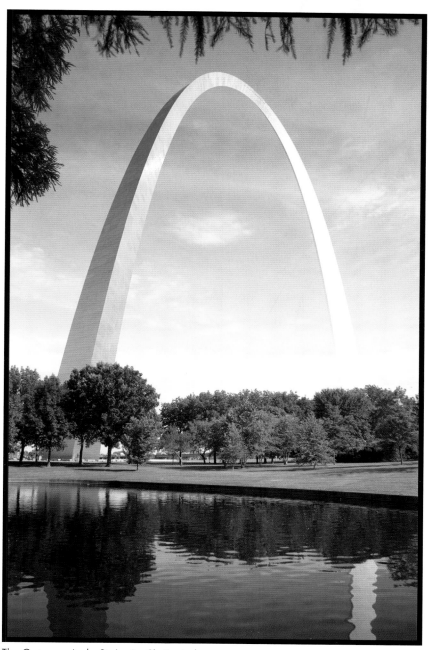

The Gateway Arch, St. Louis. *Shutterstock.com*

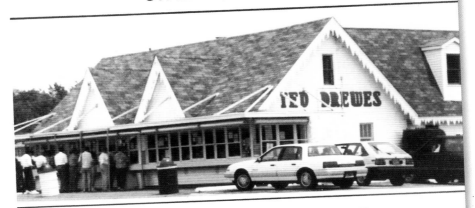

TED DREWES FROZEN CUSTARD
ST. LOUIS, MISSOURI

Famous for its "Concretes"

Postcard for Ted Drewes Frozen Custard, St. Louis. *Courtesy of Joe Sonderman*

After leaving the monument, follow I-55 south to the interchange with I-44 and then take Gravois Avenue, which is the post-1932 alignment of Route 66. On this course, Route 66 followed Chippewa Street and Watson Road, and the corridor is sprinkled with numerous roadside landmarks. Keller Drugs (520 Chippewa Street) is a throwback that dates to 1934. Garavelli's Restaurant (6600 Chippewa) is the latest incarnation of Joseph Mittino's Shangri-La, which opened in this building in 1940.

At 6726 Chippewa Street stands what looks like an unassuming little establishment, but Ted Drewes Frozen Custard is a revered landmark for locals and Route 66 buffs. Ted's thick frozen custard "concretes" have been a welcome treat during the sweltering summer months since 1941.

Founded by French settlers in 1764, St. Louis is an old city with a diverse history, and its attractions are an eclectic mix. Counted among the oldest sites are the Basilica of St. Louis (1834), the original courthouse (1864), and the Eads Bridge, the world's first steel truss bridge (1874).

Kirkwood, immediately west of St. Louis, is the home of Spencer's Grill, a wonderful stop at which to take a breather before setting out into the wilds of Missouri. This little roadside treasure opened in October 1947 and has changed very little since its 1948 remodel.

DON'T MISS

While you're in the **St. Louis** area, be sure to check out these attractions:

- Eads Bridge on the Mississippi River, built in 1874 as the world's first steel truss bridge;

- St. Louis Union Station (1820 Market Street), an architectural masterpiece and National Historic Landmark, now serving the city as a retail, restaurant, and entertain-ment complex;

- The Basilica of St. Louis (4431 Lindell Boulevard), built in 1834;

- The historic Anheuser-Busch Brewery (1200 Lynch Street), with free tours, the world famous Clydesdale horses, and sampling room;

- Crown Candy Kitchen (1401 St. Louis Avenue), which has produced a wide array of chocolate products since 1913 and is the site of the city's oldest continuously operated soda fountain;

- The Missouri Botanical Garden (4434 Shaw Boulevard), one of the oldest botanical gardens in the United States;

- The St. Louis Zoo (1 Government Drive), with the Emerson Zooline Railroad;

- Magic House in Kirkwood (516 South Kirkwood Road), an interactive children's museum complete with three-story beanstalk for climbing, puppet shows, and a re-creation of the White House Oval Office.

DON'T MISS

The **Museum of Transportation**, at 3015 Barrett Station Road (accessed via exit 8/Dougherty Ferry Road on I-270), is a fascinating destination. An extensive gift shop, an operational railroad through landscaped grounds, a staggering array of transportation displays ranging from automobiles (including one of the few remaining St. Louis cars), and other exhibits ensure a full day of enjoyable exploration.

One of the highlights for Route 66 enthusiasts is a re-created bungalow from the Coral Court Motel, a motel that epitomized the Streamline Moderne architectural style. Detailed photographs provided by award-winning photographer Shellee Graham, plus materials salvaged during demolition, resulted in a perfect re-creation.

Route 66 signage, Kirkwood. *Shutterstock.com*

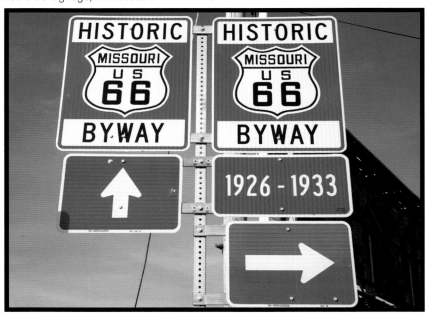

West of St. Louis are two distinct Route 66 options. At exit 9 on the I-270 loop, Manchester Road (State Highway 100) west is the course of Route 66 from 1926 to 1932, which was merely a newer incarnation of an older road. Before converging with the later alignment near Gray Summit, this early segment offers a few highlights, some beautiful landscapes, and at least in the first few miles, a great deal of traffic congestion—reminiscent of Route 66 before the advent of interstate highways. Even after the wave of

PIERCE PENNANT OIL COMPANY

The Pierce Pennant Oil Company originated in 1855 with the Waters Pierce Oil Company, one of the nation's first oil companies. When the Supreme Court mandated dissolution of the Standard Oil Trust, the 1924 reorganization resulted in the creation of Pierce Petroleum Company.

In 1926, William Clay Pierce envisioned a lucrative opportunity for the company in establishing a series of full-service travel plazas at 125-mile intervals along select highways in the newly created U.S. highway system. To initiate the endeavor, he selected US 50 between St. Louis and Jefferson City in Missouri, and US 66 from St. Louis to Springfield.

In July 1928, the first Pierce Pennant Petroleum Terminal, with a Pierce Pennant Motor Hotel as the centerpiece, opened in Springfield, Missouri. The ultramodern facility offered a wide array of amenities, including a garage and service station, a bus terminal, a soda fountain and restaurant, restrooms, and even a car wash.

By 1930, complexes were operating in Pond, near St. Louis; in Rolla; in Columbia; and in Miami and Tulsa, Oklahoma. This would be the zenith for the revolutionary idea, though, because before the end of the year this subsidiary would be sold to Henry Sinclair of the Sinclair Refining Company.

The last vestige of this idea to transform the American roadside is the Big Chief Roadhouse at 17352 Manchester Road in Pond, Missouri. The complex opened in 1929.

TIMES BEACH

For the developers, the owners of the *St. Louis Star-Times*, Times Beach presented a unique opportunity for promotion. After acquiring a 480-acre farming area on the banks of the Meramec River, they commenced an unusual marketing campaign.

For the price of $67.50, a customer could purchase a 20 × 100-foot lot and receive a six-month subscription to the newspaper. The catch was the fact that a customer needed to purchase a second lot if he or she wanted to build a house or cabin.

Those who bought lots here in 1925 dreamed of having a pleasant summerhouse, easily accessed via Route 66, on the Meramec River less than twenty miles from the gritty heart of St. Louis. By 1930, the little resort town was morphing into a real community with full-time residents as well as a business district.

In 1935, the luxurious Bridgehead Inn opened, but it soon developed a reputation for illicit, and possibly illegal, activities that tarnished the image of Times Beach as a pleasant, quiet, rural community. After acquisition by Edward Steinberg in 1947, subsequent upgrades, and renaming of the inn to Steiny's, the business again ensured Times Beach was a pleasant weekend escape for St. Louis residents.

Fast-forward to the early 1970s, and Times Beach was a sleepy little village of dusty streets. Old summerhouses were now full-time residences for retirees, families looking for a quiet place to raise children, and folks who simply preferred to live life at a slower pace.

Then in 1982, the dream became a nightmare when the Environmental Protection Agency announced that deadly dioxins had contaminated the entire community because of an early program to keep the dusty streets oiled. By 1985, Times Beach was a government-mandated ghost town.

Between 1996 and 1997, all structures save one were razed, more than 260,000 tons of contaminated topsoil was removed and incinerated on-site, and three-quarters of a century of memories, landmarks, and community roots were erased. The state of Missouri had decided to use the site for a pilot restoration program, and in October 1999, Route 66 State Park reopened the former Bridgehead Inn to serve as a visitor center housing a museum.

postwar modernization and suburbanization, numerous hints of this early history remain.

In the town of Pond is the Pond Inn, an old tavern from 1875, and the Pond Hotel, built in 1840 and now a private residence. The Big Chief Dakota Steak House is housed in an old Pierce-Pennant roadhouse and motel built in 1929. The Pierce-Pennant complexes were envisioned to bring to the highways the Harvey House concept that first had been applied to the railroads in the previous century. Several such roadhouses opened along Route 66 in Missouri, but plans to build a chain with establishments every 125 miles faded after just a few years.

Gray Summit is home to the oasis that is the Shaw Nature Reserve, a 2,500-acre preserve of natural Ozark landscapes established in 1925. The Gardenway Motel, a roadside classic that dates to the 1940s, is also located here.

Your second travel option after leaving St. Louis is to follow I-44, a highway laid over Route 66 in most places, west to exit 261. A stop of particular note on this course (located at exit 266) is Route 66 State Park, built on the site of Times Beach. A state and federal effort transformed this site, which had been contaminated by dioxins, into a wildlife sanctuary on the banks of the Meramec River. All that remains from that forgotten community is the Bridgehead Inn, built in 1935. This building, used as the EPA headquarters during the cleanup phase, now houses a Route 66 museum and extensive gift shop.

The scenic Meramec River Bridge once operated as the river crossing for Route 66 at Times Beach, but now it is barricaded at both ends. The decking was removed in 2012 to prohibit traffic of any kind after an engineering study deemed it unsafe. Route 66 boosters and preservationists are hoping that with repair and upgrades, it will be incorporated into the area's extensive bicycle trail network. Until then, the visitor center is located on one side of the river while access to the park requires a detour of several miles on the interstate.

Overshadowed by modern trappings, Eureka and Allenton west of Route 66 State Park offer a few vestiges of the old Route 66 roadside. But here, the brightly lit rollercoasters and rides at Six Flags amusement park have obscured the neon.

INTO THE OZARKS

At exit 261 on I-44, the Route 66 adventure continues. The old road skirts a blend of modern, generic restaurants, service stations, and retail stores as well as roadside classics. In the latter category is the former Red Cedar Inn (with a future currently in limbo), nestled against raw limestone bluffs pockmarked from silica mining. As the highway enters Pacific, the veil between past and present grows thin.

During the Civil War, these bluffs, with a commanding view of the valley below and shadowing a key railroad line, were an area of contention between the Confederate and Union forces. On October 2, 1864, Confederate troops carried the day and decimated the railroad infrastructure here.

A memorial that includes an information kiosk and a Civil War–era gun battery is located at Jensen Point overlooking the city and the Route 66 corridor. Named in honor of Lars Jensen, the first president of the Henry Shaw Gardenway Association, Jensen Point is an ideal place for a picnic. The Civilian Conservation Corps built the park and memorial during the late 1930s.

Route 66 through Pacific

From Pacific, old Route 66 twists and turns with the contours of the weathered hills shrouded in forest as it climbs into the beautiful Ozark Mountains and flirts with its modern counterpart, I-44. This is a land of clear mountain streams, caves, and legends.

Route 66 in the Ozarks is signed with a variety of state highway alphabetic designations, but it is relatively easy to follow. Missouri, like Illinois, is quickly capitalizing on interest in this amazing highway, and the first step is adequate signage. Most communities along Route 66 in Missouri take pride in their association with the old road and have developed unique ways to promote it, all with a goal of making these towns destinations for Route 66 travelers.

At Stanton, these efforts come together in a classic roadside attraction updated with modern perks, including a zipline through the trees that shade the Meramec River. And because the development of Meramec Caverns as a tourist attraction paralleled the development of Route 66 as a highway, this is a very special stop.

As a bonus, Meramec Caverns has a lengthy and colorful history. It includes exploration by Frenchman Jacques Renault in 1720 and a raid on a Union powder mill in the cave during the Civil War by Quantrill's raiders, a pro-Confederate force that employed guerrilla-style tactics. There is even a carefully fostered legend that links the caverns with outlaw Jesse James.

The caverns' first incarnation as an attraction began in the 1890s, when an unknown entrepreneur installed a wooden dance floor and a bar to create a subterranean ballroom in the section hollowed out during the era of saltpeter mining. In 1933 Lester Dill, a promoter cut from the cloth of P. T. Barnum, leased Salt Peter Cave (now Meramec Caverns) and immediately commenced its transformation into a gold mine.

The former ballroom became a parking lot, and signs proclaimed this to be the world's first drive-in cave with "air cooled" parking.

Circa 1940s brochure for Meramec Caverns, Stanton. *Courtesy of Steve Rider*

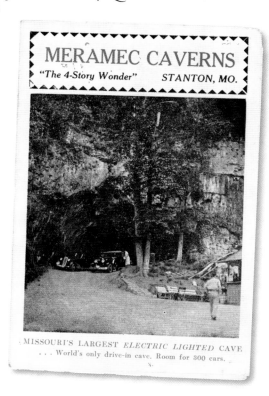

MERAMEC CAVERNS
"The 4-Story Wonder" STANTON, MO.

MISSOURI'S LARGEST *ELECTRIC LIGHTED* CAVE
... World's only drive-in cave. Room for 300 cars.

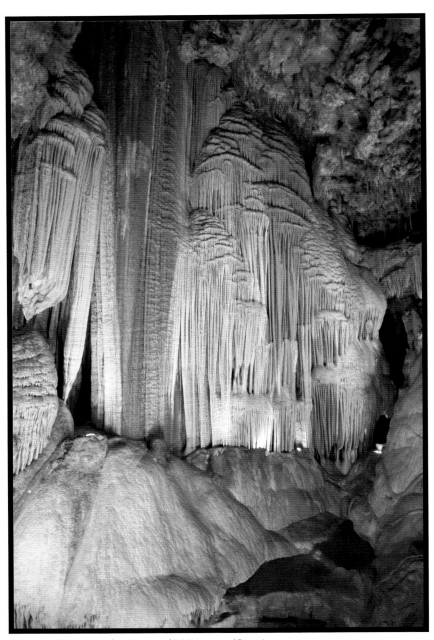

Meramec Caverns. *Alan Copson/AWL Images/Getty Images*

While visitors toured the underground wonderland, kids in Dill's employ wired promotional bumper signs to cars, purportedly the first use of what would become bumper stickers. Further promotion came with huge signs painted on roadside barns, similar to those that promoted Rock City in Tennessee.

As the years passed, and the traffic detouring from Route 66 to see the underground wonder increased, the hype and creative promotion kept pace. In 1941, with the discovery of rusty relics and the reconstruction of a moonshiner's cabin in the cave, the caverns became the hideout of Jesse James. As the fear of nuclear war increased during the late 1940s and early 1950s, the cave became the "World's First Atomic Refuge."

Today, the caverns—as well as other attractions in the area, such as the Jesse James Wax Museum, the Antique Toy Museum, and nearby Reptile Ranch—have made Stanton a mecca for Route 66 enthusiasts. It is a time capsule from the era of road trips in station wagons.

QUIRKS OF THE ROAD

As you follow Route 66 west from Stanton, you flit between the past and the present. On this part of your journey, you'll note the stark contrast between the sterile interstate highway slicing through the land and the gentle ribbon of asphalt that flows around and over the hills and through the hearts of towns.

The old highway skirts farmlands, woodlots, and forests, and then funnels traffic through communities such as Bourbon, with its landmark water tower and Circle Inn Malt Shop. Billboards and signs hint that adventure and oddball attractions await in the Ozarks. Occasionally the little detours are well worth the trip.

The resurgent interest in Route 66 has sparked a unified sense of purpose to help transform sleepy, forgotten villages into destinations for Route 66 travelers by offering an old-time experience. Cuba, with a population of fewer than 4,000 and origins predating the Civil War, is just such a magical place.

Beautiful murals that illustrate the town's rich history adorn vintage service stations, modern car washes, and varied businesses along the Route 66 corridor and throughout this community. A shoe store owned by the same family for more than fifty years, delightful restaurants where locals and travelers mingle, and refurbished roadside treasures ensure a visit to Cuba will be most memorable.

To enhance your visit, plan on stopping during Cuba Fest, held on the third weekend in October. Excellent regional foods and homegrown music frame this delightful festival, which hark back to the America of Norman Rockwell paintings.

Route 66 Mural, Cuba, Missouri. *Carol M. Highsmith's America, Library of Congress, Prints and Photographs Division*

Among the special places in Cuba is the now iconic Wagon Wheel Motel, dating to 1934. Charming, fully renovated stone cabins in a park setting, a former service station, a café transformed into a fascinating boutique and gift shop, and the distinct gastronomic charms of Missouri Hick Bar-B-Q as a neighbor make this a destination, not just a place to sleep off a long day on the road.

Wagon Wheel Motel neon sign, Cuba

I won't spoil the surprise, but an attraction of particular note can be found at Missouri Hick Bar-B-Q. Even if you stop only for a cup of coffee or a cold drink, be sure to check out the bathrooms.

The Fanning 66 Outpost, built in the 1980s a few miles west of Cuba on the site of the Fanning Outpost General Store, is an attraction in the otherwise-minor town of Fanning. Home to the World's Tallest Rocking Chair (forty-four feet tall), the outpost also sells a variety of souvenirs and the finest offerings of area wineries and farms, including jams and jellies. Perhaps the most unexpected find here is an indoor archery range!

Produce stands are a common sight along Route 66 in this part of the Ozarks. The best of them all is the little roadside store of 4M Farm and Vineyard a few miles west of Fanning. What better way to top off the picnic basket than with a couple of slices of fresh grape pie, homemade bread, locally produced cheese, and a chilled bottle of fresh apple cider?

If you drive a car with manual transmission, there won't be time to hit fifth gear before you arrive at Rosati, a memorable stop even if it is a small, nondescript community. My hope is that you'll still remember it after a visit to the historic Rosati Winery.

This community at the summit of Kings Hill, a landmark on the old Springfield Road, was established in 1890 under the name Knobview. The current town name came from an amended post office application filed in 1930. The namesake is Bishop Joseph Rosati, the first American bishop of Italian descent.

WINERY DETOUR

A few miles east of Cuba along Route 66, dominating a hill overlooking a vast and scenic wooded valley, is the Belmont Winery. Savoring a bottle of the winery's signature Pink Dogwood wine—and the excellent hummus on homemade whole grain crackers— in the open-air pavilion, while the sun sinks in the west, is an excellent way to unwind after a day on the road.

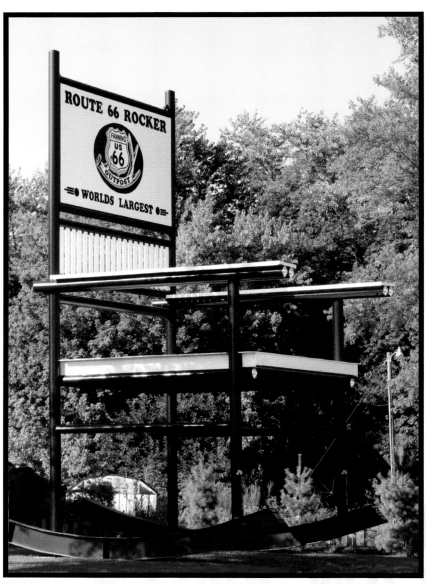

World's largest rocking chair, Fanning. *Carol M. Highsmith's America, Library of Congress, Prints and Photographs Division*

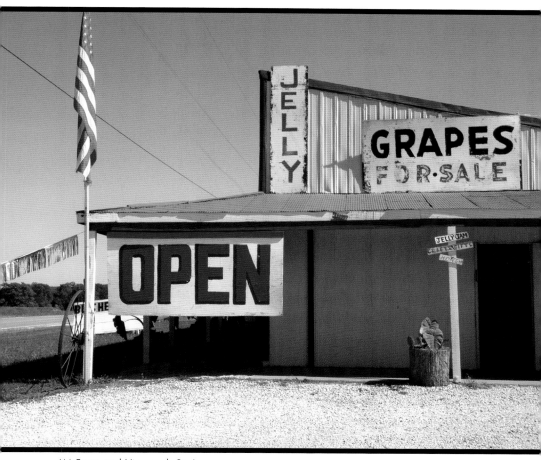

4M Farm and Vineyard, St. James

Quirky roadside attractions are as much a part of the Route 66 experience as are neon-lit nights. Diminutive St. James, the next stop on your westward journey, has an attraction that is truly unique—a vacuum cleaner museum combined with a factory outlet store.

A few miles west of St. James, at the junction with State Highway V, is another notable attraction. Frank Ebling established the Mule Trading Post near Pacific in 1946. With completion of the I-44 bypass in 1957, Ebling relocated the trading post, with its trademark neon sign, to the current site near St. James. The trading post today is an interesting blend of old roadside attraction and modern convenience store.

MARAMEC SPRING PARK DETOUR

If you filled your picnic basket at the 4M Farm and Vineyard store, or if you just love historic places in stunning landscapes, then you will want to take this detour. From Saint James, drive south on State Highway 8 for about seven beautiful miles to Maramec Spring Park, a delightful park in one of the most scenic places in the state of Missouri.

With facilities for camping, picnicking, fishing, and hiking, as well as a museum, playground, store, and café, the park is an ideal setting for a simple picnic or weekend visit.

The showpiece of the park is the spring itself, the fifth largest in the state, with an average of ninety-six million gallons of water each day flowing from a submerged cavern. The spring, ringed by beautiful hills and a paved walking trail, provides the water for the trout hatchery located here.

Massive remnants from the Maramec Iron Works established in 1826 dominate the picnic area and provide wonderful photo opportunities. A historic drive winds through the park to the pretty cemetery and the old iron mine.

Maramec Spring Park. *Judy Hinckley*

FIGHTING THE MODERN WAVE

The twists and turns necessitated by the Ozark Mountains end abruptly with Rolla, a bustling, modern, progressive community where the battle to preserve the glory days of Route 66 is fought with passion. One survivor is the Totem Pole Trading Post, which opened at its current location in 1977 with the totem pole that graced the roof of the original incarnation in 1933.

On occasion, a severed alignment of Route 66 will necessitate a brief foray into the modern era and use of I-44. However, these truncated and isolated segments of the old road often hide some of the most delightful landmarks, treasures, and surprises, which make the detour well worth the trip.

West of Rolla, accessed via exit 176 on I-44, are several delightful examples, including the forlorn but picturesque ruins of John's Modern Cabins. The collapsing, overgrown old cabins began life more than sixty years ago as Bessie's Place, a roadhouse and cabins complex.

Murder, scandal, indifferent new owners, and changing times led to abandonment. Today the fast-fading cabins—as well as neighboring Vernelle's Motel, which clings to life by the thinnest of threads—provide a favored photo stop.

A few scenic miles to the west, this segment of old Route 66 ends at the Big Piney River and the once-vibrant community of Arlington, known worldwide for its association with Stonydell Resort. The resort was built in 1932, and at

(Continued on page 76.)

SCHOOL OF MINES DETOUR

Take a little side trip to the Rolla School of Mines and see a half-scale version of Stonehenge. This model was carved from granite slabs with high-pressure water jets and cutting torches and was aligned with the summer solstice by computer. Also on campus are a replica of the solar calendar used by the ancient Anasazi of the prehistoric Southwest and a Polaris window for sighting the North Star.

JOHN'S MODERN CABINS

Today these overgrown and collapsing cabins in the woods along a marooned segment of Route 66 are a favored photo stop for enthusiasts of the old highway. When framed by fall colors, the buildings stand as a colorful monument to the pre–interstate highway era.

Bill and Beatrice "Bessie" Bayless built the complex, which consists of six cabins and a roadhouse, in 1931. Soon, Bessie's Place, located eight miles west of Rolla, was proving to be a profitable enterprise in spite of the Great Depression.

In October 1935, the good times ended with the sound of gunfire as Eugene Duncan gunned down his estranged wife at the roadhouse. For fifteen years, the property languished along Route 66. Then, in 1950, John Dausch purchased the property and gave it a new lease on life as John's Modern Cabins.

Changing times and the rise of franchise motels doomed the place. By the 1960s, business was almost nonexistent. After John's death in 1971, abandonment of the property allowed the forest to begin reclaiming the cabins and the roadhouse. The remnants stand as mute monuments to the glory days of the Double Six.

STONYDELL RESORT

George Prewett built the Stonydell Resort on the site of a campground along the infamous Cherokee Trail of Tears. Constructed with locally quarried stone, the complex was a favored vacation spot as well as famous roadside stop for Route 66 travelers.

In time, the complex developed a reputation as a modern resort. Relaxation surrounded by the raw beauty of the Ozark Mountains lured the rich and famous. On the lengthy list of celebrities who visited the resort was Mae West.

Fred Widner acquired the property in 1954. He managed it successfully until 1967, the year construction of I-44 necessitated demolition.

Stonydell Resort, Arlington. *Courtesy of Joe Sonderman*

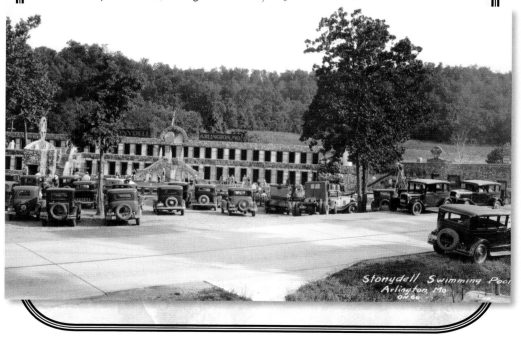

(Continued from page 73.)

its peak in the immediate postwar years, it included a 100-foot swimming pool, a large hotel, ten cabins, a large goldfish pond, and a restaurant. The resort lasted until a large segment of the complex was demolished to make way for the construction of I-44 in 1967, leaving the old restaurant, the goldfish pond, and a few cabins marooned on the north side of the highway with limited access from the Jerome exit (169). Arlington suffered a similar fate. With the exception of a massive old store, a hotel, and a few houses, little remains of the once-thriving community with roots extending more than 150 years into Missouri history.

West of Arlington there is a rare opportunity to experience the entire evolution of Route 66 from beginning to end. It requires a drive along a scenic loop filled with surprises, manmade and natural.

At Clementine, after crossing I-44, continue west on County Highway Z through Hooker Cut. Built during World War II to accommodate the in-

Hooker Cut. *Judy Hinckley*

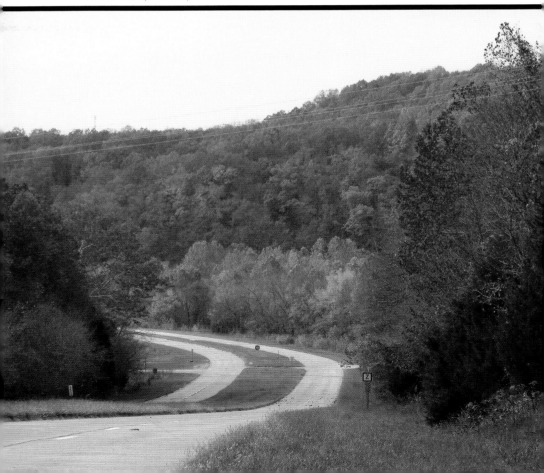

Devil's Elbow Bridge. *Judy Hinckley*

crease in traffic from the expansion of Fort Leonard Wood, this ninety-foot cut was the deepest of its kind in the United States at the time. Finished in 1943, this was the first four-lane segment of Route 66 in Missouri. In 1981, it became the last segment of Route 66 supplanted by I-44.

West of the cut, you can follow the original alignment of the highway bypassed with completion of Hooker Cut. Through a series of shady twists and turns, the old road drops past stunning views to the picturesque steel truss Devil's Elbow Bridge (built 1923) over the Big Piney River. The road then climbs up the other side with another series of twists and turns.

In 1941, the state planning commission in Missouri designated the Devil's Elbow area along Route 66 as one of the "Seven Beauty Spots" in the state. A scenic overlook near the west end of the drive provides ample justification for this designation. With the exception of businesses that have closed since the highway's bypass, little has changed. This is still a beautiful drive framed by thick stands of forest mirrored in the river below.

A rare survivor is the Elbow Inn Bar and BBQ Pit, located at the east end of the bridge, with its unique ceiling decor. Originally, in 1936, this was the Munger-Moss Sandwich Shop. Another vestige of a time gone by is the old Miller's Market, now Sheldon's market, on the south side of the river. The store dates to 1954 and still serves as the post office for Devil's Elbow, Missouri.

Hooker Cut was not the only change necessitated by World War II along this segment of Route 66. The expansion of Fort Leonard Wood during the war transformed the town of St. Robert, and that transformation continues to this day. Scattered here and there are links to past eras, including the Ranch Motel built in the 1940s and the George M. Reed Roadside Park established in 1955 on the then-new four-lane alignment of Route 66. The park remains an excellent place to stop for a picnic.

Waynesville, named for General "Mad" Anthony Wayne, is another community transformed by its proximity to Fort Leonard Wood. Today it is a thriving, modern community sprinkled with historic sites. In 1941, a WPA guide described the town as having a "leisurely atmosphere, unmarred by the smoke of industry and the impatient panting of trains, and but little jarred by farmers' Saturday night visits." Five years later, Jack Rittenhouse noted in *A Guide Book to Highway 66* that the community was "the chief recreational center for the soldiers from Fort Leonard Wood. It experienced a sudden boom."

The Pulaski County courthouse here flew the Confederate flag in 1861 and 1862. In 1903, the community replaced the courthouse with a more modern building that now serves as a museum. It was here in 1990 that Governor John Ashcroft signed the bill designating Route 66 as a historic highway in Missouri.

PRESERVING A LIVING HISTORY

On the pleasant drive from Waynesville to Lebanon, sleepy little towns dotted with picturesque ruins, vintage bridges over streams and rivers, and deep forests blend into a rich tapestry of photo opportunities.

Lebanon, our next Route 66 stop, is a treasure trove of nostalgic attractions. Topping the list of sites here is the Munger Moss Motel. This lovingly maintained motel with roots dating to 1946 features themed rooms accentuated with the work of acclaimed Route 66 artists such as Jerry McClanahan and Shellee Graham. Only a few modern amenities intrude on the illusion that here the clock stopped shortly before John F. Kennedy became president. The recently refurbished, majestic neon sign enhances that sense of traveling back in time.

Across the street, the Forest Manor Motel & RV Park, of similar vintage, and the Starlite Lanes bowling alley further blur the lines between past and present. Wrink's Market, established in 1950 and now closed, most recently housed D. C. Decker's Emporium, a delightfully eclectic restaurant, Western history museum, and Western art gallery.

A highly recommended stop is the Route 66 and Laclede County Museum in the county library building. With incredible attention to detail, exhibits feature

CAVE DINING DETOUR

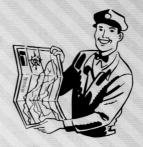

For a unique dining experience (food as well as ambiance) and an unforgettable adventure, turn north on State Highway 7 at the junction just west of Waynesville, exit 150 on I-44. Drive six miles toward Richland and turn right on Rochester Road. Follow the signs to the Cave Restaurant and Resort, a subterranean eatery complete with waterfall where menu choices run the gamut from simple, traditional fare to alligator tail in apricot sauce.

From the gravel parking lot, the shuttle bus transports you to the restaurant over a scenic road that climbs to a shelf carved from a sheer rock wall over the river. During the short drive past log cabins and other sites, the bus driver provides commentary about the area's history.

Near the restaurant, a string of shops housed in rustic cabins overhanging the river present the illusion of a remote Ozark village circa 1900. They offer a wide array of locally crafted goods, from chocolate to woodcarvings.

Since the restaurant is part of a resort complex with more than a century of history, this could easily become a weekend-long detour. There are cabins, campsites, canoe rentals, float trips on the scenic Gasconade River, and special all-inclusive packages.

For more information, consult the Cave Restaurant and Resort at 573-765-4554 or www.thecaverestaurantandresort.com.

many windows into the past, including a fully furnished motel room circa 1955 and a soda fountain from the same period. The stunningly detailed dioramas of Route 66 businesses, such as the once legendary Nelson Dream Village crafted by artisan Wilhelm Bor of Holland, are highlights of a visit to the museum. Through Bor's work, long-vanished Route 66 establishments live on.

From Lebanon to Springfield, old Route 66 resumes its leisurely course with an occasional interruption by I-44. Amid the beauty of the Ozark Mountains, faded little towns and delightful modern communities blend Route 66 with Missouri's colorful history.

(Continued on page 82.)

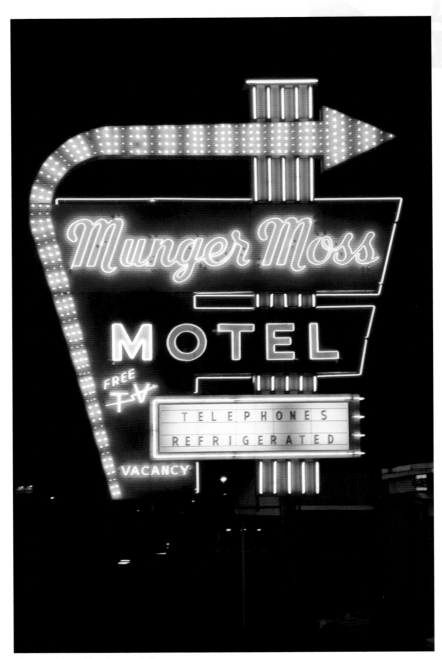

Munger Moss Motel sign, Lebanon

ARTHUR NELSON

Nelson's Service Station. *Courtesy of Steve Rider*

Arthur Nelson's many invaluable contributions to the development of Route 66 in Missouri, as well as the transformation of Lebanon, give testimony to a life well lived. Nelson's relative obscurity in the annals of history is difficult to understand.

A visionary thinker and astute businessman, Nelson began using trucks to transport apples from his family's award-winning orchards in 1913. As a result, he soon became an ardent supporter of the movement that was pressuring state and federal governments for improved roads.

He combined his funds, his business acumen, and his association with leading state politicians to develop the state's first highway designed specifically for automobiles. In about the same period, he began working with W. H. Harvey to launch the Ozark Trails Association, a highway through Lebanon that would connect St. Louis with Romeroville, New Mexico, and that was later utilized by Route 66 in 1926.

When the new federal highway system was created in 1926, Nelson donated forty acres of his orchard for the new highway designated US 66. With an eye on potential profit, he also built a modern service station on this corridor with landscaped grounds that reflected his horticultural expertise. As traffic on the new highway increased, Nelson expanded the business. By 1930, the complex consisted of a service station, cabins, a hamburger stand, and the two-story Nelson Tavern, later the Nelson Hotel.

Promoted as "A Place for Those Who Care," the Nelson Tavern was nothing short of astounding. A full-time gardener maintained the landscaped grounds, and the interior featured colorful parrots and macaws in cages and a botanical garden of exotic plants.

Next, he constructed the Nelson Dream Village on the opposite side of the highway. The stylish auto court was built of native stone in a parklike setting. It had as its centerpiece a fountain where each evening choreographed lights, music, and water transformed the courtyard into an attraction.

Nelson's contributions ended abruptly with his death in 1936. Route 66 and the roadside evolved, and in time, progress claimed his properties. However, they live on in the astounding work of William Bor, a Dutch artist and Route 66 enthusiast who creates detailed dioramas such as the one displayed at the Route 66 Museum in the Laclede County Library complex in Lebanon.

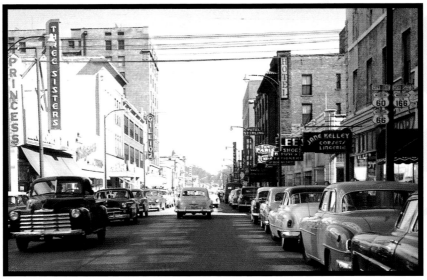

Route 66 through Springfield, Missouri, circa 1953. *Courtesy of Joe Sonderman*

(Continued from page 79.)

In Caffeyville, an old barn is still festooned with a promotion for Meramec Caverns. Near Sampson, the little clapboard cabins of the former Abbylee Motel (1940) still stand. At the junction with Highway M, the Niangua Junction Store has provided staples for travelers since 1935.

Because Marshfield is the hometown of astronomer Edwin Hubble, it is not surprising to find a quarter-scale model of the Hubble Space Telescope on the lawn of the courthouse or to learn that here Route 66 is signed as Hubble Drive. The Webster County Historical Museum has more detail about the town's favorite son as well as the area's rich history.

Strafford is a small town that became world-famous because of Route 66. When the highway's realignment bypassed the main street and directed traffic past the backs of the stores, owners transformed their properties into buildings with two front facades. *Ripley's Believe It or Not* proclaimed Strafford the only town in America with two main streets and no back alley.

In Springfield, as with most large communities along US 66, the highway followed various routes through town. Initially the road entered from the east on what is now Highway YY and Division Street. Other corridors utilized include Glenstone, Kearney Street, College Street, and Chestnut Street.

Many people argue that Springfield is the birthplace of Route 66. Purportedly, it was in the offices of John Woodruff in the Woodruff Building on the corner of St. Louis Street and Jefferson that U.S. highway system planners proposed the designation of 66 for the highway connecting Chicago and Los Angeles in 1926.

Route 66–related sites and attractions abound. The Rest Haven Court at 2000 East Kearney—with its delightful neon sign from 1953 that mirrors the one found at the Munger Moss Motel—opened in 1947 and continues to garner favorable reviews.

At 203 South Glenstone Avenue, the Best Western Route 66 Rail Haven is another treasure. Initially, in 1938, the complex consisted of eight small cabins framed by a split-rail fence. Changes and expansion that resulted in the current configuration continued through 1954. This motel also continues to receive favorable reviews. It retains the Best Western affiliation first acquired in the early 1950s.

On the corner of St. Louis Street and National Avenue is a Steak 'n Shake with original signage and curbside service. Pictures from the restaurant's opening in 1953 indicate there has been little alteration.

The friendly atmosphere of the lively community will inspire you to stay a spell. Route 66 represents a relatively recent chapter in the community's long history, which began with the establishment of a homestead by John Polk Campbell in 1829. There are ample older attractions, ensuring that you'll have

SPRINGFIELD

The endless flow of traffic along Route 66 through the city of Springfield—coupled with restrictions that prohibited African Americans from using many restaurants, hotels, and motels along the road—inspired Alberta Ellis with a lucrative idea. Why not establish a full-service hotel that catered to the disenfranchised Route 66 traveler?

Borrowing money from family members who also became employees, Ellis purchased the former city hospital on the 600 block of Benton Street, just north of City 66, and converted it into a hotel with a dining room, nightclub (the Rumpus Room), beauty parlor, and barbershop. By 1953, the success of Alberta's Hotel led to various expansions. One of these was a ten-acre farm near town that served as a bed and breakfast as well as a primary source of food for the dining room.

Nat King Cole, the singer whose hit "(Get Your Kicks on) Route 66" made the highway internationally famous, was a regular guest at Alberta's Hotel. Other celebrity guests included Frankie Lymon and the Harlem Globetrotters.

plenty to do and see, whether you stop for a day or for a week. Sites run the gamut from macabre and trivial to somber and fascinating. For example, a marker at Park Central Square commemorates the death of Dave Tutt by the hand of James "Wild Bill" Hickok in 1862. South of town is Wilson's Creek National Battlefield, site of a major battle in the Trans-Mississippi Theater of the American Civil War.

DON'T MISS

Route 66 attractions and other sites to see in **Springfield** include the following:

- Kentwood Arms Hotel (700 St. Louis Street), built in 1926 by John Woodruff and now serving Kentwood Hall on the campus of Southwest Missouri State University, the site of many National Highway 66 Association meetings;

- Ginny Lee's Restaurant and Pub (2204 College Street), housed in the former Rockwood Court;

- The Abou Ben Adhem Shrine Mosque (601 East St. Louis Street), built in 1923, the Shriners hall has hosted a wide array of celebrities and dignitaries, including Franklin Roosevelt, Elvis Presley, and Ronald Reagan;

- The Mizumoto Japanese Stroll Garden, with Moon Bridge, Tea House, and other structures and a lake stocked with koi fish;

- Wilson's Creek National Battlefield and Civil War Museum, located in a bucolic setting that makes it difficult to envision the carnage of the pitched battle that took place here on August 10, 1861, between 12,000 confederate soldiers and 5,400 Union soldiers;

- Fantastic Caverns, "America's Only All Riding Cave Tour," located just northwest of the city (4872 North Farm Road 125) near the junction of Highway 13 north and I-44— the first explorers of the cavern were twelve women who answered a newspaper advertisement in 1867.

"Ghost town highway" is the descriptor most often used for the course of Route 66 through Lawrence County and west from Springfield to Carthage. However, this term presents a distorted view of what is actually a charming drive full of delightful surprises and photo opportunities.

Plano would need a few residents to qualify as a wide spot in the road. Still, the overgrown stone ruins that shadow the old road here are a popular photo stop and an endless source of conjecture about what the building once housed. (It was a mortuary and casket factory.)

Halltown is a bit larger, but it is a tossup as to whether there are more occupied buildings or empty ones. A hint at the age of the town, and a link

Gay Parita service station, Paris Springs. *Judy Hinckley*

to its more vibrant past, is the Whitehall Mercantile, built in 1900. The mercantile now serves as an antique and souvenir store. This now-quiet little town figured prominently in the downfall of the Eddie Adams gang, bank robbers who plagued western Missouri and eastern Kansas in the early 1920s. The arrest of Basil Quilliam, a gang confederate, in late 1922 stemmed from the discovery that $19,000 worth of marked liberty bonds came from the bank in Halltown, robbed earlier that year.

At Paris Springs Junction, Gary Turner has constructed a wonderfully nostalgic window into another time with the re-creation of the Gay Parita Station, which reflects rural service stations of the 1930s. The station blends beautifully with the neighboring cobblestone-built garage that dates to 1926 and the old post office across the highway.

Spencer, Missouri, welcome sign. *Judy Hinckley*

Many maps and guidebooks published in the past sixty years refer to this as Paris Springs, but that community, now a pure ghost town, is actually a mile to the north. Before the twentieth century, this was a prosperous community with a bottling company, broom factory, and wagon works.

To find the next treasure, a very slight detour from the primary course of Route 66 is required. West of Gay Parita Station, rather than continuing on State Highway 96 (Route 66), turn south on County Road N and then right on the first paved road (Farm Road 2062), which will return to the later alignment (Highway 96) within a few miles. This is the original alignment of Route 66.

Shortly after you cross the narrow steel through-truss bridge (1923) over Turnback Creek, the woods open into a clearing with a scattering of buildings nestled on the shoulder of the original concrete pavement. This picturesque complex dates to 1925, but it replaced the ruins of an older community, Spencer, which included Johnson's Mill (circa 1866) and a post office (built after 1868).

Peppered with many sites and once-famous Route 66 landmarks are Heatonville, Albatross, Phelps, Rescue, and Plew. For example, built on the site of the post office that operated from 1872 to 1881 in Heatonville is the old D. L. Morris Garage (1936).

Each of these communities has a unique and fascinating history. Just consider Albatross, which began as a simple bus stop for the pioneering Albatross Bus Line. Through the early 1950s, the town grew as traffic increased on Route 66. Now a private residence, Shady Side Camp was built by L. F. Arthur in about 1927, and it still stands in a grove of oak trees. Log City Camp, built in 1926 by Carl Stansbury, survives in part with the former gas station serving as a body shop. A forlorn cabin is all that remains of Forest Park Camp, established in 1928.

Avilla is a bit big to qualify as a ghost town. Still, it is a mere shadow of the prosperous community that boldly flew the Union flag during the American Civil War or that Jack Rittenhouse, in 1946, noted as being a town with gas stations, cafés, stores, a lumberyard, and a farm implement store. Counted among the many interesting structures is the former bank (1915), which served as the post office until 2012, one block north of Route 66. A short walk through town along Route 66 will reveal vestiges of a more prosperous time.

Eight miles from Avilla, as you drive through farmlands bordered by vast woodlots, you'll encounter the architectural wonderland of Carthage. Here, at every turn there is a historic marker, monument, or site. On the square alone the shadow of the stunning Jasper County Courthouse (1895) shades markers commemorating the Osage War (1837), Battle of Carthage (1861), Missouri Home Guards (1861–1865), election of Anna Baxter (1890), destruction of the courthouse during the Civil War, and Sergeant Charles Wood (1875–1898).

AVILLA

On October 28, 1861, Governor Claiborne Jackson met with the Missouri General Assembly in Neosho and declared that Missouri would be the twelfth state to join the newly formed Confederate States of America. Business and civic leaders in Avilla defied the decree and hoisted the American flag in the park.

To defend the community as well as their farms and homes, Dr. J. M. Stemmons organized a militia. On March 8, 1862, the militia successfully repelled an attack by William T. "Bloody" Anderson and his band of Confederate raiders, but Stemmons and three of his sons died during the battle.

In the summer of 1862, the Union Army initiated a series of skirmishes in the area. A year later, it established its headquarters in Avilla. As a result, Avilla avoided the devastation that decimated other communities in the area, such as Carthage.

Surrounding the courthouse is a historic district considered one of the Midwest's most complete business districts from the period 1880 to 1940. In the surrounding residential district are numerous homes listed on the National Register of Historic Places, including the Kendrick House, one of the few structures to have survived the Confederate raid of October 1864; the stunning Baker House, built in 1893; and the Phelps home (1895).

Remnants of the community's association with Route 66 are as varied in nature as the monuments in the courthouse square. The crown jewel is the recently renovated Boots Motel (1939) that began providing lodging again in the summer of 2012.

If you happen to choose the Boots Motel for the end of the day's journey, between April and October, you can also take in a movie at the 66 Drive-In Theater west of town (17231 Old Route 66 Boulevard). Built in 1949 and recently renovated, this theater is the last of its kind along Route 66 in Missouri.

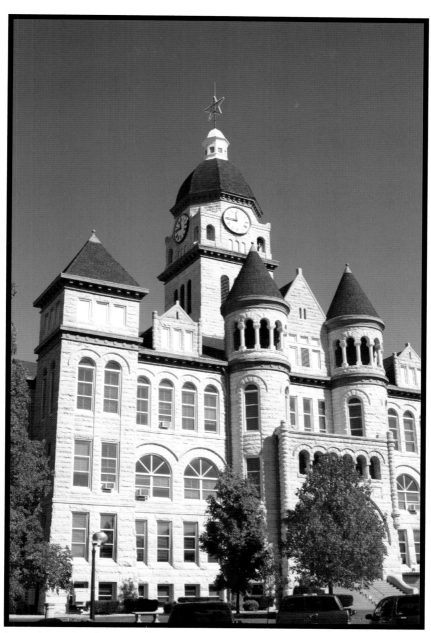

Jasper County Courthouse, Carthage

CARTHAGE

During the 1830s, members of the Osage tribe forcibly relocated to the Indian Territories moved into the area of present-day Carthage because it provided better opportunities for hunting and farming. Governor Lilburn Boggs ordered the state militia to use force in pushing the Indians back into the territories, and the ensuing conflict became the Osage War. A marker in the courthouse square commemorates the incident.

The bloody formative years of Carthage continued when on July 5, 1861, the Battle of Carthage, the first major battle of the Civil War commenced. This would be the first of thirteen major military engagements centered on Carthage during this war. The final battle occurred on September 22, 1864 The city was decimated after Confederate forces torched it.

The city's association with the Civil War did not end with the formal surrender of General Lee at Appomattox Court House. Myra Belle Shirley, born in Carthage, became one of the war's most famous Confederate spies, and under the name Belle Star, earned the moniker of Queen of the Outlaws after the war.

The Powers Museum, through rotating exhibits and an extensive collection of artifacts and photographs, documents much of this colorful history. The museum is located on Route 66 at 1617 West Oak Street.

Woodgraving, "The Battle of Carthage, Missouri. From a Sketch Made on the Spot," 1861. *Library of Congress Prints and Photographs Division*

From Carthage, it is a short drive to Carterville, Webb City, and Joplin, a series of old mining towns stitched together by Route 66. In the decades bracketing World War I, these communities marked the eastern boundaries of a tri-state lead- and zinc-mining district that was the largest in the world.

Remnants from this gritty era of opulence and prosperity abound, as do links to even earlier history (including the Civil War) and to the glory days of Route 66. The latter led to the Route 66 Alliance's selection of Joplin as the host city for the 2013 Route 66 International Festival.

Exploration of the area should begin with the Joplin Museum Complex (Everett J. Richie Tri-State Mineral Museum and Dorthea B. Hoover Historical Museum) on the grounds of Schifferdecker Park at 504 South Schifferdecker Avenue. In addition to fascinating mining exhibits, mineral displays, and relics from every era of the city's development, there is a notable collection of artifacts pertaining to the legendary outlaw duo Bonnie and Clyde.

After an attempt to arrest the bandits at a Joplin apartment that left two police officers dead, officers recovered poems written by Bonnie, jewelry, photographs, and other personal effects. Today these items constitute the largest single collection of items associated with these outlaws.

CARVER NATIONAL MONUMENT DETOUR

From Carthage, drive south on US 71 eight miles to the junction of State Highway 59, then continue south about ten miles on State Highway 59 to Diamond. From Diamond, drive two miles west on County Road V to George Washington Carver National Monument (5646 Carver Road).

The centerpiece of the site, the beautiful Carver Nature Trail, leads from the historic marker where Carver's birthplace cabin stood to the Carver family cemetery. The trail is a relatively easy walk that twists through the forest and past two idyllic springs.

Joplin, Missouri

West 7th Street in Joplin often was referred to as "the Strip" during the glory days of Route 66. Remnants of that past glory make for excellent photo opportunities.

Moffet Avenue and Sergeant Avenue, just off of 7th Street, are two of the primary corridors in the Historic Murphysburg District. Heavily shaded streets bordered by diversely designed mansions from the dawn of the twentieth century are the highlights of this area.

After miles of scenic mountain drives and urban exploration, dozens of fascinating stops, and countless photo opportunities, the last miles of Route 66 in Missouri are rather anticlimactic. From Joplin, the old highway (now State Highway 66) simply runs straight as an arrow for less than a dozen miles before entering Kansas.

JOPLIN

Almost from its inception, Joplin was an important transportation hub, first as a terminus for several frontier-era trails and then, in the modern era, as part of the Ozark Trails Highway, Route 66, and I-44. As a result, a well-established and diverse service industry was an integral component in the local economy, especially as the mining boom of the World War I era began to decline. An assortment of hotels, auto courts, and service stations were listed in various AAA guides published between 1927 and 1954, but surprisingly few have survived into the modern era.

A rare exception is the Plaza Motel at 2612 East Seventh Street. The *Western Accommodations Directory* published by AAA in 1954 noted that this was "an attractive new motel. Air conditioned rooms have radios, vented heat and tiled shower or combination baths." Rates ranged from five to eight dollars per night.

Panorama of Joplin in 1910, by the Haines Photo Company. *Library of Congress Prints and Photographs Division*

CHAPTER 3

KANSAS

Kansas has a unique relationship with US 66. The highway traverses just over thirteen miles in the Sunflower State, the shortest distance among all eight states through which it passes. Kansas was the only state bypassed entirely when the interstate highway system supplanted the Double Six. As a result, only in Kansas can you drive Route 66 from border to border and not encounter an interstate highway.

Rainbow Bridge over Brush Creek

SHORT BUT SWEET ROUTE

Route 66 sweeps into Kansas with little fanfare. First, there is the dusty State Line Bar nestled in a gritty area once dominated by mining. Then the viaduct—built in 1922 over the tracks of the Missouri-Kansas-Texas Railway and supported by concrete posts that appear as ancient as petrified logs—serves as a portal into historic Galena.

The first intersection is dominated by a row of empty brick buildings predating Route 66 and an abandoned two-story frame house that dates to the late 1800s—once a brothel, it has been refurbished and now operates as a bed and breakfast. But before you explore this tattered old mining town, where resurgent interest in Route 66 has spurred an impressive cleanup campaign, you must stop at Cars on the Route.

Your initial impression might be that this is simply another restored service station, a franchise of the Kanotex Refining Company. In fact, the station is merely a front for a gift shop and snack bar where Melba, the self-proclaimed Mouth of the South, reigns supreme. The battered old tow truck out front served as the inspiration for the Tow Mater character in the animated film *Cars*.

Cars on the Route service station, Galena. *Mike May*

Galena has a long and colorful history that begins shortly after the Civil War. But it was the discovery of a chunk of pure lead ore during the digging of a well at the turn of the twentieth century that transformed the sleepy little town and the surrounding area.

Within a few very short years, Galena (named for a type of lead ore) became a mining boomtown. It lay at the center of a tri-state district that was the largest lead-producing area on earth. The combined population of Galena, and the community of Empire that abutted it, mushroomed to more than 10,000.

Galena today is but a shadow of Galena during the peak years bracketing World War I. Still, it's far too big to be considered a ghost town. The business

DON'T MISS

The **Galena Mining and Historical Museum** is more than a museum. It is also a monument to community spirit, dedication, and perseverance. The story begins with Howard Litch, a longtime resident who sought to preserve the Galena's history by collecting artifacts as the town faded with each passing year.

Then in 1983, the old Missouri-Kansas-Texas Railway depot became available to serve as an actual museum. But it had to be moved from its location on property belonging to the Burlington Northern Railway. The community responded with a fundraising endeavor, a donation of property for relocating the depot, and extensive development, which included the extension of highway drainage, tons of fill dirt, and building remodeling.

Today the museum complex is a showpiece. It rates high on my list of must-see attractions.

Galena Mining and Historical Museum

district, with its turn-of-the-century brick storefronts, and the fine old homes that survive here are evidence of those glory days. The former Missouri-Kansas-Texas Railway Depot, relocated to its current site in 1984 (319 West 7th Street), houses the Galena Mining and Historical Museum, an excellent place to learn more about the history of this fascinating old community.

Midway between Galena and Baxter Springs is Riverton—a small community associated with a power plant since 1914—and its Riverton Store. This delightful old store, originally the Eisler Brothers Grocery, opened in 1925. It retains many of its original fixtures and architectural elements,

GALENA LABOR HISTORY

In June 1980, the Eagle-Picher Mining and Smelting Company suspended operations in Galena, Kansas. The plant's closure marked the final chapter in a long and colorful history. This history includes a bloody labor dispute that catapulted Kansas Governor Alf Landon into the national political spotlight and the Republican presidential candidacy against incumbent Franklin D. Roosevelt.

In 1935, United Mine Workers president, John L. Lewis, called for a labor strike. The employees of the Eagle-Picher smelter heeded the call, walked off the job, and blocked the company's gates on Route 66.

This was during the depths of the Great Depression, so the company turned to non-union miners and mill workers from nearby Joplin, Missouri, to fill the void. The striking miners blocked the highway and pelted the replacement workers' cars when they left the plant to return to Missouri.

Route 66 traffic was detoured, deputies attempted to protect the workers, and the violence escalated. Governor Landon declared martial law and dispatched the National Guard to Galena. But intermittent violence and labor disputes continued. The climax of the unrest came on April 11, 1937. Four thousand pick handle–wielding miners began a demonstration that escalated into gunfire. The demonstration left nine men dead in front of the headquarters for the International Mine, Mill, and Smelter Workers Union.

Old Riverton Store

including the decorative pressed tin ceiling. Now also serving as a deli, it is a favored hangout for locals and travelers alike.

West of Riverton, Route 66 is signed as Beasley Road before it makes a sharp southerly turn onto 50th Street, which becomes Willow Street in Baxter Springs. Cradled in that curve is the graceful Rainbow Bridge, the last of three Marsh Arch Bridges that carried Route 66 traffic in Kansas.

Dating to 1923, the refurbished bridge now serves as a one-way crossing over Brush Creek, since a modern bypass was built immediately to the east. The lovely span frames lush woodlands and is a favored photo stop for Route 66 enthusiasts.

Baxter Springs, like Galena, is no ghost town, yet it is a far cry from its past incarnations. It was a prosperous shipping point for cattle during the 1870s, a world-acclaimed resort center in the late 1880s, and a mining boomtown in the World War I era.

On this site along the Spring River, John Baxter established an inn on the military road that connected Fort Leavenworth with Fort Gibson in the Indian Territories shortly before the Civil War. During this conflict, in 1863, the First Kansas Colored Infantry built a fort at Baxter Springs.

An assault on this fort by William Quantrill's legendary Confederate guerillas in October 1863 was the first act in an unfolding tragedy. Repelled at Fort Baxter, Quantrill turned his forces north and decimated a cavalry unit under the command of General James Blunt. The location of that battle, known today as the Baxter Springs Massacre, is one of twelve Civil War sites in the city and surrounding area, which may be explored with a self-guided driving tour.

Current attractions in this city include the Route 66 Visitor Center in a refurbished Philips 66 service station, built in 1930 at the intersection of 10th Street and Military Avenue. The Baxter Springs Heritage Center and

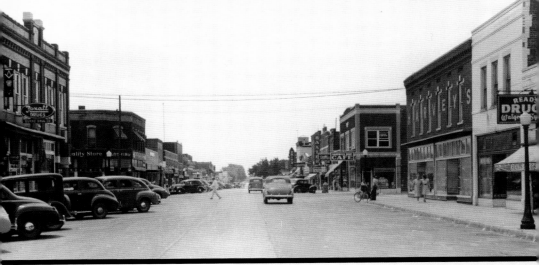

Main Street in Baxter Springs, circa 1940. *Courtesy of Steve Rider*

BAXTER SPRINGS

Long before Route 66 elevated Baxter Springs to a destination for fans of the road, the Osage Indians favored this site as a summer campground. Revered for their perceived health benefits were the various mineral springs in the area.

These springs were a primary reason for John J. Baxter to file a claim for a homestead on the site, and to establish an inn and store on the military road that traversed the area, in about 1853. The springs also played a role in the decision to establish Fort Blair (also known as Fort Baxter)—the military outpost targeted by Qauntrill's Raiders in 1863—near the inn.

In the late 1860s, the springs helped establish the community as a shipping point for Texas cattle on the Missouri River, and the development of the Kansas City, Fort Scott and Gulf Railroad. As the frontier was pushed farther west in the 1870s, the prominence of Baxter Springs as a shipping point waned, and the springs spawned a modern enterprise with very old origins: the marketing of the waters for their healing powers.

The town morphed from a rough-and-tumble cattle town into a posh resort community. As a vacation and convention center, Baxter Springs served as the host city for the annual Grand Army of the Republic reunions. And then came the discovery that changed everything: the spring's mineral properties were the result of the richest deposits of lead and zinc in the world.

BAXTER SPRINGS BASEBALL

Baxter Springs may seem an unlikely place for a base-ball legend, but since the dawn of the twentieth century, baseball has been a passion for the folks here. Mining companies formed teams that competed throughout the tri-state mining district. In the early 1950s, the local Lions Club provided the funds for construction of one of the finest Little League parks in the nation.

The town even sported a minor league team, the Baxter Springs Whiz Kids, during the late 1930s and 1940s. One of the teams' star players was a kid from Commerce, Oklahoma, a mining town south of Baxter Springs on Route 66. His prowess garnered national attention for the Whiz Kids. It also landed the boy from Commerce—Mickey Mantle—a contract with the New York Yankees.

Museum is also a must-see. There is even a former bank, purportedly robbed by Jesse James in 1876, that most recently housed the Café on the Route.

If all this exploration leaves you hungry, try the charming Red Ball Café at 539 West 5th Street in Baxter Springs. It is a favorite of both locals and the exploring traveler.

On the outskirts of town, a Walmart shatters the illusion of time travel. Then, less than a mile later, a sign looming large welcomes you to the Sooner State, Oklahoma.

Route 66 Visitor Center, Baxter Springs

CHAPTER 4

OKLAHOMA

Although the numeric designation of 66 has its origins in Springfield, Missouri, Oklahoma, too, has a legitimate claim as the birthplace of Route 66. This bold claim is rooted in the work of one Oklahoman: Cyrus Avery (see sidebar).

Route 66 in Elk City, Oklahoma. *iStockphoto*

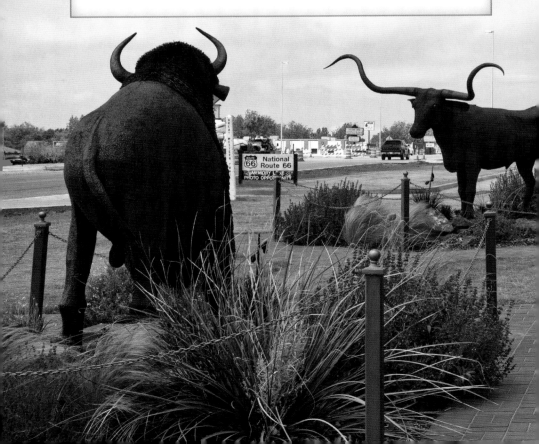

GO WEST, YOUNG MAN

Initially Route 66 twisted its way westward across Oklahoma for 415 miles. A decade of realignment shortened that distance to less than 390 miles, much of which remains drivable.

Vestiges of the century-old tri-state mining boom first encountered near Carthage, Missouri, dominate the first miles of Route 66 in the Sooner State. Among these fading remnants is the community of Quapaw, less than five miles from the Kansas state line.

CYRUS AVERY

As an early proponent of the good roads movement, Cyrus Avery joined numerous associations, including the Oklahoma Good Roads Association. He was also the founder and president of the Albert Pike Highway Association.

These high-profile positions, as well as numerous successful lobbying efforts and tireless work to develop means for the grading of roads, led to his appointment as president of Associated Highways of America. In turn, it also led to his appointment as Oklahoma state highway commissioner.

All of this was but the prelude to his most important role in the development of a highway system. In 1925, he accepted an appointment to the Joint Board of Interstate Highways at the U.S. Department of Agriculture, a group tasked with creating a national highway system.

His mediation of a disagreement between the board and the governor of Kentucky overcame a major obstacle in the highway system's formation. Because of his intervention and compromise, US 66 replaced US 60 as the designation for the highway linking Chicago with Los Angeles.

In February 1927, mere months after the certification of US 66, Avery spearheaded the creation of a promotional organization, the U.S. 66 Highway Association. At this inaugural meeting, the association decided to promote the highway as the Main Street of America.

The name refers to the Quapaw Indians relocated here in the 1830s. In 1897, the bucolic cattle pastures and hayfields that surrounded the small community vanished with the discovery of extensive lead and zinc deposits. Production in the tri-state mining district peaked in 1926, the year of Route 66 certification, with 423,000 tons of zinc and 912,117 pounds of lead.

Mining served as the economic foundation for the next town, Commerce, as well. The town's favorite son, baseball Hall of Famer Mickey Mantle, was memorialized when the post-1952 alignment of Route 66 was designated Mickey Mantle Boulevard. Between 1926 and 1952, the highway followed Commerce Street and Main Street. For sports fans, a drive past Mantle's childhood home at 319 South Quincy Street is an absolute must.

Miami (pronounced my-am-uh) has fared better than the first old mining towns you've encountered along Route 66 in Oklahoma. A vibrant history,

Waylan's KuKu Burger, Miami

Coleman Theater, Miami

interesting sites, and good food are the hallmarks of a visit to this pleasant little community.

Located along Route 66 at the north end of town (915 North Main Street) and promoted as a "Quality Fast Food Restaurant" is Waylan's KuKu Burger, the lone survivor of an early 1960s regional chain. The slogan *Don't ask for a burger, ask for Waylan's* returns visitors to an earlier time, as do the simple menu selections, interior appointments, friendly service, and distinctive vintage neon sign. The monthly summer car cruises, held on the fourth Saturday of April through September, further enhance the Route 66 experience.

A highlight of any visit to Miami is a stop at the stunningly beautiful Coleman Theater, 103 North Main Street (Route 66). It was built in 1929 and painstakingly restored in the 1990s. Free tours are available Tuesday through Saturday.

Southwest of the city, the completion of a steel truss bridge in 1937 marked the last link in the paving of Route 66 in Oklahoma. The bridge was replaced in 1997, and this segment of the old highway, now signed as US 69, continues to Narcissa and Afton.

ROUTE 66 IN OKLAHOMA

The state of Oklahoma contains several superb segments of Route 66 that demonstrate the evolution of highway engineering during the early twentieth century. One of the most unique segments of the early alignment of Route 66 is located immediately south of Miami, between Narcissa and Afton.

Built between 1919 and 1921 as part of State Highway 7, this concrete-edged segment is only nine feet wide. Amazingly, this narrow roadway served as the course of US 66 until 1937.

In November 2011, a monument with a Will Rogers theme was dedicated near Afton, commemorating the road segment's role in the evolution of Route 66. Detailed directions to the southern segment of the road and monument are available at Afton Station in town.

Just west of Sapulpa is a 3.3-mile segment of highway that initially served as part of the Ozark Trails Highway, predecessor to Route 66. Though currently overlaid with asphalt, the roadway is actually the original eighteen-foot-wide Portland cement underneath. West of Stroud, you can find another section of early Route 66 that also served as the course for the Ozark Trails Highway. Bypass occurred in 1930.

From Bridgeport Hill west to Hydro an approximately eighteen-mile segment of Route 66 represents highway engineering standards of the 1930s with a twenty-foot-wide roadbed.

Sidewalk Highway, near Narcissa

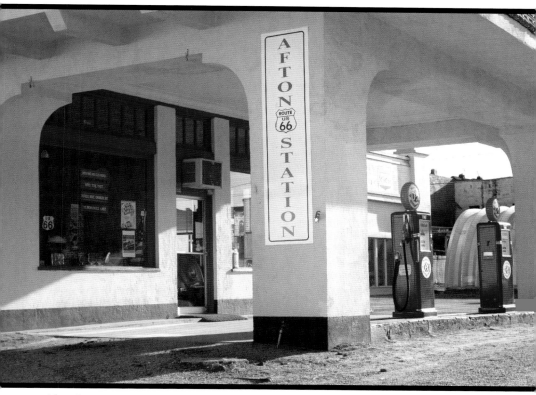

Afton Station

I recommend following South Main Street instead. This is the 1926 to 1937 alignment of Route 66, and it contains a unique little treasure where E Street Southwest ends. Listed as an Oklahoma National Historic Landmark, this short segment of Route 66 that connects with the later alignment (US 69) near Narcissa is only nine feet wide. Built in 1922, and now known as the Sidewalk Highway, this rarity is a missing link in the evolution of highway engineering and development.

Afton is another place that is too big—and too alive—to be called a ghost town. However, the empty Palmer Hotel, vacant wagon works building, closed grocery store, Avon Motel ruins, and faded signs indicate the good times are a fading memory here.

Photo opportunities abound in historic Afton, but Afton Station is *the* attraction. A former D-X service station and garage, Afton Station now houses a fascinating collection of automobiles, with twelve vintage Packards as

the centerpiece. It's an eclectic museum preserving the history of Route 66 as well as the town of Afton.

US 69, the highway that currently uses the former course of US 66, continues on to Vinita, the first community in Oklahoma to have electricity and the oldest non-Native American village in the state. This charming little town is named for renowned sculptor Vinnie Ream, best known for her statue of Abraham Lincoln in the rotunda of the Capitol building in Washington, D.C. It is home to such diverse attractions as a McDonalds that straddles I-44, several vineyards, the gravesite of the Depression-era Barker Gang, and the Eastern Trails Museum. There is even a Civil War battle site on Cabin Creek.

The dining recommendation here is Clanton's Café at 319 East Illinois Street (Route 66). This classic little diner has been managed by the same family since 1927.

West of Vinita, US 69 (formerly Route 66) is a four-lane highway. Shortly after US 69 turns south, the highway is signed as State Highway 66, a designation it carries all the way to Tulsa, and resumes its two-lane form. Here the landscapes are pleasant and rural.

The road transforms into a four-lane highway again near Chelsea and then enters the community over a steel truss bridge built in 1932 over Pryor Creek. For an earlier Route 66 experience, follow East 1st Street as it crosses this creek on a bridge built in 1926.

Wineries, a flea market, a home mail-ordered from a Sears and Roebuck catalog in 1913, and some picturesque old motel signs are a few of the gems sought by Route 66 enthusiasts. As a historical footnote, Gene Autry called Chelsea home for a while when he worked for the Frisco Railroad.

Dennis Bushyhead, principal chief of the Cherokee from 1879 to 1887, is the namesake for the village of Bushyhead. Foyil, a short distance to the west, is a small town directly linked to an early promotion for Route 66: the 1st Annual International Trans-Continental Footrace, dubbed the Bunion Derby, held in 1928.

At each end of Foyil along the 1926 to 1963 alignment of Route 66 (Andy Payne Boulevard) is a small park with a historical marker. One commemorates the race and the other recalls Andy Payne, a native of Foyil who claimed first place in this grueling race.

For a truly unique attraction, follow Highway 28A four miles east of Foyil to Totem Pole Park, a folk art emporium that showcases the work of Ed Galloway. The centerpiece of the whimsical collection of concrete sculptures is a ninety-foot behemoth that required eleven years, six tons of steel, and twenty-eight tons of cement to complete.

BUNION DERBY

The so-called Bunion Derby was not devised as a means to promote Route 66 but as a way for sports promoter C. C. Pyle to line his pockets. Still, the First Annual International Transcontinental Footrace of 1928 put the highway front and center. And one community stood at the forefront of this publicity.

With a first-place cash prize of $25,000, even the steep entry fee of $100 did not deter entrants. More than two hundred people, ranging in age from sixteen to sixty-four, signed up for the race. A few were serious marathoners and long-distance

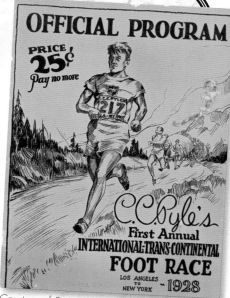

Courtesy of Steve Rider

runners, but the majority were rank amateurs, such as Andrew "Andy" Payne of Foyil, Oklahoma. The footrace commenced on March 4, 1928, at the Los Angeles Ascot Speedway and culminated with tremendous fanfare at Madison Square Garden in New York City on May 26, 1928.

Initially Payne was lost in the pack, but as runners fell by the wayside, Pyle drummed the press into a fever pitch over the Cinderella story of Andy Payne. The media frenzy over this Cherokee boy from Foyil only increased when he became the front-runner at the Oklahoma state line near Texola.

Of the original entrants, only fifty-five crossed the finish line. Payne—with an elapsed time of 573 hours, 4 minutes, and 34 seconds—was declared the winner. He used his prize money to pay off the family farm and buy one of his own in Foyil.

Payne was but one winner of this amazing sports event. For almost three months, Route 66 was featured in news headlines and articles around the globe.

Totem Pole Park, Foyil. *Courtesy of Steve Rider*

Courtesy of Joe Sonderman

A few miles west of Sequoyah (named for the inventor of the Cherokee alphabet) the quiet, rural landscapes little changed since the era of the last Studebaker give way to the bustle of Claremore. Peppered with fascinating attractions, Claremore is forever linked to the legacy of Will Rogers.

The Will Rogers Memorial and Museum is a fully interactive facility that includes artifacts, a theater, and art to offer a multidimensional look at the life of America's most famous twentieth-century humorist. The complex is but a short detour from the Route 66 corridor on Will Rogers Boulevard.

The J. M. Davis Arms and Historical Museum at 333 North Lynn Riggs (Route 66 from 1926 to the summer of 1958) houses one of the nation's largest private collections of firearms. The collection numbers more than 20,000 pieces. It includes a tank and guns that once belonged to the famous and the infamous. It houses an eclectic collection of rare Native American artifacts, a firearm research library, memorabilia from the western frontier, music boxes of all kinds, 1,200 beer steins, and, of course, an excellent gift shop.

Other attractions of note include the Will Rogers Hotel, built during the era of radium baths, which made this community a destination for international travelers who sought a cure for various ailments. The hotel now serves as a senior citizens' apartment complex.

OIL WELLS AND BUFFALO

The distance from Claremore to Tulsa is less than twenty miles. Your reward for braving the ever-thickening traffic is an attraction with international appeal from the twilight era of Route 66.

From the town's inception, transportation has been integral to Catoosa's economy. First, on March 27, 1883, the St. Louis and San Francisco Railroad built a line to this point, and then the Ozark Trails Highway and Route 66 added to this transportation legacy. When completed, the 445-mile McClellan-Kerr Arkansas Navigation System linking Tulsa to the Gulf of Mexico made Catoosa the farthest inland, year-round seaport in the nation.

THE BLUE WHALE

The Blue Whale is a relative latecomer in Route 66 history, but it quickly became an icon for the road and the resurgent interest in the Double Six. In 1970–1972, Hugh Davis, a zoo curator, built the concrete-and-steel whale for his wife, Zelta, who loved animals. He envisioned the whale as part of his Nature's Acres complex that would serve as the centerpiece of a park for the community.

The first creation in the complex was the Ark, a model of the biblical ark scaled to children's size, which featured cut-out animals and simplistic furnishings. To enhance the experience, Hugh Davis added a picnic area with giant mushrooms and an eighty-foot blue whale. Next, a few ponds were dug, and Zelta had an opportunity to develop her fascination with alligators, earning the park the nickname of Catoosa Alligator Ranch. In addition to alligators, the park also featured a prairie dog village and snake pit. After the eventual removal of the alligators, the ponds served as a swimming hole for locals.

Through years of abandonment, vandalism and weathering took their toll on the park. Recently, however, concerned citizens have refurbished the whale and segments of the park, including the giant mushrooms, once again making the park a roadside gem.

The town's biggest roadside attraction, however, dates to the early 1970s, when zoo curator Hugh Davis built the eighty-foot-long Blue Whale of Catoosa as an anniversary present for his wife, Zelta. For more than two decades the whale, the surrounding pond, and the picnic grounds served as a summer haven for locals and travelers alike. Davis's declining health in the late 1980s prompted closure of the park, but a decade of abandonment and vandalism is now being reversed as groups of concerned citizens have refurbished the whale and are turning their attention to the park itself.

In Tulsa, as with most large cities through which Route 66 passed, realignment occurred numerous times to meet rapidly evolving traffic needs. To keep things simple, the two primary corridors were 11th Street and Admiral Place.

Route 66–associated sites, including an array of structures with art deco facades (the Tulsa Monument Building and Warehouse Market Building are two of the best), and the Blue Dome district with the stunning Blue Dome service station (1925) range along both streets. Add a few short detours, such as to the Gilcrease Museum with one of the world's most comprehensive collections of Native American and western art, and you have a vacation.

The pre-1951 alignment of Route 66 follows Southwest Boulevard through Red Fork and continues south through Oakhurst and Bowden to Sapulpa. This original alignment then joins the later four-lane incarnation at Sapulpa, a colorful and vibrant community bypassed with completion of the Turner Turnpike in 1953. Its historic district holds refurbished advertisements from another era and a cornucopia of Route 66 shields on sidewalks, in shop windows, and elsewhere.

Carol M. Highsmith's America, Library of Congress, Prints and Photographs Division

DON'T MISS

In **Tulsa**, you can enjoy some great sites, such as these:

- Cyrus Avery Centennial Plaza, with oversize bronze statues depicting Cyrus Avery in his Model T Ford meeting a farmer with his startled team of horses;

- Tulsa Air and Space Museum at the Tulsa International Airport, with the primary collection housed in a hangar built in 1940;

- Tulsa Zoo and Living Museum (6421 East 36th Street North), a small but well-designed zoo complex often rated as a top attraction in the city;

- Admiral Twin Drive-In theater (7355 East Easton Street), refurbished in 2012;

- Woolaroc Museum and Wildlife Preserve, about 50 miles north of Tulsa, in Bartlesville (1925 Woolaroc Ranch Road), originally established as the personal ranch of Frank Phillips, one of the founders of Phillips Petroleum.

Cyrus Avery Plaza

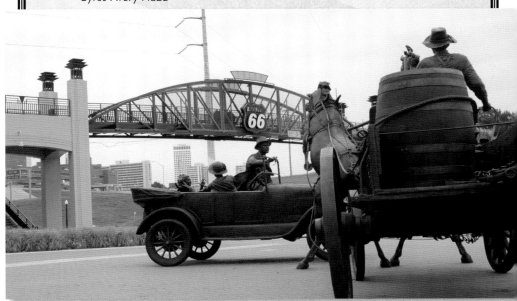

BLUE DOME STATION

Built in 1925 at the corner of Second Street and Elgin in Tulsa by T. J. Chastain, the Blue Dome Station represented the first step in diversification of the Chastain Oil Company. The state-of-the-art station included lodging for the manager under the big blue dome, a car wash, and free pressurized air.

Today, the historic station—listed on the National Register of Historic Places in December 2011—serves as the center-piece for the Blue Dome District. Bound by Kenosha, Detroit, and Eighth Streets, and portions of Second Street (Route 66 from 1926 to 1932), this district is the venue for the Blue Dome Arts Festival. It is also a burgeoning area for unique shops, galleries, and restaurants.

Courtesy of Steve Rider

THE BLUE DOME, "BEST IN WEST", 2nd AND ELGIN, TULSA, OKLA.

From Sapulpa to Oklahoma City, you'll find a staggering number of Route 66 alignments as well as segments of the earlier Ozark Trail. In fact, there are enough variations of the old road, each with unique attractions and sites, to fill a book. As it turns out, author and historian Jim Ross did just that with *Oklahoma Route 66*, a well-researched history (with maps) of Route 66 in Oklahoma from Kansas to Texas.

For a real sense of early Route 66 and the landscapes through which it passed in Oklahoma, try the short segment of the early alignment that also served as the course for the Ozark Trail west of Sapulpa. Follow State Highway 66 west, but watch for the Rock Creek Bridge marker. The second right turn will take you to this often overlooked little gem, a bumpy three-mile drive that loops back to the later alignment.

Continuing west, the post-1938 alignment of Route 66 (State Highway 66) follows the contours of the land and passes through a few small towns before entering Bristow, a quaint and fascinating community. Purportedly, there are more miles of brick streets here than in any other city in Oklahoma.

FRANKOMA POTTERY

Courtesy of Joe Sonderman

With a degree from the Chicago Art Institute and a position at the University of Oklahoma, John Frank could have weathered the Great Depression with little worry. However, his dream was to establish a commercial pottery studio for the manufacture of fine artware at modest prices, so in 1933, he established Frankoma Pottery.

When success proved elusive, he relocated the business to Sapulpa, near Tulsa, in 1938, but a fire and the Great Depression hindered his efforts to transform his dream into a reality.

In 1942, Frank's company introduced a distinctive line of Southwestern dinnerware. Acclaim for the innovative design and use of colors translated to sales, and soon Frankoma Pottery was receiving orders that strained manufacturing capacity.

The company remained in operation through 1991, even though John died in 1973. Several attempts to revive the operation failed, and in May 2011, inventory, fixtures, and equipment sold at auction.

Today, the wares produced by Frankoma Pottery are highly sought-after collectibles. Of particular interest are items associated with Route 66.

Additionally, a large number of buildings, some with unique architectural details, are constructed of red brick.

Less than a dozen miles west of Bristow lies the tiny town of Depew, with its Route 66 history and fascinating business district filled with unique time capsules. From 1928 to 1984, Route 66 (now state highway 66) followed a course just below the little town on a hill. From 1926 to 1928, however, the highway made a U-shaped loop up the hill, through town, and down the other side. Realignment made this the first community to suffer the economic impact of a Route 66 bypass.

Your next stop is Stroud, home of another famous Route 66 eatery: the Rock Café. The café was built in 1939, restored in 2000, gutted by fire in 2008, and rebuilt shortly after that. It is but one of many architectural and roadside gems awaiting discovery here.

The landscape west of Stroud continues with the theme of rolling hills, pastures, and small towns where quaint brick streets encourages exploration. For the adventurous traveler unafraid of a little dust on the tires, there is an alternative to following the paved course of Route 66 into Davenport.

At the west end of Stroud, turn south on Highway 99, drive a short distance, and turn right on Central. This is the course of Route 66 before 1930 and that of its predecessor, the Ozark Trails Highway. This zigzag route continues with a left turn on the first paved road, about one mile from the intersection with Highway 99, and then a right turn on Elm, a dirt road. Drive for approximately one mile, and then turn south on N3540 Road and continue for about one mile. Turn west on E0890 road at an intersection marked with a towering graffiti-covered obelisk, which takes you back to Highway 66.

The obelisk is one of very few surviving highway markers from the Ozark Trails Highway. Other indicators of this roadway's age are the various concrete culverts, some of which have construction dates of 1909 and 1917.

Rock Café, Stroud

PIONEERS OF ALL KINDS

From Stroud, Highway 66 winds its way through Davenport, past Gar Wooly's Food-N-Fun Emporium, and then into Chandler—home of Jerry McClanahan, author of the *EZ 66 Guide for Travelers*. McClanahan's Route 66 Gallery at 306 Manvel Avenue, just a few blocks north of Route 66, may be the primary attraction in Chandler, but there are others, too, including twelve structures listed on the National Register of Historic Places.

Additional points of interest include the offices of the Oklahoma Route 66 Association (1023 Manvel), and the Chandler Route 66 Interpretive Center. The latter is housed in a distinctively styled former National Guard Armory built in the 1930s. The old armory was a Works Progress

Route 66 through Chandler. *Robyn Beck/AFP/Getty Images*

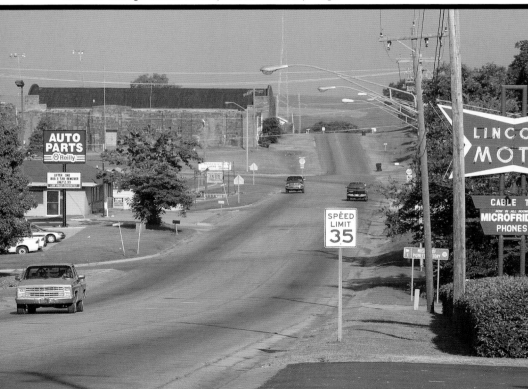

Administration (WPA) project built using locally quarried sandstone. It features a unique wooden floor in the drill hall made up of more than 150,000 hand-laid wooden blocks.

Another Chandler attraction that I recommend is the Lincoln County Museum of Pioneer History (7171 Manvel Avenue). In addition to well-crafted displays that chronicle area history, the museum offers surprises ranging from a marionette exhibit to silent movies produced by pioneering cinematographer Benny Kent.

Eight miles west of Chandler, the town of Warwick is slowly fading into the Oklahoma prairie, with one very notable exception: Seaba Station. Built in 1924 and listed on the National Register of Historic Places, this former machine shop now houses a motorcycle museum. Before you leave,

Seaba Station, Warwick

check out the former outhouse. Its walls are studded with material used to strengthen the concrete, and it features a one-of-a-kind flush toilet of unknown vintage.

The horrendous wildfires of summer 2012 transformed some of the landscapes, rural and urban, in the area of Luther. But Route 66 here still brings a sense of serenity. An obscure and often overlooked landmark here is located at the intersection of Highway 66 and North Pottawatomi Road.

Now a private residence, the unassuming sandstone bungalow dates to 1915. It was listed on the National Register of Historic Places in 1995. The building, which originally served as a service station, was owned by the Threatt family, who began homesteading in the area in 1899. The Threatts were former slaves, and the station was one of the few in the area owned by African Americans.

After a few miles through the rural landscape, the highway enters the charming village of Arcadia, where the past and future share the roadside.

ARCADIA

What do Arcadia, Oklahoma, and Washington Irving have in common? Jack Rittenhouse, in his 1946 guide, noted that a historical marker on the east side of town along the highway commemorated the encampment of a contingent of U.S. Rangers of which Washington Irving was a member.

Still, it is not Washington Irving or his literary work for which the community is best known. That honor is bestowed on the legendary round barn that has been a landmark in the area since 1899. Listed on the National Register of Historic Places in 1977, the barn—sixty feet in diameter and forty-three feet tall—was near collapse in the mid-1980s. Through the intervention of concerned citizens under the leadership of Luke Robinson, the barn underwent a complete renovation and has become a popular attraction today.

Arcadia round barn

The past, in the form of a refurbished round barn built in 1898, dominates a hill along the highway. Now used for dances and events, the distinctive building also houses a gift shop and informative Route 66 exhibit.

The future appears on the opposite side of the road in the form of Pops, a space-age gas station nestled in the shadow of a sixty-six-foot soda pop bottle, complete with straw. The giant bottle is illuminated at night. One part 1950s malt shop, one part gift shop, and one part convenience store, Pops' primary claim to fame is soda pop. The shop carries more than 400 different varieties, ranging from classic favorites and international brands to obscure regional brands and oddities such as bacon-flavored soda.

As you drive west from Arcadia, the traffic becomes heavier with each passing mile. This is the first indicator that you're fast approaching the metropolis of Oklahoma City. State Highway 66 ends at the intersection with I-35 and US 77 near Edmond. The course of Route 66, between 1926 and 1954, continued on 2nd Street, also signed as US 77.

Pops Restaurant, Arcadia. *Carol M. Highsmith's America, Library of Congress, Prints and Photographs Division*

As in most metropolitan areas, Route 66 through Oklahoma City followed various courses as the highway evolved to meet increased demand. Over the years, Route 66 utilized Britton Road, Beverly Drive, Grand Boulevard, Classen Street, May Avenue, and Western Avenue, to name but a few.

Jerry McClanahan, in *EZ 66 Guide for Travelers*, offers a succinct overview of Route 66 options in the city: "Beltline Option (Alt 66) began in 1931 and detoured much of the U.S. 66 traffic around the northwest of the city until 1953 (Western Ave was bypassed in favor of May Ave in 1947). . . . The Capitol Option was 'mainline' 66 from 1926 to 1954 (with some changes over the years)."

A little advance planning can greatly enhance your visit to Oklahoma City and decrease your odds of getting lost. Chart your course based on attractions of interest, and, if this is your first time in Oklahoma City, be prepared for surprises. This is a delightful city with a colorful history.

Regardless of which Route 66 alignment you select to traverse the city, numerous landmarks line the roadway. The ornate 1,500-seat Tower Theater at 425 NW 23rd Street (the original alignment of Route 66) dates to 1937. The towering milk bottle on the odd little triangular building, located at 2426 North Classen Boulevard, is listed on the National Register of Historic Places and is a popular photo stop.

Another stunning landmark, the Gold Dome Building, resides at the corner of NW 23rd Street and Classen Boulevard. Utilizing Buckminster Fuller's patented geodesic design, architect Robert B. Roloff crafted the building and crowned it with a massive gold-anodized dome in 1958.

OKLAHOMA CITY

Aside from being the only city with a state capitol surrounded by oil wells, Oklahoma City also has the distinction of being a state capital with a historical identity crisis.

Designation of the city as the Oklahoma County seat, and state capital, occurred on June 11, 1910. However, the name *Oklahoma City* appeared first on a postal application approved on July 1, 1923. The initial establishment of a post office in December 1887 was under the name *Oklahoma Station*. The following year an amendment changed this to simply *Oklahoma*.

DON'T MISS

Attractions of note in **Oklahoma City**:

- Oklahoma City National Memorial (620 North Harway), a moving memorial and museum honoring the 168 victims of the Alfred P. Murrah Federal Building attack of 1995;

- The National Cowboy and Western Heritage Museum (1700 NE 63rd Street), with its paintings and sculptures by contemporary artists; its wide array of work by classic western artists such as Frederic Remington, Albert Bierstadt, and Charles Russell; and a special children's exhibit, gift shop, and restaurant;

- The Oklahoma History Center (2401 North Laird Avenue), a 215,000-square-foot museum complex housed in an architectural gem with a huge variety of exhibits, many of them interactive, that chronicle the area's geology, aviation history, diverse culture, and oil field development;

- The former warehouse district Bricktown, which now bustles with canal taxis, horse drawn carriages, and eclectic shops and restaurants;

- The Oklahoma State Capitol (2300 North Lincoln Boulevard), located on more than 100 acres, the only state capitol surrounded by working oil wells;

- Frontier City, an amusement park with roots in the 1950s that has evolved into a modern complex offering the latest in thrill rides as well as a few classics.

On the west side of the city, old Route 66 again becomes State Highway 66 passing through Warr Acres and Bethany. These were once independent communities, but the urban sprawl of Oklahoma City has engulfed them. Now it is difficult to tell where one begins and one ends.

(Continued on page 128.)

Gold Dome Building, Oklahoma City

FRONTIER CITY

Frontier City near Oklahoma City is unique among Route 66 associated attractions in that is has survived and evolved to remain relevant and profitable. Opened on May 30, 1958, the park was the brainchild of Jimmy Burge, a promoter who had once served as press agent for Joan Crawford.

Burge established the park on a unique business model. It was built on a revenue stream from businesses opening subsidiaries in the park and advertising. This model allowed the park to operate profitably without charging admission.

At the opening ceremony, Oklahoma Governor Raymond Gary shot the rope across the entrance with a bow and arrow. The entrance was designed to look like wooden stockade gates, and the mayor of Oklahoma City, as well as several city councilmen, arrived in a covered wagon. The park had a post office and its own zip code, a newspaper, a fire department, a police department with deputy and marshal, and even a church for marriages and regular services.

In its first year of operation, the park entertained 1.3 million people, which spurred extensive expansion. In 1960, the park garnered a boost in promotion with the announcement that it was one of the most photographed places in America.

Fires, reorganization, and changing societal patterns resulted in a checkered pattern of profitability through 1983 when Gary Story, a successful amusement park manager from Australia instituted an aggressive modernization of Frontier City. To this day, the park remains a major attraction in the Oklahoma City area.

Courtesy of Joe Sonderman

WHERE THE WIND COMES SWEEPING DOWN THE PLAIN

To regain a sense of history, follow Route 66/North Overholser Drive over the Lake Overholser Bridge (1924) and around Lake Overholser to West Overholser Drive and continue about one mile to Route 66 Park. The pleasant little park offers a walk that features a passing nod to famous attractions along the eight-state Route 66 corridor and a statue of Andy Payne, winner of the 1928 Bunion Derby.

Lake Overholser Bridge

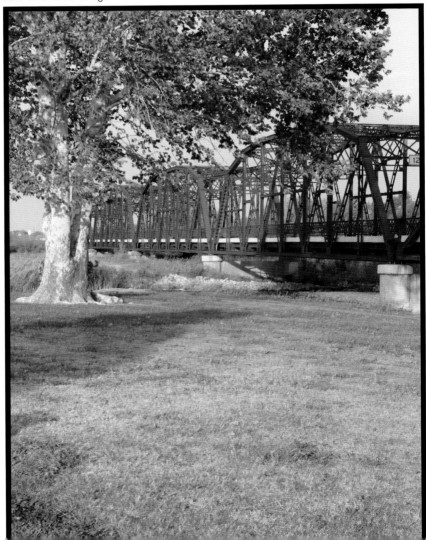

At the east end of Yukon, a few miles west of the lake, the 1926, 1949, and 1958 alignments of Route 66 flow together and sweep into a small town dominated by towering grain elevators emblazoned with the sign "Yukon's Best Flour." Chisholm Trail markers and murals are a dominant theme here, where that famous trail crossed what is now State Highway 66 (formerly US 66) at 9th Street.

For railroad enthusiasts, this community is known as the home of Yukon's Best Railroad Museum, located at the corner of 3rd and Main Streets. Rock Island Railroad artifacts, as well as a yard filled with various rolling stock, ensure an afternoon of enjoyable exploration.

Surprisingly, this little town has two notable features. It is the hometown of singer Garth Brooks, and it's also the site of the largest Czech festival in the nation.

In El Reno, the next town west of Yukon, Route 66 used a number of different streets over its history. However, the primary route for fans of the Double Six today is the alignment now signed as the business loop for I-40.

A number of fascinating attractions here span the community's colorful history: nearby Fort Reno, established in 1874 and serving as a German POW camp during World War II; the El Reno Hotel, dating to 1892; and Robert's Grill, 300 South Bickford Avenue, to name but a few. If the schedule allows for only one stop, I would suggest the Canadian County Historical Museum (300 South Grand), rated one of the most outstanding museums in the state and also the ticket office for the one-mile loop Heritage Express trolley.

The museum is actually a complex that includes a historic depot, jail, school, and other buildings that house a wide array of exhibits. The museum in Heritage Park sits on the 98th meridian, which in territorial days served as the dividing line between unassigned lands and lands assigned to the Cheyenne and Arapaho.

From El Reno, the old highway sweeps into the scenic rolling hills of the South Canadian River Valley. The highlight of this particular drive is the segment from the Highway 281 spur west to Hydro, since it is an almost perfect reflection of highway engineering from the 1930s: curbed concrete roadbed, concrete bridges, and the majestic South Canadian River Bridge, an artistic span that incorporates a series of thirty-eight pony trusses.

As Route 66 continues west, running parallel with its modern incarnation (I-40) toward Hydro, a landmark of the highway remains the primary attraction. Located immediately west of the junction with Highway 58 is Lucille's, a service station built in 1929. It is one of only two existing stations of this type found on Route 66.

The current owner of Lucille's has built a replica that serves as a restaurant in Weatherford at I-40 exit 84 (North Airport Road). The ambiance and good food continue the Route 66 experience gained by driving through the valley of the South Canadian River.

(Continued on page 132.)

CANADIAN RIVER BRIDGE

During the dark days of the Great Depression, highway construction and road improvements funded through federal and state money were key components in stabilizing unemployment. In Oklahoma, a major realignment of Route 66 created a direct course between El Reno and Hydro and eliminated the loop through Calumet, Geary, and Bridgeport. The project commenced in 1930.

The centerpiece of the project was to span the South Canadian River with a bridge nearly one mile long that utilized a series of thirty-eight pony truss spans. When completed, the new bridge was an engineering marvel and an artistic addition to the river valley and roadway.

Construction of the bridge, awarded by contract to the Kansas City Bridge Company, began in October 1932 and was completed in July 1933, months ahead of schedule. Still, the bridge and bypass did not open until the summer of 1934.

Paving on the east leg of the bypass to the bridge had been completed in July 1933. Paving of the west segment, to a point three miles from the bridge, had been completed in 1931. But paving of the final three miles was delayed countless times because of funding issues, red tape, and weather.

Finally, on July 17, 1934, with an estimated 15,000 attendees, the cutoff and bridge officially became part of Route 66. Today, the historic Canadian River Bridge is counted among the most popular photo locations on this highway in Oklahoma.

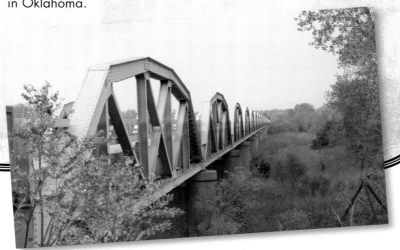

EARLY ROUTE 66 ALIGNMENT DETOUR

If you follow the spur to US 281 and continue north toward Geary, you will find the pre-1933 alignment of Route 66 now signed as US 270. South of Geary, just past the intersection of County Road N2630, a dirt road will turn south along the rail bed. This is a continuation of the pre-1933 alignment of Route 66.

At the intersection of County Road E0980, this road is signed as County Road N2620. Continue south to County Road E1000, also dirt, and drive west to the ghost town of Bridgeport. This road dead-ends on the banks of the South Canadian River, where the pillars from the 1921 Key Suspension Bridge recall the highway's river crossing before completion of the realignment in 1933.

Since this is a dirt road detour, take into consideration the ground clearance of your vehicle as well as indications of recent rain. This segment of Route 66 was, and is still, known for turning into gumbo after it rains.

Lucille's service station, near Hydro

(Continued from page 129.)

As you continue west on Route 66 (East Main), the town of Weatherford soon looms into view. Attractions in Weatherford, home of astronaut Thomas P. Stafford, are a delightful blending of past, present, and future, including Thomas P. Stafford Air and Space Museum, Lee-Cotter Blacksmith Shop (a four-generation shop established in 1910), and 66 West Twin Drive-In Theater, to name but a few.

Drivers flit between the past and present on the road west of Weatherford as I-40 intercedes in the unbroken course of Route 66 from El Reno. However, the intrusion is a short one, and the reward is one of the crown jewels in the Oklahoma Route 66 experience: the Oklahoma Route 66 Museum, at 2229 West Gary Boulevard in Clinton.

The building's stunning design creates an impression enhanced by stepping into the lobby and gift shop. The self-guided tour—with audio narration by Michael Wallis, author of *Route 66: The Mother Road* and voice of the sheriff in the animated film *Cars*—allows visitors to experience the entire history of the road in Oklahoma with detailed exhibits.

An additional attraction in Clinton is the Mohawk Lodge Indian Store (22702 Route 66 North), an authentic trading post that dates to 1892. In addition to offering authentic handcrafted items, the store is also a museum with displays of rare Native American artifacts.

Last, but not least, is the Cheyenne Cultural Center at 2250 NE Route 66 in Clinton. From landscaping that re-creates the original Oklahoma prairie to an exhibit area showcasing the work of Cheyenne artists, the complex allows you to immerse yourself in the history, culture, and customs of the Cheyenne people.

Oklahoma Route 66 Museum, Clinton. *Judy Hinckley*

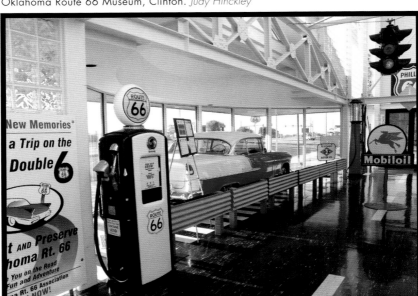

National Route 66 Museum, Elk City. *Judy Hinckley*

West of Clinton, the old highway continues its duel with I-40. Its course passes through the almost–ghost town of Foss; through Canute, with its world-famous Cotton Boll Motel sign; and into Elk City, home of the National Route 66 Museum in the Old Town Museum Complex (27117 West Highway 66). Here a blending of roadside classics and standards of the modern era shadow Route 66, signed as Business Loop 40.

While the informative and delightful Route 66 museum is the highlight of any visit to Elk City, it is not the only attraction here. Often overlooked is the fascinating Anadarko Basin Museum of Natural History in the old Casa Grande Hotel at 204 North Main Street. The hotel hosted the national US Highway 66 conference in 1931.

Shortly after leaving Elk City, I-40 again intrudes into the Route 66 experience, but while cruising through the last communities along the highway in Oklahoma—Sayre, Hext, Erick, and Texola—you can still find links to the past. Each town may seem a place to bypass, but each has something special to offer.

In Sayre, the 1911 Beckham County Courthouse is forever linked with Route 66 because of its appearance in the 1940 film *The Grapes of Wrath*. Other attractions include the Shortgrass County Museum in the former Rock Island Depot at 106 East Poplar, and Sayre City Park, a 1940 WPA project that includes a beautiful stone-faced bathhouse and a swimming pool.

Hext is another blink-and-you'll-miss-it village, but for the sharp-eyed enthusiast, there are some interesting links to Route 66. Among them are early abandoned alignments. These are scheduled for inclusion in a proposed bicycle path utilizing the entire course of the highway from Chicago to California.

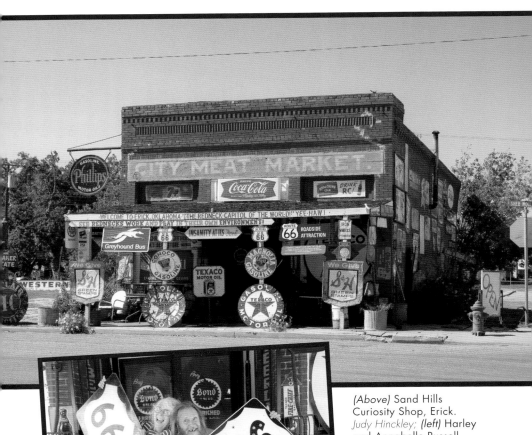

(Above) Sand Hills
Curiosity Shop, Erick.
Judy Hinckley; (left) Harley
and Annabelle Russell,
Sand Hills Curiosity Shop.
Judy Hinckley

Territorial-era jailhouse, Texola

The first hints that Erick is someplace special are street signs for Sheb Wooley Avenue and Roger Miller Avenue (Route 66). However, celebrity associations and museums are just part of the charm found here. At the intersection of the two streets named to honor the city's favorite sons, the imposing century-old bank building dominates. It now houses the 100th Meridian Museum, an eclectic collection chronicling more than 150 years of history, including the community's association with Route 66.

From the highway's inception, roadside attractions have been an integral part of the Route 66 experience. A few defy description and must be experienced to be believed. In Erick, one such attraction is located a few blocks south of Route 66 on Sheb Wooley Avenue. The Sand Hills Curiosity Shop, housed in the former City Meat Market Building, is unusual, to say the least. However, the most entertaining aspects of a stop here are the colorful proprietors, Harley and Annabelle, who perform their special brand of redneck vaudeville for visitors.

The last stop on your westward journey through Oklahoma is at Texola, a faded community with a bit of an identity problem. Since the date of its founding in 1901, the town has been known as Texoma, Texokla, and Texola—the result of conflicting surveys that showed it in Texas or Oklahoma at various times.

The concrete Route 66 corridor through town is shadowed by remnants of better times, such as the overgrown shell of the WPA-built school. Unique photo opportunities abound, but the empty business district and the one room, territorial-era stone jail built in 1910 are among the highlights.

CHAPTER 5

TEXAS

From border to border, US 66 stretched less than 180 miles across the Texas Panhandle. Only Kansas had a shorter segment of this legendary highway. Of this distance, approximately 150 miles of paved highway remain in the Lone Star State for cruising, exploring, and contemplation. From Texola, Oklahoma, to Amarillo, Texas, with the exception of a short segment at McLean, Route 66 runs south of I-40. From Amarillo to a point near the ghost town of Glenrio on the New Mexico state line, its course lies on the north side of the interstate.

Cadillac Ranch, Amarillo. *Shutterstock.com*

It is impossible to plan the weather, but if I could, I would choose an early fall day. I'd pick one with leaden skies and light rain to set a haunting mood for the drive across the Panhandle's arroyo-scarred plains dotted with twisted scrub oak. I would also plan to arrive in Shamrock for dinner at Big Vern's Steakhouse followed by a cruise past the neon-trimmed art deco masterpiece that is the iconic U-Drop Inn, which currently houses the chamber of commerce offices.

Of course, a late arrival would necessitate an overnight stay, since there are many delightful treasures worth sticking around for in Shamrock. Among these are a restored Magnolia service station (circa 1930) and the Pioneer West Museum at 204 North Madden.

From Shamrock, Route 66 flows across a series of rolling wooded hills, heads past the tiny town of Lela, and then (at exit 146 or County Line Road) swings north of I-40. Before continuing the Route 66 adventure, I suggest a short detour of approximately one mile north of the exit on County Line

SHAMROCK

Unsurprisingly, St. Patrick's Day is a major event in a town named Shamrock, where a fragment of the genuine Blarney Stone is a revered treasure. Festivities include a colorful parade, a carnival, a Donegal beard contest, a Miss Irish Rose Pageant, and a wide array of unique food vendors.

This, however, is not the only event that knits this delightful community together. Held on the first weekend of each October at the Shamrock Area Community Center on South Main Street is the Irish Craft Fest. On Thursday evenings, from June through August, the iconic U-Drop Inn casts its neon glow over the best of local musical talent at Thursday Under the Neon.

The community has a little something special for the golf enthusiast, too. With any overnight stay at a local hotel or motel, a guest receives a free round of golf at the Shamrock Country Club.

U-Drop Inn, Shamrock

Road. There you'll find a historic marker commemorating an obscure chapter in the history of the Panhandle at the site of the McLean POW camp.

Shortly after resuming your journey toward California on Route 66, the old highway sweeps onto the quiet streets of McLean, the last community in Texas bypassed by I-40. McLean may seem nearly empty, but it is home to several interesting attractions , and the Red River Steak House offers an opportunity to savor some excellent Texas cuisine. There is even a quaint place to lay your weary head: the Cactus Inn, which has changed little in the past forty years.

MCLEAN

To say Alfred Rowe, the founder of McLean, Texas, was a colorful character would be like saying it gets warm in Death Valley during the summer. Born to British parents in Lima, Peru, Rowe received a formal education centered on agricultural studies. He then traveled the world before setting his sights on owning a ranch in the Texas Panhandle.

In spite of his formal education, he decided to learn ranching from the ground up. He hired on as a cowboy for the JA Ranch owned by John Adair, a fellow Englishman, and Charles Goodnight. Within a year he began purchasing herds in south Texas, established a ranch in Donley County, and drove cattle on the trail to the railhead in Dodge City, Kansas. By 1895, his RO Ranch, at 200,000 acres, was among the largest in the Panhandle.

In 1902, he donated lands along the recently completed Rock Island Railroad line for the town site of McLean, a community named for William Pinkney Mclean, a hero of the battle for Texas independence.

As a prosperous and successful cattleman, Rowe often traveled back to England. In April 1912, he booked passage back to America on the new passenger liner *Titanic*. The rest, as they say, is history. His body, discovered the morning after the tragedy, was initially recorded as body 109, Folder 109 in the coroner's *Titanic* files.

Housed near a beautiful park in a former factory that produced ladies' undergarments, the Route 66 and Devil's Rope Museum is a classic roadside attraction. In addition to a surprisingly compelling collection of barbed wire (hence the name Devil's Rope), related tools, and artwork made from the wire, extensive displays chronicle the area's fascinating and diverse history, including a direct link to the *Titanic*.

On the west side of town, a refurbished cottage-style Phillips 66 gas station (circa 1930) makes for a great photo opportunity. This was the first station in Texas to sell products manufactured by this company.

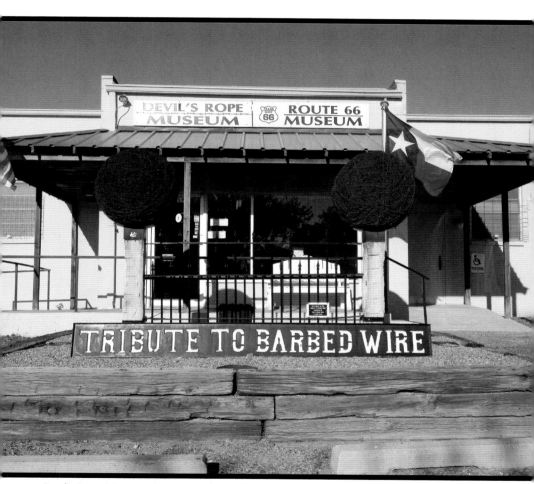

Devil's Rope Museum, McLean. *Judy Hinckley*

West of McLean, old Route 66 again dips south of I-40 as it courses across the rolling hills toward Alanreed, another tiny, sleepy community. Sleepy though it is, it contains some marvelous vestiges from better times that provide delightful photo opportunities, including the Super 66 service station (circa 1930).

From Alanreed to exit 124, you will have to put the Route 66 experience on hold and join the modern era by following I-40. In 1946, Jack Rittenhouse noted that here you are "upon the vast High Plains of the eastern Texas Panhandle."

At exit 124, the junction with State Highway 70, the Route 66 adventure continues along the post-1937 alignment, which bypassed the infamous Jericho Gap. (See the sidebar for information about this interesting chapter in Route 66 history.) The landscapes along this segment of the old highway are more arid and almost featureless. Jack Rittenhouse quipped that here the highway "lies straight as a dropped arrow."

The lack of natural landmarks inspired creative alternatives, and that trend has continued into the modern era. In the faded town of Groom, two manmade wonders—and the massive concrete grain silos that cast long shadows across the old road—dominate the skyline. One of these wonders is a water tower emblazoned with "Britten USA" on the north side of I-40. The tower seems to defy gravity with its severe lean, but in fact, it was built that way to promote a now-vanished truck stop.

The second landmark is the 190-foot, illuminated Cross of Our Lord Jesus Christ, built in 1995. The park that surrounds the cross includes statues illustrating the Stations of the Cross.

Surprisingly, diminutive little Groom has both a pleasant café that offers good food at reasonable rates and an excellent place to rest after a long day of exploring Route 66. The motel is the Chalet Inn just off I-40, and the café is the Route 66 Steakhouse, formerly the Golden Spread Grill, one of four cafés that operated here along Route 66 in 1959.

At Conway, the next skeletal community to the west, the noteworthy landmark is a bit more whimsical in nature. The Bug Ranch, bracketed by a long-closed trading post and a defunct service station, sports a row of Volkswagens buried nose-down in the prairie soil, mimicking the world-famous Cadillac Ranch in Amarillo.

Amarillo, our next stop, is unique in that its most famous Route 66 attractions are not even on Route 66. The Big Texan Steak Ranch, with its world-famous seventy-two-ounce steak eating challenge, originated on Route 66 but was relocated to its current place along I-40 in the early 1970s.

The Cadillac Ranch never had a direct association with Route 66. It's actually located on the south frontage road for I-40, between exit 62 and exit 60. Route 66 is on the north side of the interstate and is signed as Indian Hill Road.

JERICHO

Established in about 1880, a small settlement named Jericho grew around a station established along a coach line in what would become known as the Jericho Gap section of the Texas Panhandle. With completion of the Chicago, Rock Island, and Gulf Railway through the gap, and establishment of a station in 1902, the little community received legitimacy with approval of its application for a post office.

Establishment of the Ozark Trails Highway system (Route 66 after 1926) fueled growth, and by 1930, the little town of Jericho had a population of nearly 100 and a business district that included several stores, a grain elevator, an auto court, and a garage–service station complex. It was during this era the legend of the Jericho Gap was born.

The rich black soil in the shadow of Old Trails Ridge was either powder-dry or, with rain, a sea of gluelike gumbo. A traveler's journal from the late 1920s noted spinning tires, deep ruts, and mud building in the fenders to such a point the wheels would no longer turn. Guidebooks of the era suggested travelers carry a shovel, tow chain, and block and tackle.

Even with these tools, once stuck, most travelers required a team of horses or tractor to extricate themselves from the mud. This led to rumors that farmers were flooding the road on purpose to make money off the travelers' need for help.

The era of Route 66's association with the Jericho Gap was relatively short, since a bypass to the north was completed in 1934. The old town of Jericho held on for a few years, but by 1955, the population no longer warranted a post office. Today, only a few forlorn, weathered buildings remain.

In Amarillo, the Rick Husband International Air Terminal severs the Route 66 corridor. Therefore, city guides suggest following I-40 to Business Loop 40 and then taking Amarillo Boulevard, the later four-lane alignment of Route 66. At Taylor Street, turn south to 6th Avenue, a delightful one-mile corridor of shops, galleries, and eclectic restaurants housed in architecturally interesting buildings, some of which predate Route 66.

An unassuming treasure found along this 6th Avenue corridor is the Golden Light Café. This little gem has the record for the longest continuous operation of any restaurant on Route 66 in the city—its doors opened in 1946.

Route 66 Store, Amarillo

Route 66 in Amarillo

DON'T MISS

Sites to see in **Amarillo** include the following:

- The San Jacinto district between Georgia and Washington Streets on 6th Avenue, featuring a wide array of architecturally fascinating buildings, many of which predate Route 66;

- The Santa Fe Railroad Building (900 South Polk Street), built between 1928 and 1930 at a cost of $1.5 million;

- The Nat Ballroom, known locally as the Natorium (just off 6th Avenue on Georgia Street) built in 1922—before its recent transition to an antique mall, it served as the concert venue for a wide variety of performers, from Duke Ellington and Tommy Dorsey to Joe Loesch and the Road Crew at the 2011 Route 66 International Festival.

THE STAKED PLAINS

From Amarillo west, Route 66 (signed as Indian Hill Road) serves as the north frontage road for I-40. The suburbs give way to large swaths of dry farms. Signposts for Bushland and Wildorado hint at a real community, but neither really is.

Vega, however, is a veritable cornucopia of Route 66 treasures. With a turn north on US 385, you can access the original alignment of Route 66 that skirted the courthouse. In this district, you will find a roadside masterpiece in the form of a restored 1920s Magnolia Oil service station, a small-town hardware store called Roark's that has been in operation for more than seventy years, and a courthouse square in a parklike setting. As a bonus, near the dead end of West Main Street (another segment of original Route 66), you'll find Dot's Mini Museum.

From Vega, Route 66 shadows I-40 as it passes by vast farmlands before entering the quaint and quiet hamlet of Adrian. The small park contains a massive sign proclaiming this as the Route 66 midpoint between Chicago and Santa Monica. The café across the street is appropriately named the Midpoint Café.

The café has roots dating to 1956. Today, especially during the busy season between April and October, the parking lot is often jammed, the café filled to capacity, and a string of cars and motorcycles parked along the highway. For travelers from dozens of countries, as well as locals, this is one of the most famous restaurants on Route 66.

First-time visitors to the nondescript Midpoint Café are often overwhelmed by the sea of tourists who have stopped in for a slice of the café's signature ugly crust pie or to browse the gift shop. The food offered is basic American fare, and the prices range from reasonable to moderate.

From Adrian to exit zero, just east of the New Mexico state line, I-40 is the only option. Most of Route 66 here lies under that highway's concrete, and the earliest alignment is now a rutted dirt road on private property. Still there is one more surprise, and in my humble opinion, it is one of the most fascinating stops on Route 66 in Texas: the ghost town of Glenrio.

Turn south at exit zero and in an instant, you'll see a four-lane segment of Route 66 flowing to the west, which originally served as this now-empty community's main street. With a population that hovers near five, an overgrown dividing island, empty service stations and cafes, and a motel where the wind plays haunting tunes as it passes through the glassless windows, a stop in Glenrio is truly a memorable experience.

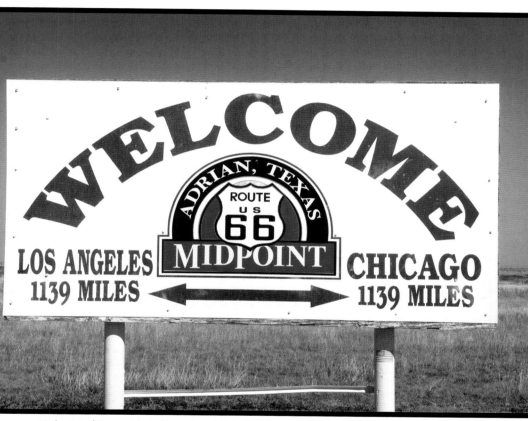

Midpoint of Route 66, Adrian. *David P. Smith/Shutterstock.com*

WILDORADO

Wildorado once had a reputation that garnered headlines throughout the nation on a regular basis. The *Syracuse Herald* addressed the unsavory nature of the town in a January 29, 1928, feature entitled, "Wildorado: Texas Town Plundered So Many Times that Six Shooters No Longer Terrorize."

"The Wildorado State Bank has been robbed eight times in the last three years, and the general store next door has been visited by bandits so frequently that the proprietors have lost count of the number of times they have looked down revolver barrels."

The article also noted, "The latest robbery of the bank occurred when two youths, armed to the teeth, entered the building. Sharp shooting citizens of the town had gathered quickly and captured one of the bandits. They were forced to release him when his partner threatened to kill O'Neal, the bank president.

"One of the men participating in the attempted capture of these bandits was the night watchman, who killed one robber and wounded another in a recent gun battle during an attempt to rob the Wildorado Grain and Mercan-tile Store."

In May 1933, robbers again targeted the bank. This time they destroyed much of the interior through their efforts to remove the one-ton safe from the building through the front door!

GLENRIO

A fast-fading adobe service station that hugs the New Mexico state line, a small diner, an old service station, and the vestiges of the Texas Longhorn Motel Café, which was promoted with a sign reading "Last Stop in Texas" on one side and "First Stop in Texas" on the other, are about all that remain of Glenrio. It strains the imagination to think that in 1920 this town supported a railroad depot, a hotel, a land office, a newspaper, a grocery store, several restaurants, a hardware store, and numerous service stations and garages.

It is also difficult to imagine that this dramatic transition from vibrant community to ghost town occurred in less than a dozen years. With the completion of I-40, which bypassed the community in 1975, the town quickly withered, and now the population hovers at five.

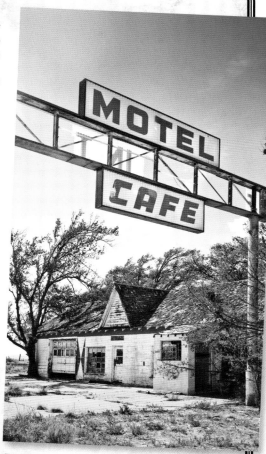

Texas Longhorn Motel Café, Glenrio.
Andrey Bayda/Shutterstock.com

In 2007, the seventeen remaining buildings that constituted the business district and the four-lane roadbed of Route 66 received recognition with listing on the National Register of Historic Places.

CHAPTER 6

NEW MEXICO

Route 66 in New Mexico is all about making choices, taking detours, following short loop drives, and creating memories. This theme begins at the New Mexico–Texas state line. Here you have the option of following the pre-1950s alignment, now an occasionally graded county road through the ghost town of Endee to San Jon, or the later alignment, a paved road accessed from exit 369 on I-40.

My suggestion—depending on road conditions, type of vehicle, and time constraints—is to take in the highlights with a loop drive. Start with a cruise along the empty four-lane segment of Route 66 in Glenrio, Texas, continue carefully west along the gravel segment to San Jon, pick up the later alignment north of I-40, backtrack on this to exit 369, and then take I-40 back to San Jon. The rewards of taking this little loop drive are numerous.

Route 66 in New Mexico. *Jonas Jensen/Shutterstock*.com

THE PLAINS OF LLANO ESTACADO

The ghost town of Endee west of Glenrio presents numerous photo opportunities. These are often enhanced by deer and other wildlife, usually seen early in the morning.

Entering San Jon from the east reveals a three-dimensional picture of why Route 66 was once promoted as the Main Street of America. The old road sweeps into town as a now-empty four-lane highway shadowed by equally empty cafés, garages, motels, service stations, and one motel that hangs onto life by the thinnest of threads.

In 1946, Jack Rittenhouse noted that San Jon offered an array of amenities, including gas stations, the San Jon Garage, the San Jon Implement Company, two auto courts, several cafés, a hotel, and numerous stores. He also noted that "San Jon is still a center where cowboys can come for Saturday night relaxation, and has performed this function for over two generations."

At the east end of the later alignment of Route 66, north of I-40 at exit 369 near the site of the ghost town of Bard, is Russell's Truck and Travel Center, a wonderful blend of modern travel plaza–truck stop and vintage roadside general store. As a bonus, Russell's has a free automobile museum on-site.

Russell's Truck and Travel Center, Glenrio. *Judy Hinckley*

ENDEE

In 1946, the old town of Endee, nestled on a brush-covered knoll just west of the Texas state line, was little more than a dusty oasis that offered travelers the most basic of services. Jack Rittenhouse noted that there was a gas station with a small garage, a grocery, and a "scant handful of cabins."

From its inception in 1886, Endee was a hardscrabble community of tough individuals. A report from 1890 noted that most houses were built using upright poles for walls and sod-covered poles for roofs.

The dawn of a new century made little difference in Endee, where the rough-and-tumble frontier lifestyle was firmly rooted. In 1906, one of the last horse-mounted posses captured a gang of outlaws involved in a major cattle-rustling enterprise. In the summer of 1909, a band of mounted cowboys rode their horses into the middle of a temperance meeting shooting and shouting.

Today, Endee is little more than a forlorn ruin along an abandoned rail line and a dusty segment of pre-1950s Route 66. It is one of the places on Route 66 where the silence is so deep that you can practically hear the whispers of its ghosts.

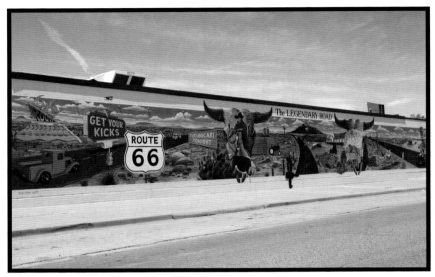

Route 66 mural, Tucumcari. *J. Norman Reid/Shutterstock.com*

After returning to San Jon, you can resume your Route 66 adventure by following that old highway on its scenic course as it cuts away from I-40, drops down off the cap rock mesa, and runs past the remnants of an old service station and out onto a sweeping plain, where Tucumcari Mountain looms on the horizon. You cross the interstate before Route 66 flows into Tucumcari as a wide boulevard flanked by all manner of roadside businesses representing almost a century of societal evolution.

This community has lost almost half its population over the past thirty years, a decline that is evident in the empty storefronts, restaurants, and motels that line the Route 66 corridor. But in recent years, Tucumcari has put forth a valiant effort to stem this tide of abandonment and decay. The town is still a treasure trove of vintage roadside haunts, some with stunning displays of refurbished neon, and its innovative mural program presents the illusion of life and vitality even on empty buildings.

You'll find a number of fascinating attractions here. Among these are the Tucumcari Historical Museum on Adams Street and the Mesalands Community College Dinosaur Museum at 211 East Laughlin Street.

The old business district north of the Route 66 corridor, accessed via Highway 104 and US 54, is full of fascinating buildings. One of the more photogenic of these is the old train depot currently undergoing renovation.

If you plan to spend the night so that you can see the refurbished neon light up the desert sky, you have two period motels to choose from, as well

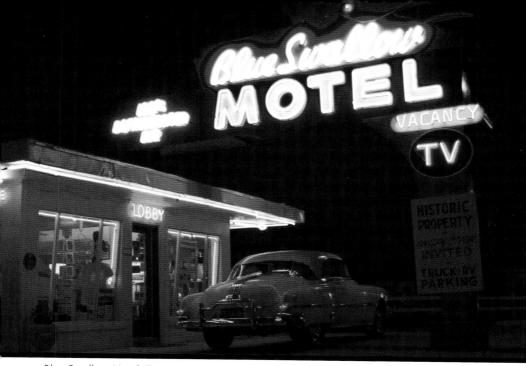

Blue Swallow Motel, Tucumcari

as several modern motels. The fully renovated Motel Safari dates to the late 1950s, and the overlay of modern amenities does not detract from the painstaking detail of the restoration. Across the street, the iconic Blue Swallow Motel (1939) is another time capsule restored with attention to detail to ensure modern conveniences do not intrude on the illusion. Here, the traveler steps back into the neon-lit world of 1940 roadside America.

Shortly after Route 66 rolls west from Tucumcari, past an overgrown motel and abandoned truck stop, the old road is truncated, forcing you to use I-40, at least to exit 321. (Use exit 311 if you are driving a motor home or if it has rained recently. A narrow, low tunnel often floods during periods of rain.) Often squeezed

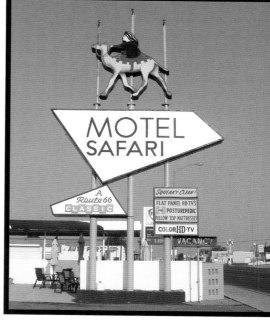

Motel Safari, Tucumcari

between the raised bed of the railroad and the blur of traffic on I-40, this segment of Route 66 appears suspended between the world immortalized in *The Grapes of Wrath* and that of today. The vast western landscapes and the haunting roadside relics, including the ghost towns of Montoya, Newkirk, and Cuervo, inspire the imagination and fuel visions of the road's glory days and the frontier era that preceded it.

Each of these old communities originated long before certification of Route 66 or creation of the U.S. highway system. The remnants from the territorial era present interesting photo ops, especially in Cuervo, a community neatly halved by I-40.

Cuervo

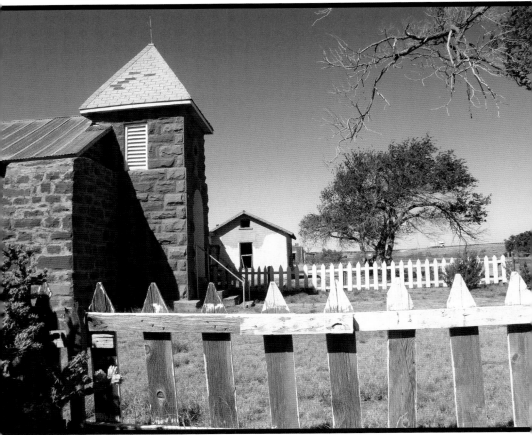

Unless one dares brave the old pre-1950 "Cuervo cut off" to Santa Rosa, now an overgrown tract of broken asphalt, gravel, and washouts, the only option is to take the interstate. In fact, from Cuervo to Moriarty, I-40 has decimated the old road, leaving little more than tattered vestiges at the exits—with the exception of Clines Corners, which is thriving quite nicely.

BLUE HOLE DETOUR

No visit to Santa Rosa is complete without a detour to the Blue Hole, a stunning natural wonder and a world-famous destination for scuba divers. The clarity of this artesian well is such that you can almost see the bottom through eighty feet of water from the stone observation decks built by the Civilian Conversation Corps (CCC) during the 1930s. The CCC also built the surrounding park.

From the east, Route 66 enters Santa Rosa as Will Rogers Drive but is signed as Parker Avenue in the city. At 4th Street, turn south and continue to La Padira where you will turn east after about a quarter of a mile. It should be noted this little detour is entirely along the earliest alignment of Route 66.

Blue Hole, Santa Rosa. *Sue Smith/Shutterstock.com*

Your one opportunity to experience a bit of the old road and its distinctive culture here is to cruise the various alignments that traverse Santa Rosa. Here, at every turn, links to more than a century of colorful history entice the traveler to slow the pace and explore. For the Route 66 enthusiast, the highlights are the Comet II restaurant and Joseph's Bar and Grill. A relative newcomer is the Route 66 Auto Museum, featuring an eclectic auto collection and fascinating gift shop.

ALONG THE OLD SANTA FE TRAIL

From Santa Rosa, you have two options, or the prospect of a very large loop drive. Before 1937, Route 66 followed the course of the Ozark Trails Highway north from a point near Santa Rosa to Romeroville and then over the course of the old Santa Fe Trail into Santa Fe.

With completion of a direct route to Moriarty and down Tijeras Canyon into Albuquerque, almost two hundred miles were lopped off the course of Route 66 in New Mexico. With the exception of the segment between Moriarty and Albuquerque, I-40 obliterated the old highway.

Before detailing that segment of the old road, I will outline a tour along the pre-1937 alignment to Albuquerque via Santa Fe. In my opinion, this stretch of Route 66, accessed by a slight detour, is one of the most fascinating segments of the entire highway.

On this drive, Route 66 is more than the former Main Street of America; it is an asphalt thread that links our earliest history, and even prehistory, with the modern era. It also passes through some stunning western landscapes.

From Santa Rosa continue west on I-40. The alignment of Route 66 used between 1926 and 1937, now a gravel track, is on private property, but you'll find a small portion of the roadway located at exit 267. You will need to make a slight detour from Route 66 by continuing to exit 256 and turning north on US 84. This highway overlays Route 66 from the quaint little village of Dilia north to exit 339 on I-25, with the exception of a short segment that goes through Romeroville, now a ghost town that served as the western terminus for the Ozark Trails Highway.

At exit 339 on I-25, Route 66 resumes its westward course through the Pecos River Valley, framed by the towering Sangre de Cristo Mountains, Tecolate Mountains, and Glorieta Mesa. The fact that it hugs the interstate highway does little to detract from the area's raw natural beauty and historical significance. Here, Route 66 often literally follows the ruts of the Santa Fe Trail and courses through dusty towns with histories that predate even that trail.

ROMEROVILLE

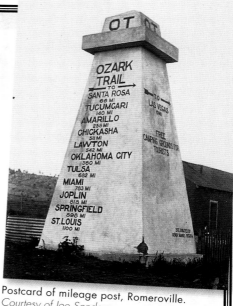

Today the hamlet of Romeroville is little more than a few homes and ruins embraced by the vast western landscape of New Mexico. There is nothing to indicate this was a haven for the rich and famous, men such as General William Tecumseh Sherman and President Rutherford B. Hayes. Nor is there any hint that this was once the key junction for the Ozark Trails Highway System and the National Old Trails Highway, or a service center for travelers on Route 66.

Postcard of mileage post, Romeroville.
Courtesy of Joe Sonderman

The town's namesake is a forgotten footnote to history. But considering the astounding accomplishments of Don Trinidad Romero, this omission from history texts is surprising.

Born in Santa Fe in 1835, Romero quickly adapted to the transition from Mexican to American rule and used his language skills and contacts to launch a successful freight company operating on the Santa Fe Trail. He followed this enterprise with the establishment of a large, profitable ranch south of Las Vegas at what would become Romeroville.

Romero proved to be more adept at politics than business. In 1863, he accepted a seat as a member of the Territory of New Mexico House of Representatives. He followed this with tenure as probate judge for San Miguel County, as representative of the Territory of New Mexico to the United States Congress from 1877 to 1879, and as U.S. Marshall from 1889 to 1893.

His palatial home in Romeroville, built for more than $100,000, served as the political and social center of northeastern New Mexico during the 1880s. Upon his death, it was transformed into a sanatorium that burned in 1930, seven years before bypass of the town by realignment of Route 66 sounded a death knell for the community that bore his name.

LAS VEGAS DETOUR

Travelers on the Ozark Trails Highway, as well as the pre-1937 alignment of Route 66, often considered the frontier-era metropolis of Las Vegas, New Mexico, a destination instead of a detour of a dozen miles or so. With origins in 1821, Las Vegas, on the old Santa Fe Trail, is today a delightful cacophony of historic districts with narrow, twisting streets and stunning architectural treasures.

Las Vegas also holds nondescript wonders like the Dice Apartments at 210 Old Town Plaza. Historians believe General Stephen Kearney stood on the roof of this building when he addressed the citizens in the plaza to proclaim New Mexico part of the United States in 1846.

The crown jewel of the more than 900 structures listed on the National Register of Historic Places is the Plaza Hotel, built in 1881. Except for the cars nestled against the curb, the view from the dining room, or from the saloon where Doc Holliday sent a cowboy to meet his maker, is unchanged from when Teddy Roosevelt hosted the first reunion of the Rough Riders here. Even though the large rooms provide travelers with twenty-first-century amenities, the ghosts of the past seem close enough to touch.

Fine museums, excellent restaurants, a wide array of quaint shops, and multigenerational businesses further ensure that this wonderful little town needs to be included on the list of destinations for every Route 66 enthusiast.

Tecolate dates to at least 1824. In 1850, the United States Army garrisoned here during campaigns against the Navajo. Bernal was the first stage station on the Santa Fe Trail east of Las Vegas, but historical evidence suggests initial settlement of the town may date to the mid-eighteenth century.

San Jose requires a very slight detour of less than five miles, but this truncated segment of early Route 66 is littered with treasures, including the picturesque steel truss bridge (1921) over the Pecos River, which now

Las Vegas, New Mexico

marks the road's end. Over its long life, San Jose's small adobe chapel has cast its shadow across the Santa Fe Trail, the National Old Trails Highway, and Route 66.

West of San Jose, Route 66 crosses I-25 and then crosses it again at Rowe, where it becomes Highway 63 on the northward trek to Pecos. Just south of this historic community, which now serves as a hub for hunters, hikers, and fisherman, is Pecos National Historic Park, a ruined pueblo that was once a thriving community where the Coronado expedition stayed in 1540.

From Pecos, Highway 50 becomes the modern incarnation of this early alignment of Route 66. The narrow old road twists its way through richly forested valleys and deep green meadows, one of which is the site of some old tumbledown log cabins, all that remains of Arrowhead Camp.

Immediately west of Arrowhead Camp, on the north side of the road, lies a landmark of particular note. In the shadow of Glorieta Pass, the desolate and weathered adobe structure that presses against the guardrail is all that remains of the Pigeon Ranch.

Established in the 1850s as a hostelry on the old Santa Fe Trail by a Frenchman who spoke only pidgin English, the Pigeon Ranch was used as a field hospital during the Battle of Glorieta Pass in the American Civil War in 1862 before morphing into a tourist attraction in the 1920s. Less well known is its second claim to fame, a stone-lined well on the south side of the road that may predate the Coronado expeditions and was the reason the Pigeon Ranch was built here.

Pigeon Ranch

GLORIETA PASS

Before extensive realignment of Route 66 in 1937, which resulted in bypass of the loop from Santa Rosa through Santa Fe to Albuquerque, Glorieta Pass at 7,500 feet was the highest point on that highway. That, however, is but small part of the colorful history associated with this pass.

Named during the survey expedition of Hernando de Coronado in 1542, the pass played a pivotal role in the events that culminated with the Mexican-American War. In 1841, before their capture, a wagon train of traders from Texas following the Santa Fe Trail to Santa Fe engaged in a pitched battle with the Mexican army at the pass.

On August 18, 1846, General Stephen H. Kearney overwhelmed the forces of General Manuel Armijo in the shadow of the pass. This proved to be a key moment in the conquest of the New Mexico territory.

One mile east of the village of Glorieta, on March 26, 1862, Major John M. Chivington of the Union Army engaged Confederate troops in fierce fighting that lasted two days. The old hostelry at the Pigeon Ranch served as a field hospital during the battle.

Civil War Reenactment of the battles of Glorieta Pass and Apache Canyon. *Education Images/UIG/Getty Images*

Before the 1937 realignment of Route 66, Glorieta Pass marked the highest point of elevation on that highway. This particular segment of the highway is now truncated by the interstate, so you'll have to rejoin I-25 at exit 299 and continue into Santa Fe.

A highlight of following the pre-1937 route is the city of Santa Fe, where, as Jerry McClanahan notes in *EZ 66 Guide for Travelers*, "The street names and one-way streets are confusing, so expect to get lost!" Here, however, getting lost provides an opportunity for discovery.

Exploring the various alignments of Route 66 in the city requires more than a few loop drives, because of the numerous one-way streets and changes that have occurred over the past eighty years. As an example, the earliest alignment used Galiste, De Vargas, San Francisco, and Don Gaspar, but now Don Gasper is a one-way southbound street. Other streets utilized by Route 66 before the 1937 realignment include Water, Palace, Ortiz, Cerrillos, and Old Santa Fe Trail. By 1931, rerouting of the highway bypassed the city's historic but congested plaza area.

Regardless, even something as exciting as seeking the course of Route 66 can be overshadowed by the treasures found in this ancient city. Officially established in 1610, Santa Fe's roots go even deeper, because the Spanish built their city on the ruins of the pueblo of Ogapoge, abandoned in about 1425 A.D.

Just in the area surrounding the plaza are buildings representing more than four centuries of history, with the Palace of the Governors, built in 1680, as the centerpiece. On the corner of East San Francisco Street and Old Santa Fe Trail the hotel La Fonda, built in a mission revival style in 1920, remains one of the city's premier hotels. An inn has stood on this site since at least the early eighteenth century.

Route 66 sign, Santa Fe. *Martha Marks/ Shutterstock.com*

Market at the Palace of the Governors, Santa Fe. *Shutterstock.com*

DON'T MISS

The wide array of attractions in **Santa Fe** can easily consume several vacations, and a few truly special places must be included on any visit to the city:

- Loretto Chapel (211 Old Santa Fe Trail), built between 1873 and 1878, the first stone masonry building in the city—the construction and design of the unsupported spiral staircase to the choir loft has baffled carpenters and engineers for more than a century;

- San Miguel Mission (401 Old Santa Fe Trail) survived the Pueblo Revolt of 1680, was rebuilt in 1710, had the altar remodeled in 1798, and is the city's oldest church;

- Museum of New Mexico History (105 East Palace Avenue), with a variety of exhibits, including "archeological windows" left by recent renovations that weave an entrancing tapestry of the area's colorful history;

- Institute of American Indian Arts Museum (108 Cathedral Place), the largest repository of American Indian art in the world—five galleries with revolving exhibits as well as a beautiful sculpture garden.

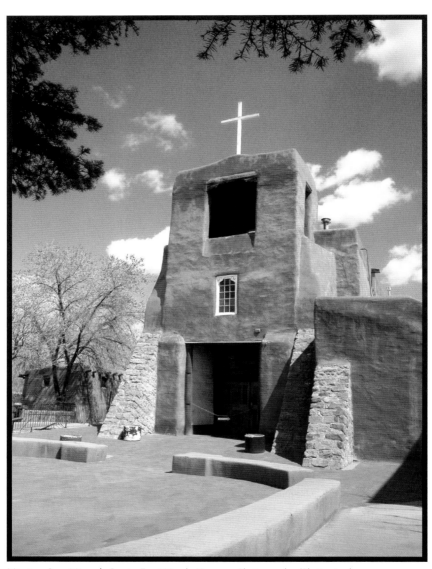

Mission San Miguel, Santa Fe. *Wendy Kaveney Photography/Shutterstock.com*

ALL ROADS LEAD TO ALBUQUERQUE

From Santa Fe to Albuquerque, time and abandonment have rendered large segments of old Route 66, both the 1926–1932 alignment and the 1932–1937 alignment, impassable or inaccessible. Traces of the old road—as well as the El Camino Real that predates Route 66 by centuries—still survive in the ancient villages nestled between the cities.

LA BAJADA HILL

LA BAJADA HILL, NEAR SANTA FE, NEW MEXICO

Courtesy of Joe Sonderman

The first incarnation of Route 66 linking Santa Fe with Albuquerque utilized a road down the face of La Bajada Hill that had been "improved" for automotive traffic in 1909. This roadway dropped eight hundred feet in 1.6 miles through a series of twenty-three switchbacks.

These improvements, however, were merely the latest in an evolutionary series that mirrored the changing face of the New Mexico landscape. Construction of the initial roadway down this steep escarpment, the Camino Real de Tierra Adentro, commenced in about 1640 to link Santa Fe with the Spanish colonial empire in present day Mexico. In the years that followed, the road met the needs of Spanish, Mexican, and American pioneers and the military. Emily Post even drove it during her epic adventure of 1916.

In the memoirs of her adventure, *By Motor to the Golden Gate*, she wrote, "The best commentary on the road between Santa Fe and Albuquerque is that it took us less than three hours to make the sixty-three miles, whereas the seventy-three from Las Vegas to Santa Fe took us nearly six. The Bajada Hill, which for days Celia and I dreaded so much that we did not dare speak of it for fear of making E. M. nervous, was magnificently built."

Today the old road is best traversed on foot, even though it is passable with a four-wheel-drive vehicle. For fans of the Double Six, the hill represents one of the most challenging segments of the old highway.

The village of Domingo, established in about 1770, is located three miles from the Santa Domingo Pueblo that Spanish explorers noted in their journals during the expedition of 1598. San Felipe is even older; Coronado noted a pueblo at this site in 1540, and a colonial outpost was established in about 1620.

At exit 248 on I-25, the Route 66 adventure can continue on the old road, now signed highway 313. This highway—and in places the El Camino Real as well—passes through Algodones and Bernalillo and into Albuquerque on 4th Street.

The theme of antiquity continues on this portion of Route 66. The village of Bernalillo was built over a Tiwa pueblo that served as the winter encampment of the Coronado expedition of 1540. The earliest reference to Real de Bernalillo dates to a 1696 report, and its Las Cocinitas district contains buildings dating to 1690.

As you enter Albuquerque on 4th Street, the course of the original alignment of Route 66 runs through the Barelas-South 4th Street Historic District, one of the city's oldest areas. Tangible links to more than 150 years of history are found here. From the peak Route 66 era are a former Hudson dealership garage and a former Magnolia Oil station.

The post-1937 alignment remains intact from Moriarty, a quaint little town with some interesting survivors, through the old communities of

San Felipe de Neri Church, Old Town, Albuquerque. *Shutterstock.com*

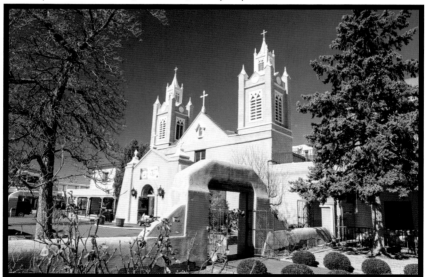

Edgewood and Barton, down Tijeras Canyon (where urban sprawl reigns supreme), and into Albuquerque on East Central Avenue. In fact, with the crush of traffic along East Central Avenue, this is a veritable Route 66 time capsule from 1961, when the *Albuquerque Journal* noted this corridor presented the "greatest traffic slowdown in the entire 2,000-mile length of Route 66."

DON'T MISS

Some of the best of the best in **Albuquerque**:

- Old Town and its historic plaza mere blocks from Route 66—the historical heart of the city presents the illusion this is still a small Spanish presidio with quaint restaurants and shops on the banks of the Rio Grande; don't miss the San Felipe de Neri Church, built in 1793;

- The National Hispanic Cultural Arts Center (1701 4th Street SW), including a genealogical center and library, as well as several galleries featuring work from Hispanic artists;

- The New Mexico Museum of Natural History and Science (1801 Mountain Road NW), a state-of-the-art complex where learning about New Mexico's incredible natural history and geology is never boring—includes a display that mimics a volcanic eruption;

- ABQ BioPark (2601 Central Ave NW), consisting of three separate facilities on the banks of the Rio Grande: the Albuquerque Aquarium, Rio Grande Zoological Park, and Rio Grande Botanic Garden;

- The 2.7-mile Sandia Park Aerial Tramway, accessed from East Central Avenue (Route 66)—the longest tramway in America, providing stunning views of the city and surrounding area on the ride up as well as from the 10,378-foot summit, where a wonderful restaurant provides another opportunity to satisfy the appetite.

The Central Avenue corridor still features numerous roadside businesses from the golden era of Route 66. Of particular interest to enthusiasts are the Hiland Theater and Shopping Center (1952), the recently renovated Kimo Theater (1927), and El Vado Motel (1937), closed as of this writing. The Monterey Non-Smokers Motel (2402 Central Avenue SW) opened in 1946 as Monterey Court and still receives favorable recommendations in travel guides.

THE TECHNICOLOR LAND

From Albuquerque there are two distinct options to continue your Route 66 adventure. You can follow the pre-1937 alignment that loops south along the Rio Grande River before turning west near the ancient Isleta Pueblo (Highway 47 and Highway 6), or you can continue west on Albuquerque's Central Avenue and then along a segment that now serves as a frontage road for I-40. Of course, you can always take the loop drive, if your schedule allows.

St. Augustine Church, Isleta Pueblo

The primary highlights along the early alignment are the Isleta Pueblo, about thirteen miles south of Albuquerque, and the Luna Mansion in Los Lunas, which was built in 1881 and now serves as a fine-dining restaurant. The pueblo's modern life dates to the establishment of a post office in 1882, but its origins predate this by centuries—a Spanish colonial expedition in 1540 noted a village at this site. (Please note that visitors are welcome to visit the historic plaza and church, but rules regarding photography are strictly enforced.)

On the later alignment, the 1933 Rio Puerco Bridge, now closed to vehicular traffic near the Route 66 Casino, and the old Enchanted Trails Trading Post and RV Park are two places to visit. The latter encapsulates Route 66's modern revival in a most charming way. The original structure houses a gift shop, a laundry, offices, and related services, but the real treasure is in the RV park itself, where owner Vickie Ashcraft transformed refurbished vintage travel trailers into motel rooms.

From a point just past the historic Rio Puerco Bridge, at exit 140, the jaunt westward requires use of I-40 to exit 117 at Mesita. From there to Continental Divide (exit 47), old Route 66 twists and turns across colorful landscapes with towering bluffs and through quiet villages and ghost towns before finally reaching the tarnished mining town of Grants.

As with any journey across New Mexico, the theme of antiquity looms large. For example, there is no certain date of origination for the pueblo at Laguna, but Spanish expedition reports reference an established community here as early as 1540. Construction of the current pueblo commenced in 1698, and the San Jose Mission was built the following year.

Immediately west of the forlorn remnants of Budville, look for a small road that turns north to the village of Cubero, an ancient town bypassed with the highway's realignment in 1937. Littered with picturesque ruins of adobe set against stunning backdrops of buttes, mesas, and haciendas, Cubero provides few hints of the history that unfolded here. Early maps indicate a village at this location as far back as 1776. This fascinating little detour rejoins the latter alignment at Villa de Cubero, a nondescript complex consisting of an old auto court (now closed) and a small store in the former trading post, owned by Wallace and Mary Gunn.

From Villa de Cubero, the old highway continues to shadow I-40 across quintessential western landscapes. The only intrusion in the seemingly timeless landscape, aside from the interstate highway, is Grants, a town where evidence of times gone by overshadows signs of recent growth or development. Still, this dusty old mining town holds a few surprises for the traveler as well as many photo opportunities. Topping the list of attractions, the New Mexico Mining Museum at 100 North Iron Avenue has a fascinating array of displays ranging from mining equipment to minerals, as well as a re-created mineshaft.

At Continental Divide, exit 47 on I-40, you once again return to the modern era, because the interstate has buried Route 66. However, the detour is relatively short, as the Route 66 odyssey resumes at exit 36 near Iyanbito.

CUBERO

The first reference to a European village—built on the site of a former Native American village—at Cubero dates to a 1776 map produced by cartographer Bernardo Miera y Pacheco. For the next century, the little village developed a well-deserved reputation as a haven for outlaws and renegades of all stripes, as well as an occasional military outpost when the armies of Mexico, and then America, staged campaigns against the Indians in the area.

During the era of the National Old Trails Highway, predecessor to Route 66, the flow of tourists traveling by automobile in western New Mexico inspired Wallace and Mary Gunn to establish a trading post in Cubero. In exchange for coal oil, flour, and other staples, the Gunns accepted native handicrafts of jewelry, pottery, and rugs that were then sold to tourists.

Shortly after the realignment of Route 66 in 1937, the Gunns relocated their trading post to a new facility with an auto court at the junction of the two alignments west of town. The scenic and remote location made it a favored escape for movie stars working in the area of Gallup.

As word spread, Villa de Cubero became a haven for the rich and famous. The lengthy guest list includes Gene Tierney, Desi and Lucy Arnaz, and the Von Trapp family. Ernest Hemingway resided here for two weeks and, purportedly, wrote much of *The Old Man and the Sea* while in town.

Ruins at Cubero

ACOMA

Accessed via a paved road that runs south from I-40 at McCarty's (or the Sky City Casino exit west of Laguna) is the village of Acoma. Perched high atop a 365-foot mesa, Acoma, dubbed the sky city, is one of the oldest continuously inhabited communities in the United States with a confirmed history to at least A.D. 1150.

About a dozen families still reside on the hilltop without electricity or running water, access some of the two and three story buildings by ladder, and collect rainwater in cisterns carved in the stone more than eight centuries ago. The residents are charged with maintaining the buildings because the village plays an important role in tribal ceremonial events.

A "modern" intrusion in the village is the Esteban del Rey Mission, built in the early seventeenth century. Under the direction of Friar Juan Ramirez, Indian laborers carried all construction materials, including soil for the cemetery, to the summit from the valley below.

At the Sky City Cultural Center located at the base of the mesa, you can buy a photography permit, hire a guide, or schedule a tour.

Josemaria Toscano/Shutterstock.com

NATIONAL MONUMENT AND PUEBLO DETOUR

Grants is at the center of a diverse group of attractions that make excellent day trips:

- El Malpais National Monument, a stunning land of old lava flows that surround islands of colorful sandstone;

- El Morro National Monument, a towering sandstone spire in a forested park crowned by the ruins of an ancient Indian village where centuries of travelers—from Juan de Onate in 1605 to Lieutenant Edward Beale in 1857—carved their names in the soft rock above the springs;

- Zuni Pueblo, a living time capsule where the line of unbroken habitation spans more than seven centuries.

Path to Inscription Rock, El Morro National Monument. *Jeffrey M. Frank/Shutterstock.com*

Continental Divide sign, New Mexico

Shortly after returning to your cruise along the old Main Street of America, the highway sweeps into Gallup, where the old, the new, and the ancient cast long shadows at sunset. Real trading posts deal in Native American handcrafted items and are housed in buildings that predate Route 66. Vintage and modern motels, cafés in business since the 1920s, and modern fast food joints, museums, and of course, the El Rancho Hotel, ensure that a drive through Gallup will inspire exploration.

The El Rancho Hotel, built by R. E. Griffith, opened in December 1937. The stunning hotel captured the essence of the western frontier with its "ranch house rustic" lobby and provided guests with the most modern amenities. As a relative of movie mogul D. W. Griffith, R. E. Griffith received some promotional help in making the hotel a haven for the rich and famous and the area the center of a burgeoning movie industry. The association with stars of the silver screen is commemorated today with rooms named for the celebrities who frequented the hotel: John Wayne, Ronald Reagan, Kirk Douglas, and Kathryn Hepburn, to name but a few.

The drive to the Arizona state line from Gallup along old Route 66 is relatively short, in part because the modern incarnation, State Highway 118, curves to the north away from the original course of the Double Six, which lies buried under the concrete and asphalt of I-40. Still, the drive from Gallup to Lupton, Arizona, where you will return to the modern interstate highway, provides some of the most breathtaking natural scenes yet encountered on your journey west.

Rancho Hotel, Gallup. *Judy Hinckley*

CHAPTER 7

ARIZONA

Except for the longest remaining uninterrupted section of Route 66 that flows into the desert at the western edge of the state, the course of the highway in Arizona runs broken and segmented, which means you will have to drive long distances on I-40 and get your kicks in small doses. Even though this can make it difficult to maintain that Route 66 state of mind, the old highway in Arizona traverses some of the most spectacular landscapes in America, and the detours are some of the most amazing found between Chicago and Santa Monica.

Route 66 sweeps into the Grand Canyon State in the shadow of towering walls of stone and past trading posts like Chief Yellowhorse, which hark back to the glory days of the Double Six. All of this sets the stage for an adventure that culminates on the banks of the Colorado River, the border between Arizona and California.

Route 66 in Arizona. *Expression Photo/Shutterstock.com*

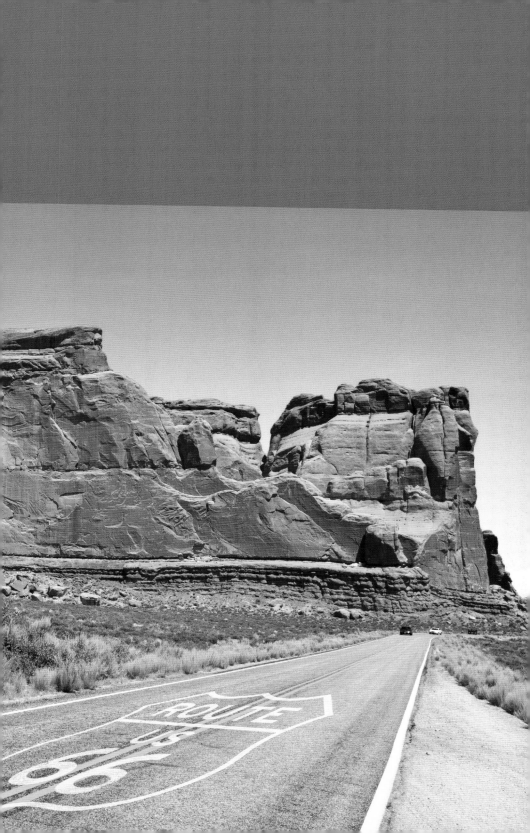

THE BROKEN ROAD

In the eastern part of Arizona, Route 66 must be driven in short segments: from exit 359 to exit 351, from exit 348 to exit 341, and from exit 339 to exit 333. Still, each forlorn remnant of the old highway is full of surprises.

South of exit 351 on a segment now turned to gravel, a quaint little bridge built in 1923 once carried Route 66 traffic across the Rio Puerco until 1931. Another bridge of the same era can be found near Sanders, and between exits 346 and 341, on the formerly paved segment used after 1931, you'll find the beautiful 269-foot Querino Canyon Bridge, built in 1930.

The dusty little towns along old Route 66 provide additional treasures. In Sanders, an old Valentine Diner, originally located in Holbrook, still serves as a café. In Chambers, picturesque ruins and empty old businesses provide hints of better times, when Route 66 funneled traffic through the center of town.

The truly awe-inspiring landscapes in this portion of Arizona have lured tourists since before Arizona became a state. For example, the town of Adamana, on the National Old Trails Highway just south of the original alignment of Route 66, was established in 1896 as a departure point to the Petrified Forest for tourists on the Atchison, Topeka and Santa Fe Railway.

Originally Route 66 swept across the colorful plains of the Painted Desert north of the current course of I-40. Incorporated into the Petrified Forest

Petrified Forest National Park. *Frank Bach/Shutterstock.com*

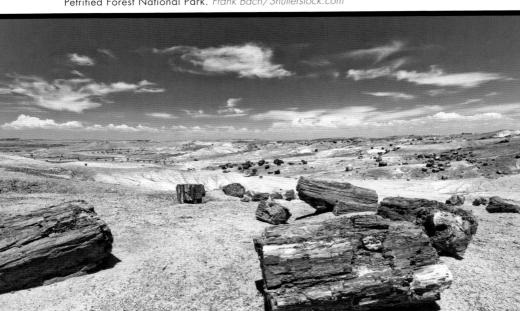

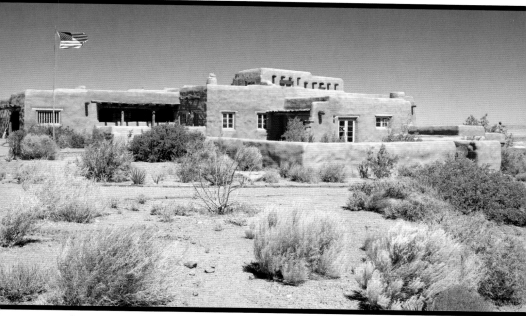

Painted Desert Inn at Petrified Forest National Park. *iStockphoto*

National Park, this segment is largely off-limits. However, a vestige of the old road remains in the museum and visitor center two miles north of I-40 on the park loop road. Built in 1924, this facility was originally the Painted Desert Inn, and later, a Fred Harvey Company enterprise.

Holbrook is the gateway city to the Petrified Forest National Park and preserves the past with dusty relics from the frontier era, as well as from the golden era of Route 66 in the 1950s. The town boasts two classic motels—the recently refurbished Globetrotter Lodge, which opened in 1956 as part of the Whiting Brothers chain, and the iconic Wigwam Motel—a couple of truly classic diners, and even a few rock shops reminiscent of the roadside era immortalized in the film *The Long, Long Trailer*.

The old Navajo County Courthouse, built in 1898, now serves the community as a museum chronicling the area's colorful history. The courthouse was only a year old when Sheriff Frank Wattron received a personal reprimand from President William McKinley for sending out invitations that read, "George Smiley, Murderer – His soul will be swung into eternity on December 8, 1899 at 2 o'clock P.M. sharp. The latest improved methods of scientific strangulation will be employed and everything possible will be done to make the surroundings cheerful and the execution a success."

(Continued on page 182.)

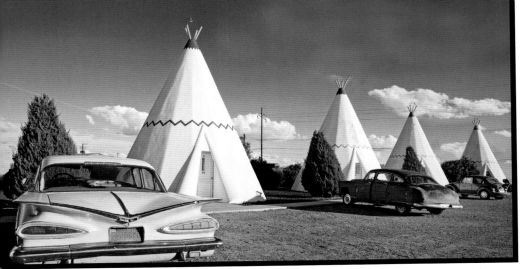

Wigwam Motel, Holbrook. *Carol M. Highsmith's America, Library of Congress, Prints and Photographs Division*

HOLBROOK

Long before Holbrook became a Route 66 boomtown or a dusty, tarnished relic bypassed by the interstate highway, it was a boisterous town at the center of vast cattle ranching empires, with a reputation for violence that exceeded that of Tombstone. Appointed to bring law and order to the town was Commodore Perry Owens, sheriff of Apache County, and veteran of the brutal Pleasant Valley War.

Owens gave the impression of being a bit of a dandy, something that caused the citizens of Holbrook concern. They openly wondered if he was up to the task. All concerns vanished, and Owens became a legend, in 1887 when he rode to the Blevins home on Center Street to serve a warrant for horse theft.

Andy Cooper, a guest at the home, assumed incorrectly that Owens was there to arrest him for the murder of two men in Pleasant Valley. Before Cooper could fire at Owens through a slightly opened door, the sheriff, armed with a Winchester, put two bullets through the door, and the outlaw fell mortally wounded.

When the smoke cleared that afternoon, Owens was unscathed. At the Blevins home, three outlaws lay dead, along with an overeager fourteen-year-old boy who had grabbed the revolver from Cooper's body.

HOLBROOK LOOP DETOUR

With Holbrook at its start and finish, a sixty-mile loop drive near the town will provide memories to last a lifetime and enough photo opportunities to fill several memory cards. To ensure the adventure is not rushed, I suggest you reserve a room and make a day of the drive.

Your trip begins with US 180 and a cruise through Holbrook, past the beautiful cut stone railroad depot, and out onto vast high desert plains after crossing the Little Colorado River on a beautiful old bridge. Twenty miles from town, turn north on the loop drive through the Petrified Forest National Park, and the return trip will be on I-40. The drive through the park is a distance of twenty miles.

The south end is anchored by the Rainbow Forest Museum, the north by the former Painted Desert Inn. In between are stunning and colorful landscapes dotted with a forest turned to stone that stretches to the horizon in all directions.

Voyageur Press collection

(Continued from page 179.)

To continue the westward journey from Holbrook, you must resort to I-40, but the interstate has not managed to sweep all traces of the old road away. At exit 280, the old Geronimo Trading Post has the dubious distinction of being one of the few Route 66 businesses in eastern Arizona to have survived into the modern era and to have its own exit. The claim to fame continues to be the "World's Largest Petrified Log" at an estimated 89,000 pounds.

Between Holbrook and Winslow, there is but one accessible segment of Route 66, between exits 277 and 269. But nestled along this portion of the highway is a unique and legendary establishment: the Jack Rabbit Trading Post. Opened in 1949, the trading post still employs its simplistic roadside promotion of yellow signs adorned with the black silhouette of a long-eared rabbit.

Just west of the Jack Rabbit Trading Post, I-40 again buries the old pavement of Route 66, and you can't resume your trip until exit 257 at the intersection with highway 87, a few miles east of Winslow.

The Route 66 corridor (3rd Street westbound, 2nd Street eastbound) through Winslow is a delightful cornucopia of time capsules from both the territorial era and Route 66's heyday. Among the many treasures awaiting discovery in this historic railroad town, two in particular are popular destinations for legions of international travelers.

At the intersection of Kinsley and Second Street, the Standin' on the Corner Park is more than a Route 66 photo opportunity. It is a monument to creative marketing and the transformation of disaster into opportunity. The centerpieces of the park are a beautiful two-story mural by acclaimed artist John Pugh that appeared on the east wall of the J.C. Penney building (which burned in 2004), a life-sized sculpture of a musician by Ron Adamson, and, of course, a vintage flatbed Ford. The park is a three-dimensional portrayal of the Eagles song "Take It Easy!"

Jack Rabbit Trading Post sign

Standin' on the Corner Park, Winslow

At 303 East Second Street, the majestic La Posada Hotel, the last of the great Harvey House hotels built, again welcomes visitors. This stunning facility consisting of hotel, restaurant, and gift shop on landscaped grounds dates to 1928. Listed on the National Register of Historic Places in 1992, the fully refurbished La Posada came very close to becoming a historical footnote, since it was scheduled for demolition after the Santa Fe Railroad restructured and relocated operations. The property consistently receives highly favorable reviews and should be considered a "must stop," even if just for lunch or pictures.

LA POSADA

Built in 1929 for the Fred Harvey Company and listed on the National Register of Historic Places in 1992, La Posada in Winslow remains a premier example of the now classic Harvey House facility. Acclaimed architect Mary Colter designed the entire complex to present the illusion that this was an aging Spanish colonial era estate.

Attention was given to landscaping, the selection of flagstone for the floors, and the color of the stucco and roof tiles, as well as to the decorative components. Planks to be used for doors and window shutters were sandblasted, and iron rajas adorning the windows and wrought-iron railings for the staircases were manufactured locally.

In 1959, the Santa Fe Railroad transformed the beautiful complex into offices for a regional headquarters. Shortly after it closed and a demolition order was issued, the property received recognition for its historical significance, and restoration commenced in 1997. Today the hotel and award-winning restaurant preserve the vision of Mary Colter and the visionary customer service of Fred Harvey.

Judy Hinckley

THE LAND OF TALL PINES

Driving west from Winslow to exit 211 at Winona, I-40 is your only option. Again, Route 66 must be experienced in small doses.

At exit 239 you'll find the first of these roadside treasures. The Meteor City Trading post (closed as of this writing) is the latest incarnation of a string of trading posts at this site. The big claim to fame, and an excellent photo opportunity, is a long map of Route 66 originally painted by acclaimed artist Bob Waldmire. Until completion of the Route 66 map at the El Trovatore Motel in Kingman, this was the "World's Longest Route 66 Map."

Accessed from exit 233, Meteor Crater is the site of a tremendous prehistoric meteor strike and now a fascinating mineralogical museum. Here too, along a segment of old Route 66 that is now little more than broken asphalt and gravel, are the towering and picturesque ruins of the Meteor Crater Observatory and American Meteorite Museum that opened in the late 1930s.

Two Guns, accessed from exit 230, is a real roadside gem and will provide at least a full day's worth of photo opportunities. Once a vast complex of real

Meteor Crater, near Winslow. *Mark Higgins/Shutterstock.com*

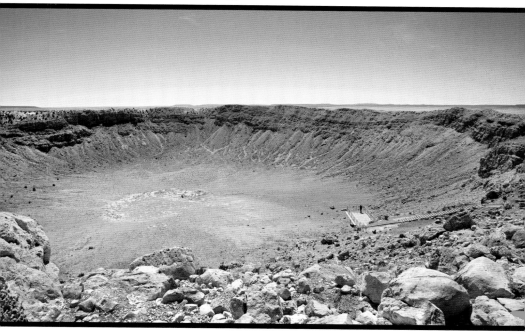

TWO GUNS

World-famous Route 66 attraction Two Guns was originally built along the National Old Trails Highway Bridge spanning Canyon Diablo to capitalize on the area's stunning beauty and a frontier era legend (based on fact) about a nearby Apache death cave. Originally established in 1915 by Ed Randolph, the property evolved in direct correspondence with the amount of traffic passing by.

In 1924, Earl Cundiff bought the property and built the Canyon Lodge, a complex consisting of a store, campground, and cottages. Establishment of a post office occurred the following year, and Cundiff leased a section of the property to a colorful local character, Harry "Indian" Miller, who claimed to be half Apache. Miller set up a small rock and curio shop, named his place Two Guns, and began calling himself Chief Crazy Thunder. With certification of Route 66 in 1926 and expansion that included a pueblo-styled zoo with animals native to the area, a café, and fake ruins in the death cave, Miller's business soon overshadowed that of Cundiff.

The ensuing dispute over the lease and property boundaries came to a violent end on March 3, 1926, when Miller gunned Cundiff down. The resulting trial put Miller and Two Guns on the front pages of newspapers throughout the country. Miller was acquitted, even though Cundiff was unarmed, and then he was again arrested for defacing Cundiff's grave after he attempted to erase "Killed by Indian Miller" from the headstone.

Miller sold the property soon after and established another tourist outpost, the Cave of Seven Devils, now Fort Chief Yellowhorse Trading Post, at the Arizona line near Lupton.

Judy Hinckley

and re-created ruins, wildlife zoo, and trading post, the ruins of Two Guns, nestled on the edge Canyon Diablo, are a photographer's dreamland. To the west, the often snow-covered San Francisco Peaks loom on the horizon. Fields of colorful stone broken only by the Canyon Diablo gorge, I-40, and the National Old Trails Highway (marked by a beautiful concrete bridge that spans the canyon) dominate the landscape. This site's murderous and colorful history is detailed in the sidebar. If exploring the area, use caution. The ruins are not stable, nails and broken glass litter the grounds, and during the summer months, this place is a haven for rattlesnakes.

Your next excursion into the world of Route 66 begins at exit 219. Here you'll find the shuttered remains of the 1954 Twin Arrows Trading Post, which originally opened as the Canyon Padre Trading Post a decade or so before that. The post remained in operation until the 1990s and has survived exceptionally well preserved. The Hopi tribe has great plans for the property, including possible restoration of the trading post as an Indian marketplace or construction of a casino, but as of this writing, the trading post remains a relic lost among the pinion and juniper on the edge of Canyon Padre.

Twin Arrows Trading Post. *Sue Smith/Shutterstock.com*

Flagstaff from above. *Tim Roberts Photography/Shutterstock.com*

The first of two options for resuming your Route 66 odyssey is presented at exit 211 and the little roadside stop of Winona, immortalized in the Route 66 anthem penned by Bobby Troup. This is the pre-1947 alignment of Route 66, and with the exception of a slight detour at the old steel truss bridge at Walnut Canyon, the highway runs unbroken from here into Flagstaff.

Option number two is to continue west on I-40 to exit 204, and follow the post-1947 alignment of Route 66 into Flagstaff. The pavement here can be rather rough, but the gentle curves that wind through the east edge of the largest Ponderosa pine forest in the world are rather pleasant, especially during the summer, when most of Arizona is experiencing temperatures of well over 100 degrees.

Flagstaff presents an excellent opportunity to enjoy Route 66 as it once was. It is not just the numerous businesses and buildings from the glory days of the old road—and from as the pre-statehood era—that line the roadside but the crush of traffic that enhances the illusion. A thriving miniature metropolis nestled in a forest of towering pine trees in the shadow of the San Francisco Peaks, Flagstaff's proximity to the Grand Canyon and a multitude of other attractions have ensured a steady supply of tourists for more than a century.

As a result, lodging and dining options, as well as attractions, are plentiful, and Flagstaff alone can easily consume an entire vacation . . . or two.

FLAGSTAFF

History keeps a lengthy list of what might have been, and topping that list in Flagstaff is how close it came to being Hollywood.

Cecil B. DeMille and Jesse Laskey decided in 1911 that if their New York City–based motion picture company were to survive and expand, they needed a new location, somewhere with clear skies and open spaces. To find that special place they set out on a nationwide rail tour, but at every stop, there seemed to be a deterrent.

Then the westbound train rolled into Flagstaff. The deep blue skies, the towering snow-covered San Francisco Peaks, the forest of majestic Ponderosa pine that pressed in on the mountain town seemed tailor made for their vision. Then, a few days later, the temperature plummeted as a late spring storm swept into the area. An icy windswept drizzle turned to blinding snow and the drifts began to grow.

As soon as the storm passed, and the tracks were again open, DeMille and Laskey continued their search. Their next stop was sunny southern California, and the rest, as they say, is history.

You can follow Route 66 west of Flagstaff to exit 191 on I-40, but from this point to exit 185, the interstate highway is the only option. The Route 66 odyssey through the pines resumes at the Bellemont exit (185), dominated by a large modern travel plaza. Segments of this pre-1941 alignment of the old highway are graded gravel that, except during winter or after heavy rains, is passable in almost any type of vehicle.

Bellemont does have a few attractions of note, even though the sweep of suburbia in recent years has erased much of the essence of Route 66. Two miles east of exit 185 on the post-1941 alignment, you'll find the Pine Breeze Inn, a site featured in the film *Easy Rider*. Located near the exit is a massive Harley Davidson store and service repair facility next to the Route 66 Roadhouse, where grilling your own burgers is the order of the day.

During the summer, the cool pine-scented breezes and towering trees that shadow long segments of the pre-1941 road on the north side of I-40,

DON'T MISS

Here are some great places to visit in **Flagstaff**:

- Walnut Canyon National Monument (ten miles east of Flagstaff at exit 204, where the post-1947 alignment of Route 66 meets I-40) with a wonderful series of trails into and along the canyon peppered with cliff dwelling ruins;

- The Museum Club (3404 East Route 66), originally a taxidermist studio opened in 1931, now a true Route 66 roadhouse that hints at its original rural setting along the highway even though it is now surrounded by modern urban America;

- Lowell Observatory (1400 West Mars Hill Road), founded in 1894, an astronomical research facility that features a miniature planetarium and interactive live presentations;

- The Arizona Historical Society Pioneer Museum (2340 North Fort Valley Road), housed in the former Coconino County Hospital for the Indigent, with a staggering collection of tangible links to the area's rich history, including a steam locomotive, Route 66 related artifacts, and Pioneer Kids, a family-oriented interactive exhibit;

- The Arboretum at Flagstaff (4001 South Woody Mountain Road), a 200-acre botanical garden centered on the richly diverse ecosystem of northern Arizona;

- The Arizona Snowbowl, a few miles north of the city on US 180 and a summer and winter playground with miles of trails, chair lifts, and a scenic summer sky ride to 11,500 feet for truly stunning views.

The Parks Store

including at the highest point on Route 66 (7,410 feet), inspire thoughts of a leisurely picnic. A quaint spot on this portion of Route 66, immediately west of the summit, has been helping to transform picnic thoughts into reality for more than ninety years: the Parks Store.

This charming little country store offers gas, a variety of staples suitable for picnics or camping, and a wonderful deli. You can eat inside the store at a rustic picnic table, or outside at a shaded table on the opposite side of the road.

Route 66 west from the Parks Store continues the pattern of paved road intermixed with graded gravel to exit 167 where, again, the interstate highway becomes the only option. Along this forested segment of the old highway are two notable landmarks.

One is a picturesque two-story structure built of logs. Now a private residence, this is the old McHat Inn, a complex that during the 1940s

DON'T MISS

Some gems to discover in **Williams**:

- The Fray Marcos de Niza Hotel and Depot, a former Fred Harvey Company (Harvey House) enterprise built in 1908 that now houses a gift shop and serves as the depot for the Grand Canyon Railway;

- The Red Garter Bed and Breakfast, housed in a saloon, tailor shop, and bordello built by August Tezlaff in 1897;

- Rod's Steak House, with its tasteful neon trim, serving good food since 1946;

- The Williams visitor center, which includes a small museum, in the former freight office on Railroad Avenue.

Rod's Steakhouse, Williams

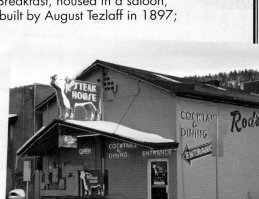

consisted of a service station, cabins, a restaurant, and across the highway, the Elmo Dance Hall.

The second, the Grand Canyon Deer Farm, is a throwback to an earlier time, before overwhelming technological illusions at such places as Disneyland. The centerpiece of this gift shop and small zoo with domestic animals is a large outdoor petting zoo with deer, a wonderful stop for families traveling with children.

The next interstate jaunt is mercifully short, from exit 167 to exit 165. Then the Route 66 adventure resumes with a cruise into Williams, the last community bypassed with completion of the interstate highway on October 13, 1984. Here

the snow can be deep during the winter. Still, any season is an excellent time to explore the wonderland of Williams with its blending of territorial and Route 66 history (including a brothel-turned–bed and breakfast), wonderful restaurants, shops, galleries, and a historic depot that is the departure point for an excursion train to the Grand Canyon.

From Williams to Ash Fork, with the exception of a few truncated segments and portions of roadway converted into bicycle trails, the only option for the westward journey is I-40. Still, this is Route 66, so there are some interesting surprises located along or near these orphaned segments of highway.

WILLIAMS OUTDOORS DETOUR

If you prefer resting under the stars rather than in the glow of vintage neon after a long day on the road, or if you enjoy a little fresh air with lunch, try following 4th Street (County Road 73) south out of Williams. A beautiful little park, with a small dam and lake, is located mere blocks from downtown.

To experience an even more amazing little oasis, continue south about eight miles, turn left on Forest Road 110 (graded gravel), and continue for seven miles. At Forest Road 109, turn left again and drive three miles to White Horse Lake Campground.

White Horse Lake

INTO THE DESERT

Before the advent of the interstate highway, the various alignments of Route 66 that twisted to the bottom of the Ash Fork grade west of Williams gave motorists a white-knuckled ride, especially during the winter, when ice was a common problem. The smell of hot brakes is still common on this precipitous drop from the pines toward the high desert below.

Although it is obvious that the old town of Ash Fork (accessed at exit 146) has seen better days, it nevertheless provides a brief opportunity to explore the real Route 66, especially through a photographer's lens.

At the west end of town, you'll again briefly rejoin I-40. At the Crookton Road exit (number 139), the most exciting part of a Route 66 adventure begins, since this is the starting point for a westward drive along the longest uninterrupted segment of Route 66 between Chicago and Santa Monica, more than 180 miles.

JOHNSON CANYON HIKING DETOUR

At the Welch Road exit (number 151), proceed a quarter of a mile north and then follow the dirt road that swings to the right. Now a bicycle trail, this is the earliest alignment of Route 66 as well as the course of the National Old Trails Highway.

Within a few hundred yards, you will encounter the broken pavement of the post-1932 alignment of Route 66, also a bicycle trail. Proceed east for approximately 2.5 miles, and turn north on forest road 6, a dirt road. Follow this road for approximately 1.5 miles to the concrete foundations of the old Welch Railroad Station and the abandoned rail bed. Now, secure your vehicle, lace up your boots (or break out your mountain bike) and follow the old rail bed east for 2.4 miles to the historic Johnson Canyon Railroad Tunnel built in the 1880s, an awe-inspiring engineering marvel.

Relatively easy and free of obstacles, the hike gives you stunning bird's-eye views of the vast wilderness from the old rail bed, carved precariously into the canyon wall.

JOHNSON CANYON

More than an engineering marvel, the Johnson Canyon Tunnel is a frontier-era time capsule framed by Arizona wilderness, with a link to World War II.

In early 1881, survey crews for the Atlantic and Pacific Railroad had determined only one canyon was suitable for rail line

Entrance to Johnson Canyon Tunnel

construction to proceed from the Colorado River Plateau near present-day Williams to Ash Creek far below. But even though the canyon represented the best option, it was not without major obstacles, one of which was a shoulder of sheer stone at a point where there was a sharp bend in the canyon wall.

Initially the 328-foot tunnel seemed like a rather straightforward project. Then the tunnel crew struck basalt, an extremely hard stone. As the tunnel developed into a time-consuming and labor-intensive endeavor, a railroad camp complete with saloons and brothels mushroomed above the tunnel along the canyon rim. Exorbitant wages—$2.40 per day for laborers, $2.80 a day for drillers— lured men from throughout the world, as well as opportunists to liberate them of their hard-earned money.

An occasional shooting ensured the remote camp's reputation for being wild and woolly, and deaths on the job sealed the tunnel's reputation as a killer. A premature explosion late in the summer of 1881 killed six men. A roof collapse killed two more.

In 1882, the tunnel was completed, but the disasters had not run their course. Initially, to prevent rock falls from the ceiling, mine timbers were used to shore it up. In 1898, the timbers caught fire and burned for days, forcing suspension of train service and rerouting through southern Arizona. Two men died fighting the blaze, and one more died when the ceiling was then sheathed in riveted steel.

During World War II, the tunnel was deemed a vital war asset because it represented a bottleneck for rail traffic across northern Arizona. To protect the tunnel, a military outpost was established above it.

The Johnson Canyon Tunnel's vital role ended in 1960, with completion of a new double-track line to the north. With removal of the rails, the old tunnel faded into obscurity.

Interior, Johnson Canyon Tunnel

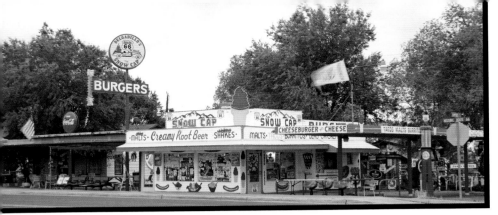

Snow Cap Drive In, Seligman. *Carol M. Highsmith's America, Library of Congress, Prints and Photographs Division*

The drive begins by following the old road across a plain of contrasting black volcanic rock, juniper, cedar, and scrub oak. Then you head into the foothills, a short but steep climb, across a vintage bridge over the railroad tracks at Crookton Overpass, and then down the other side into Seligman.

Many Route 66 enthusiasts refer to Route 66 as a linear community. If that's true, then dusty old Seligman is the courthouse square.

Vestiges of the old ranch and railroad town, as well as from the time when Route 66 was the main street, abound. However, what really sets this place apart is its vibrancy and vitality. From the historic Seligman Sundries and the zany Snow Cap Drive In, with a second generation of owners at the helm, to the Road Kill Café and the Black Cat Lounge, throngs of people speaking dozens of languages sometimes make this little rural Arizona town seem more like New York City.

Seligman Sundries. *Raffaella Calzoni/Shutterstock.com*

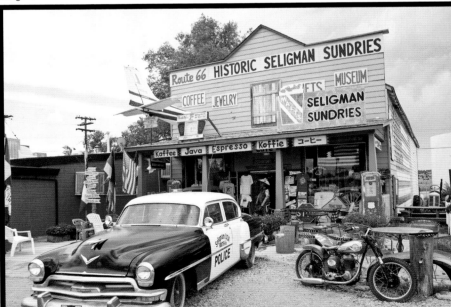

Destination one for Route 66 enthusiasts from throughout the world is the unassuming barbershop and gift shop where Angel Delgadillo, the town barber, holds court. Credited with igniting the resurgent interest in Route 66, Delgadillo called a meeting at the Copper Cart restaurant in the 1980s that would turn out to be the cornerstone for the Arizona Route 66 Association, the first of its kind.

The bypass of Seligman had devastated the community, and Delgadillo, whose family roots here stretch back almost a century, saw in Route 66 an opportunity to keep the town alive. His ardent, vocal, and passionate defense and promotion of the old road has earned him the nickname Mayor of Route 66. To spend a few minutes in his shop is truly inspiring and thought-provoking. Now well past eighty years old, Delgadillo greets all who stop by as old friends, and he still cuts hair and trims beards for all who ask, many from Europe and Australia.

From Seligman the old highway loops around the Chino promontory, and sweeps out into the wide Aubrey Valley, named for pioneer explorer Francois Xavier Aubry. Here herds of antelope still run free, and prairie dogs and black-footed ferrets are local residents, making this a favored location for wildlife photographers.

At the west end of the valley the road climbs a cedar-studded hill where the sharp-eyed adventurer will notice the last traces of Hyde Park, a complex

Grand Canyon Caverns

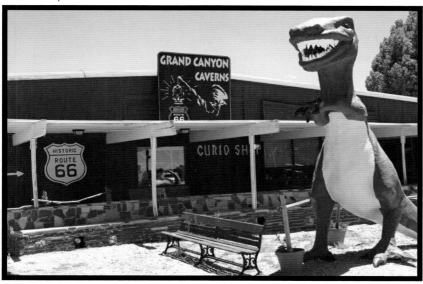

consisting of a motel with swimming pool and a service station once promoted with signs reading "Park Your Hide tonight at Hyde Park." Located on the other side of the hill is the classic Grand Canyon Caverns, which has been an attraction for tourists since its discovery in 1927 and has operated under a variety of different names, including Yampai Caverns, Dinosaur Caverns, and Coconino Caverns.

When this segment of Route 66 was bypassed in 1978, the resort began to fade, and the motel fell into disrepair. Resurgent interest in the highway and new owners have sparked a dramatic restoration as well as additions to the property, including amenities such as a stable with trail rides. Today the well-stocked gift shop, restaurant, motel, and cave tours—and the fact that this destination has direct connections to the entire history of Route 66—ensure a new generation of adventurers will be making memories here. Additionally, plans are under way to add other attractions, including an observatory for stargazing on clear desert nights.

From the caverns, Route 66 follows the gentle rolling hills and wide valleys past Indian Highway 18, which is the road to Supai, the last community in America where mule trains are used to deliver mail. The road then runs down a sweeping grade and into Peach Springs. The views along the downgrade, especially to the north, are worthy of a spread in *Arizona Highways* magazine.

Peach Springs, headquarters for the Hualapai Tribe, hosts a handful of Route 66 landmarks, limited services, and the wonderful Hualapai Lodge and

Frontier Motel, Truxton. *Carol M. Highsmith's America, Library of Congress, Prints and Photographs Division*

Restaurant. The modern lodge provides glaring evidence that the tribe is quickly embracing its tourism potential: rafting trips on the Colorado River via the only road to the bottom of the Grand Canyon begin in Peach Springs. In addition, the lodge conducts hunting expeditions, and you can stay at the Hualapai Nation's Grand Canyon West Resort.

From Peach Springs, it is a short drive into Truxton, one of the newest ghost towns on Route 66, with origins in 1950, the year Clyde McCune and Don Dilts opened a service station and garage here. Photo opportunities afforded by the empty buildings set against a backdrop of quintessential western landscapes, a garage, a bar, and a small travel store are about all that remain. Lieutenant Edward Fitzgerald Beale, on his 1857 survey expedition to map a course for the Beale Wagon Road, camped at a springs near this community. He bestowed the name Truxton in honor of his brother and his mother, Emily Truxton Beale.

Immediately west of Truxton, Route 66 drops into Crozier Canyon and squeezes between towering buttes and mesas. A Native American trade route, the Beale Wagon Road, the railroad, the National Old Trails Highway, and Route 66 all used this narrow but beautiful canyon to access the Hualapai Valley.

Attractions new and old, historical landmarks, and even a ghost town lie within the canyon and its western mouth. The first of these is the Crozier Canyon Ranch on the south side of the highway. Dating to the 1870s, it is one

Crozier Canyon Ranch

of the oldest continuously operated ranches in Arizona, and during the 1920s and 1930s, the traffic flowing through the ranch yard, first on the National Old Trails Highway and later on Route 66, inspired creation of the 7-V Ranch Resort, with its spring-fed swimming pool, restaurant, service station and garage, and cabins.

The most recently added attraction in the canyon, Keepers of the Wild, is nestled against the boulder-strewn canyon wall and offers both guided and self-guided tours to ensure the park is accessible to everyone.

The hulking and foreboding old brick schoolhouse near Valentine immediately to the west is one of the last structures remaining from the Valentine Indian School. Established in 1901 as a boarding school for area Indian children, a portion of the site serves as offices for the Bureau of Indian Affairs, Truxton Canyon Agency. Valentine itself was always a very small town, and it is even smaller today, with only a handful of residents, an abandoned garage and service station, a long-closed bar, and a couple of tumbledown motels.

Near where the canyon opens into the Hualapai Valley stands the Hackberry General Store. Dating to the mid-1930s, this favored photo stop for Route 66 enthusiasts also houses a gift shop. The town site of Hackberry, located on the south side of the railroad tracks along the original alignment of Route 66 (also the course for the National Old Trails Highway), has almost vanished. A Spanish mission–styled two-room schoolhouse that closed in the early 1990s, a hilltop cemetery, an old boarding house, and a minuscule post office are about the only remaining links to the community's more vibrant past.

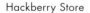
Hackberry Store

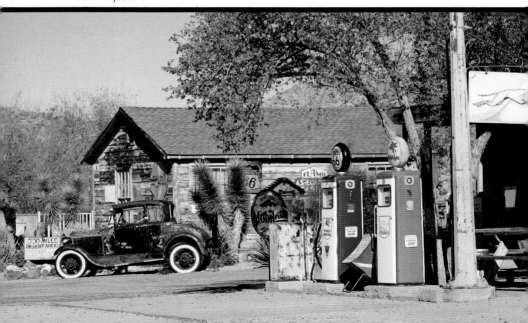

STRAIGHT THROUGH THE VALLEY

R oute 66 across the wide Hualapai Valley—framed by the often snowcapped peaks of the Hualapai Mountains, the Grand Wash Cliffs, and the Cerbat Mountains on the western horizon—runs straight as an arrow into Kingman. Along the way you'll find a handful of faded relics, including Giganticus Headicus, an Easter Island–type head adorning the parking lot of an old motel and restaurant complex, as well as a Stuckey's convenience store–turned-residence.

From the Kingman airport and industrial park (site of the Kingman Army Airfield during World War II) to the far end of town, Route 66 flows through a canyon of roadside history. First, urban sprawl and suburbia appear alongside disguised remnants from the pre–interstate highway era. Then, you'll see trappings of the generic age at the I-40 interchange before you encounter a mix of old restaurants, ultramodern motels, automobile dealerships, service stations, Lewis Kingman Park, old motels transformed into long-term rental establishments, the world-famous Dambar saloon and steakhouse, and then a string of old motels, some of which date to the 1930s and 1940s, others to the 1950s and mid-1960s. A few are boarded up, and others now rent by the week or two, but the Hilltop Motel (1954) and the El Trovatore Motel (1939) are refurbished gems.

The Hilltop Motel with its restored neon signage is pure 1950s. The El Trovatore Motel began life as an ultramodern complex built by John F. Miller, the man behind the hotel at the corner of Fremont and First Street in Las Vegas that is the cornerstone for the "Strip." This motel survived the widening of Route 66 (which necessitated demolition of the loop of the "U"), competition with more modern properties during the 1950s and 1960s (the El Trovatore added a swimming pool), and a slide into low-rent weekly usage before being abandoned. Renovation initiated in late 2011 continues, and almost half of the El Trovatore Motel has been refurbished, preserving

El Trovatore, Kingman. *Judy Hinckley*

original tile work and architectural elements. Murals have been added—including the world's longest Route 66 map—and in the spring of 2012, the restored neon of the El Trovatore on a rocky knoll at the back of the property again lit the desert sky after being dark for half a century.

KINGMAN

Besides Andy Devine Avenue (Route 66), nothing in Kingman hints at that little desert town's lengthy association with stardom over the years.

In 1914, the course for the last of the great Desert Classic automobile races (dubbed the Cactus Derby) followed the National Old Trails Highway from Los Angeles to Ash Fork before turning south toward the finish line in Phoenix. Counted among the legendary drivers who made a pit stop in Kingman were Louis Chevrolet and Barney Oldfield.

When Charles Lindbergh charted the course for the pioneering Transcontinental Air Transport (TAT) passenger airline service, Kingman received designation as an official terminal. When in town to supervise construction, Lindbergh stayed at the Hotel Beale.

In 1938, Clark Gable and Carol Lombard followed Route 66 from California to Kingman and were married in the Methodist church on Fifth Street, a building now utilized as county offices.

During World War II, when the Kingman Army Airfield was one of the largest flexible gunnery schools in the nation, it was a regular stop for United Service Organizations (USO) tours featuring many of the biggest names in show business, including Bob Hope and the Andrews Sisters. Often they arrived by rail, but if they flew into the airfield, chances are their pilots availed themselves of the services of Clayton Moore, an air traffic controller. Moore later gained fame as the Lone Ranger.

Acclaimed artist and author, as well as executive editor for *True West* magazine, Bob "Boze" Bell claims Kingman as his hometown. His father, Allen Bell, operated a Flying A station on Route 66 in town.

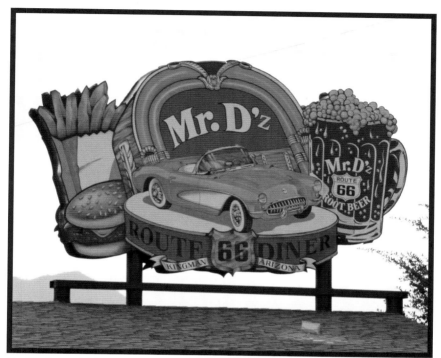

Mr. D'z Route 66 Diner, Kingman

Originally, Route 66 curved around El Trovatore Hill on a road now signed as Chadwick Drive. The transition to four-lane highway through town in the late 1950s also included a deep cut through the red volcanic cinder in the hill. Today, this cut serves as a portal into a territorial-era world with a modern windmill farm and towering buttes dominating the skyline.

The historic district in Kingman contains much to see, and a great deal to do, especially if you include the Beale Street corridor one block north of Route 66. Moreover, on the third Saturday evening of every month from April through October, the Chillin' on Beale event fills the street with cars, trucks, and motorcycles.

Before you continue with your westward adventure, the next short section of Route 66 holds a rare link to the highway's infancy and the National Old Trails Highway that preceded it. This scenic drive of a few miles, which dead-ends at the mouth of a canyon opening to the Sacramento Valley, begins when you turn south on Fourth Street from Andy Devine Avenue (Route 66) at the train depot that houses the railroad museum.

DON'T MISS

Kingman just may be one of the most overlooked destinations on Route 66. Within a radius of a dozen miles, you'll find numerous attractions and, in the city itself, several excellent museums:

- The Powerhouse Visitor Center and Route 66 Museum (120 West Andy Devine Avenue), housed in the Desert Power and Water Company building of 1907, the oldest reinforced concrete structure in the state of Arizona—features a gift shop for the Arizona Route 66 Association; an area tourism office with brochures, guidebooks, and friendly, knowledgeable staff; and an award winning Route 66 museum;

- Mohave Museum of History and Arts (400 West Beale Street), with an excellent bookstore, dioramas chronicling the area's history by acclaimed artist Roy Purcell, and an Andy Devine room preserving artifacts from the city's favorite son;

- Fort Beale at Beale Springs, half a mile from the city limits along US 93 (information and directions available at either museum)—a shady oasis and historic park at the south end of the extensive and scenic Cerbat Foothills trail system that played a pivotal role in the Hualapai Wars of the 1870s and served as headquarters for the first Hualapai Reservation;

- Hualapai Mountain Park and Hualapai Mountain Resort, located just twelve miles south of Kingman via a steep and winding paved road, a forested oasis in a sea of desert—miles of hiking trails with campsites, rustic cabin rentals, fine dining, a motel, and stunning views from the cool shade of the pine-forested mountains, a destination of choice, summer or winter.

Hualapai Mountains

Continue south for three blocks, then follow the road around a slight curve over a narrow bridge to Old Trails Road, opposite the park. This entire drive follows the pre-1937 alignment of Route 66 that was also the roadbed for the National Old Trails Highway. Carved from a shelf in the canyon wall opposite the original roadbed is the later alignment of Route 66, the one you will follow west from Kingman. At the intersection with I-40, the post-1952 alignment (buried under the interstate highway) continues to the Colorado River through Yucca, a territorial-era community with a few tarnished and weathered relics from the Route 66 era.

I recommend following the pre-1952 alignment, signed as Oatman Road, since it is also the course of the National Old Trails Highway and is arguably the most scenic portion of Route 66 between Chicago and Santa Monica. The old Oasis at the intersection, now a private residence, is the only vestige of Route 66's glory days, since suburbia has engulfed both it and the old highway at this point.

Within a few miles, the road sweeps onto a vast desert plain, the Sacramento Valley, past the forgotten Fig Springs Station, and flows toward the formidable escarpment of the Black Mountains on the horizon. At the base of those mountains is Cool Springs, a re-created roadside relic that serves as a museum and gift shop.

Route 66 through the Black Mountains

With stunning western landscapes as a backdrop and awe-inspiring views of the valley below stretching toward the Hualapai Mountains, this is a photographer's paradise. For an even better view, there is a short, moderately difficult, rock-strewn trail to the top of the towering stone escarpment on the opposite side of the highway.

From Cool Springs to the old mining town of Oatman—a ghost town transformed into a romanticized image of the old west—Route 66 twists and turns to the summit of Sitgreaves Pass and down the other side. Here are the sharpest grades and steepest curves found anywhere on Route 66, and also some of the most stunning vistas.

Photo opportunities abound: the remains of Ed's Camp framed by towering buttes and colorful walls of stone, Shaffer's Fish Bowl Springs, a stunning view of the Colorado River Valley from the summit of Sitgreaves Pass, the site of Snell's Summit Station, and the old mining town of Goldroad now dominated by a thriving gold mine. *Note: the road is very narrow, so please use the pullouts to take in the view.*

Oatman is an exciting blend of true ghost town and re-creation with Route 66 as the main—and only—street through town, just as it has been since

Shops on Route 66, Oatman. *Judy Hinckley*

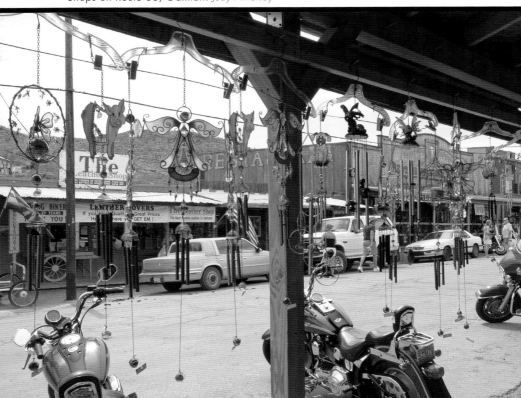

Havasu National Wildlife Refuge

1926. Here, wild burros have free rein, and the streets throng with tourists giving this old town a rare vitality.

From Oatman to the Colorado River Valley, often the hottest place in America during the summer, the old highway descends with a series of sweeping turns and stomach-dropping dips that follow the contours of the sun-scorched desert. Then it zips through the desert crossroads community of Golden Shores and along the banks of the Colorado River to the desert oasis of Havasu National Wildlife Refuge, a birdwatcher's paradise.

Just past the Topock Marina Resort, Route 66 passes under a railroad bridge and abruptly into the modern era at I-40. While crossing the Colorado River into California on the interstate highway, note the arch bridge to the south. This is the National Old Trails Highway Bridge, which was built in 1916 and carried traffic on Route 66 across the river until 1947. It appeared in the classic film *The Grapes of Wrath*.

CHAPTER 8

CALIFORNIA

Through stark deserts, small towns, and huge metropolises, Route 66 winds its way across California to the ocean. Truncated sections and multiple alignments are the order of the day in this state, but each holds surprises that will make the detour worth it. And when you finally reach the end (which may be one of several different locations, depending on who you ask), you'll need another week to enjoy all that the coast has to offer.

The end of Route 66 at Santa Monica. *iStockphoto*

THE MOJAVE DESERT

As you cross the Colorado River from Arizona into California, you'll encounter two great photo opportunities: Route 66 landmarks associated with Hollywood history. The first is the bridge that was used by both an earlier incarnation of Route 66 and the current I-40 and that features prominently in the 1969 film *Easy Rider*.

Directly to the south, the white bridge that spans the river in a graceful arch is the one on which the Joad family crossed into California in the classic 1940 film *The Grapes of Wrath*. Used by the National Old Trails Highway and Route 66 until 1947, this 1916 bridge now supports pipelines for the Pacific Gas & Electric Company.

Your Route 66 experience between the Colorado River and Needles will be limited to exploring truncated segments and sections better walked than driven, and then again from Needles to the US 95 north (or Mountain Springs Road) exit. The arrival of the interstate, privatization of property, and time have transformed the old highway into dead-end roads, dirt paths, and inaccessible pieces viewable only after a distance during the initial drive into California.

From the Park Moabi Road exit, a short drive to the north takes you across a barely discernible segment of the highway and then connects you with an early alignment that also served as the course for the National

1916 bridge across the Colorado River. *Shutterstock.com*

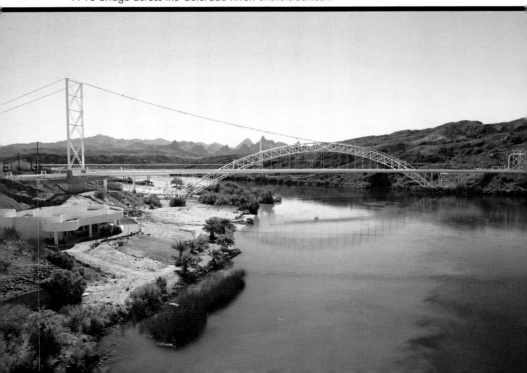

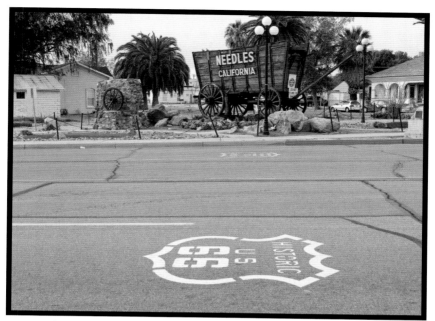

Route 66 through Needles. *Judy Hinckley*

Old Trails Highway. Route 66 stretches to the east and west, but the drive in either direction will be short, since modern changes have transformed this segment into an island.

The Pirate Cove Resort at Park Moabi on this old segment of Route 66 is an interesting desert oasis that often serves as a venue for car shows, small conventions, and off-road races. Amenities include a restaurant, an RV park, a zipline across a Colorado River cove, a bar, a boutique, and boat rentals.

At the Five Mile Road exit of I-40, you can again cruise Route 66 for your drive into Needles, another town for which long-term survival is questionable. Route 66 utilized two different corridors through Needles during its history: Front Street, which curves around the Santa Fe Park, dominated by the massive El Garces Hotel (a former Harvey House undergoing renovation), and a later alignment that followed Broadway Street.

West of Needles, the interstate highway again severs the road at the River Road Cutoff exit. This leaves I-40 as your only option, at least for a few miles. At the exit for US 95, you can pick up the pre-1931 alignment that looped through Goffs before dropping down to Fenner and Essex. As you follow I-40 farther west and up the grade, the Mountain Springs Road exit provides access to the post-1931 alignment of Route 66. Since this segment joins the earlier alignment within a few miles, I suggest you take the road through Goffs.

As deserted, empty, and forbidding as the landscapes seem along old Route 66 on the road to Goffs, they pale in comparison to what awaits on the

NEEDLES

The Whipple-Ives survey expedition of 1854 designated the rocky spires that squeeze the Colorado River at the Topock Gorge the Needles. As a result, when the Atlantic and Pacific Railroad established a station, siding, and construction camp in the area on the Arizona side of the river in 1883, it received designation as Needles, the name used on the application for a post office the following February.

As construction of the railroad spanned the river and moved west, the community in Arizona withered. Many of the buildings were dismantled and relocated to a site on the California side of the river. The following year, the old Needles camp on the Arizona side of the river began to flourish again, largely due to river traffic and mining development in the nearby Black and Cerbat Mountains.

The pattern of decline and boom alternately led to the opening and the closing of the post office under a variety of names. In 1915, the population again warranted a post office, but the initial application using the name Needles was rejected because of the community on the California side of the river using the same name, so the town instead used the name Topock.

While the community on the Arizona side of the river ebbed and flowed, the town on the California side flourished. In 1908, the massive and modern El Garces, a Fred Harvey–operated hotel and restaurant complex, opened its doors.

Even during the Great Depression, Needles experienced slow but steady growth. Then came the mid-1960s, and the bypass by I-40, an economic calamity from which the community has never recovered.

Local festival in Needles, circa 1910. *Library of Congress Prints and Photographs Division*

Mojave Desert Heritage and Cultural Association, Goffs

other side of the grade and into the valley below. If you are driving this during the peak of summer, stop for a few minutes, turn off the air conditioning, step out into the blast-furnace heat, listen to the silence, and think of the families immortalized in *The Grapes of Wrath*.

Goffs is a surprising place to find a first-rate museum. Housed in the 1914 schoolhouse, the Mojave Desert Heritage and Cultural Association preserves an amazing collection in the museum and on the grounds that chronicles the area's fascinating history.

Artifacts tell of the time when Goffs was a railroad boomtown located at the intersection of the National Old Trails Highway and the Arrowhead Highway. Other exhibits chronicle the years when vast war games under the direction of General George Patton engulfed the desert as he prepared his men for the invasion of North Africa during World War II. You'll even see a ten stamp mill relocated from a nearby ghost town.

GOFFS

Goffs has the dubious distinction of being one of the first communities severed from the lifeline of Route 66. Excepting a brief renewal during World War II, when Goffs and its schoolhouse were inundated with thousands of troops, the 1931 bypass killed the town.

Located at the high point between the steep climb from the Colorado River Valley and the valley floor of the Mojave Desert, Goffs was selected by the Southern Pacific Railroad as the site for a siding, water, and fuel stop in 1883. This served as a catalyst for the development of mining and ranching in the area, with Goffs as the focal point.

The discovery of extensive gold and silver deposits north of Goffs led to the establishment of Searchlight, Nevada, and construction of a railroad spur by the Nevada Southern Railway. Now, the community was the site of a busy railroad junction. By the second decade of the twentieth century, with the rise of automobile traffic, Goffs enjoyed the added benefit of being located at the junction of the National Old Trails Highway and the Arrowhead Highway. Then in 1920, the downward spiral commenced.

First, there was the abandonment of the spur line to Searchlight in 1923. On the heels of this disaster, the railroad consolidated operations in Barstow and Needles, making service and fueling facilities in Goffs unnecessary. Then, there was the highway bypass of 1931, and Goffs quickly faded toward oblivion.

Just west of Goffs, the old road turns south and begins a steady descent into the desert. At Fenner it again flirts with I-40, and then cuts through the dust and scrub at the forlorn and forgotten outpost of civilization that was Essex. A short distance from this town, where a steep bank borders the north side of the road, travelers began leaving messages spelled out with desert rocks. That tradition continues, and this spot has become sort of an art corridor with messages spelled out in colorful stones, bottles, and other items.

On the south side of the highway west of Essex, just past the last remnants of Danby—an old service station and a few cabins—a rest area pullout offers

expansive views of the desert and the distant mountains. Here a series of bronze tablets describe the history and geology of the area.

From this point, the road sweeps up a gentle grade toward the graffiti-covered ruins of the Cadiz Summit station, a high point before the road plummets toward the oasis of Amboy in the valley below. A string of weathered outposts along this portion of the old highway offers evidence of how the highway once made the remotest places potentially profitable locations.

ESSEX

Even photo opportunities are scarce in Essex, a faded desert oasis with a unique and interesting history. The story begins with establishment of a railroad siding and water stop in 1883 a few miles from the current location of the town site.

In the shadow of Goffs and Amboy, Essex languished into the twentieth century before relocating to a spot along the National Old Trails Highway. The Automobile Club of Southern California initiated an extensive program to facilitate automobile traffic in the Mojave Desert that included drilling a well at Essex and putting up roadside signs offering free water.

The National Old Trails Highway gave way to Route 66, and by 1931, the little oasis included a market, garage, post office, service station, and restaurant. In 1937 the school in Goffs closed, and the Needles Unified School District consolidated classes at a new school built in Essex.

Another boost came during World War II, with establishment of Camp Essex Army Airfield three miles to the northeast. In addition to serving as an auxiliary airfield and staging area for General George Patton's vast Mojave Desert war games, the camp also served as a POW camp for Italian military personnel.

Reflecting how remote Essex is, and how important Route 66 was, a story in the *Los Angeles Times* in 1977 noted the effect of the 1973 I-40 bypass on this community and the fact that it was the last in the continental forty-eight states without television service. The story resulted in the entire town of thirty-five residents appearing on the *Johnny Carson Show* and an equipment manufacturer donating the translator needed to move Essex into the modern era.

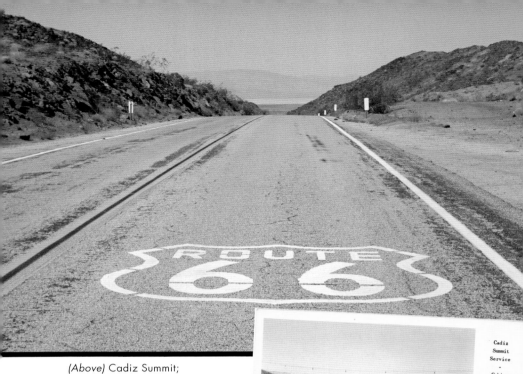

(Above) Cadiz Summit;
(right) 1950s-era
postcard of Cadiz
Summit Service Station.
Courtesy of Mike Ward

Cadiz
Summit
Service
-
Cabins
Restaurant
Service Station
Garage
Air Conditioned
Modern Rest Rooms

CADIZ SUMMIT
CALIFORNIA

on Highway 66

F 8733

STARK AND DESOLATE BEAUTY

Amboy is a sunbaked, remote settlement with a very colorful history. Here, gasoline and cold drinks are still available, and the towering sign casts its shadow across the dusty parking lot under a withering desert sun as it has since 1959, but the motel and restaurant are closed.

Incredibly, this is a location favored by a large variety of international advertisers. As a result, Amboy and its signature sign have appeared in promotional material as diverse as Chinese commercials for the Cadillac division of General Motors, Levi Strauss advertisements, and ads for Australian insurance companies and German beer companies. It is the dream of Albert Okura, founder of the Juan Pollo restaurants who recently purchased the entire town, to transform this into a living time capsule of life in the early 1960s. To that end, restoration work is underway on Amboy's motel, restaurant, and cabins.

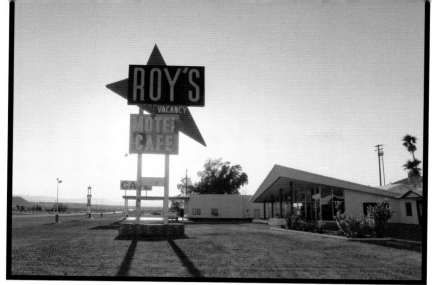

Roy's Motel, Amboy

AMBOY

Salt mining, an activity still under way in the region, commenced in the area of Amboy in 1858, making this one of the oldest communities in the Mojave Desert. With arrival of the railroad in the early 1880s, the isolated camp became an important supply and distribution center for area mines, and a water stop for the railroad.

For pioneering automobilists on the National Old Trails Highway, Amboy's service station, rustic cabins, garage, and restaurant created an oasis in the desert. Indicative of the town's importance, the J. M. Bender Garage is the only approved facility between Needles and Barstow listed in the 1927 edition of the *Hotel, Garage, Service Station, and AAA Club Directory*.

With the postwar surge in tourism and travel, Amboy became a boomtown. From 1948 to the completion of the I-40 bypass in 1973, the café, motel, cabins, service stations, and garages were open twenty-four hours a day, seven days a week. But in an instant, the good times came to an end. The bypass severed Amboy from its traffic lifeline. The owner of the town, Buster Burris, began bulldozing structures to avoid tax penalties, and as a result, most of Amboy was erased from the desert landscape.

Dominating the horizon west of town along Route 66 is Amboy Crater, a 250-foot volcanic cinder cone more than 1,500 feet in diameter. Designated a National Natural Landmark and administered by the U.S. Department of the Interior's Bureau of Land Management, the crater and its rim can be accessed via a three-mile loop trail marked with informative kiosks.

The trail begins at a well-maintained day-use area immediately off the highway, crosses a vast plain of black volcanic flow and sand, and enters the crater itself through the breach in the west wall up an 80-foot incline that is moderately steep. The highlight of the hike is the climb to the crater rim and around its one-mile circumference. Because this is an area of extreme heat, I recommend you hike in October through April. My wife and I made this hike on New Year's Day, and the temperature in the crater was still ninety degrees! With any desert exploration, it is imperative to let someone know your itinerary. It is also essential to carry water, at least one gallon per day per person. For more information about the crater or safety suggestions, contact the BLM office in Needles at (760) 326-7000.

From Amboy to Ludlow, the old highway courses through the heart of some of the most desolate and starkly beautiful landscapes in America. This is real desert.

Just west of Amboy, at a lonely site along the railroad tracks now marked by a forlorn cemetery, a twisted tree, and windswept concrete slabs, the

Amboy Crater. *Hank Shiffman/Shutterstock.com*

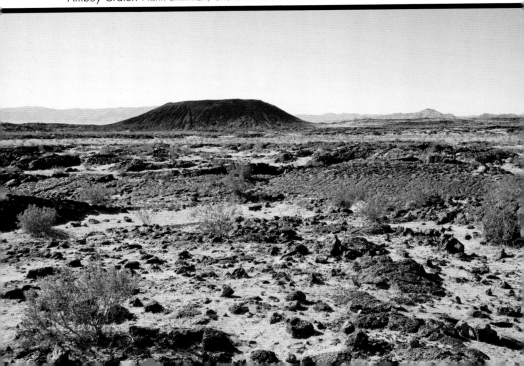

KELSO DETOUR

Although the desert oasis of Kelso in the Mojave National Preserve is forty-one miles north of Route 66 and Amboy, I would be remiss if I didn't include it. This amazing historic gem, nestled in a stark yet stunning desert landscape, is a very special destination. The centerpiece of this former railroad boomtown is the Kelso Depot. Fully refurbished with landscaped grounds shaded by towering palm trees, the depot now serves as the visitor center for the Mojave Desert Preserve. It houses a museum with exhibits detailing the area's rich history and unique geological attributes. There is also a fantastic little book store, and the Beanery is a refurbished lunch counter in the depot that seems to have been lifted directly from the 1940s. Today, as it did then, the Beanery offers a simple menu, but the setting ensures a most memorable meal.

Kelso Depot. *Shutterstock.com*

little railroad water stop and roadside oasis of Bagdad once stood. Between October 3, 1912, and November 8, 1914, the measurable precipitation here was zero, an unofficial record for the continental United States.

In the entry for Ludlow in Jack Rittenouse's 1946 guidebook, he notes, "Although quite small, Ludlow appears to be a real town in comparison to the one-establishment places passed on the way here from Needles." Still, by that time, Ludlow had faded to a mere shadow of what it had been in the era of the National Old Trails Highway, when the town served as the junction for several railroads and as a supply center for area mines.

LUDLOW

Despite the fact that water was shipped into the community by rail from Newberry Springs until 1902, Ludlow flourished during the late nineteenth century. First it was a railroad siding, then an important railroad junction linking the mining boomtowns in Nevada via the Tonopah and Tidewater Railroad and mines to the south via the Ludlow and Southern Railway with the main line.

The advent of the National Old Trails Highway during the 1910s allowed for diversification of the community's economic base, but closure of the spur lines and relocation of other railroad services to Barstow made the town wholly dependent on Route 66 for survival. Then came the bypass in 1973 and, as with Amboy, an intense downward spiral.

Today, Ludlow has the faintest of pulses, thanks to its proximity to I-40. There are a few amenities to be found among the ruins, including a café, a bare-bones motel that consistently receives favorable reviews for cleanliness, and even a Dairy Queen in the convenience store.

WEST FROM THE CAULDRON

At Ludlow, old Route 66 again resumes its shadowing of I-40, first on the north side of the highway and then on the south as it flows into Newberry Springs, home of the world-famous Bagdad Café. Although Newberry Springs has a lengthy history, the café is the only thing that gives it prominence, and that is a transplant.

The original café, which was the inspiration for the 1987 motion picture *Bagdad Café*, was located in the ghost town of Bagdad, about fifty miles to the east. With the razing of the original structure, the owner of the Sidewinder Café in Newberry Springs, which was the actual location used in the film, changed the name to capitalize on the notoriety.

From Newberry Springs, the old highway again swings north of I-40 and then enters Daggett, a forlorn desert village with some interesting but obscure landmarks. The unassuming Desert Market has operated without interruption since opening in 1908 as Ryerson's General Store.

NEWBERRY SPRINGS

According to archeological investigation, the dependable year-round supply of water from the springs at Newberry Springs has made this a haven for travelers for at least one thousand years. Modern history commences with reports from the expedition of Father Garces in 1776, and establishment of a station and water stop by the railroad in 1883.

Surprisingly, the little community languished while Ludlow and other communities that depended on Newberry Springs for water flourished. Even the advent of traffic on the National Old Trails Highway did little to alleviate that.

Route 66, and an aborted attempt to transform the town into a farming center, provided a spark of development, but

in 1946, Jack Rittenhouse noted that the population was fifty-two. In the era of resurgent interest in Route 66, the Sidewinder Café, now the Bagdad Café, remains the town's primary attraction.

Bagdad Café, Newberry Springs

Just east of the market, next to the frontier-era false-fronted store that has developed a noticeable lean, is the long-closed Stone Hotel. Dating to the late 1870s or early 1880s, the hotel, originally two stories, has direct associations with naturalist John Muir and Bill Curry, a western outlaw. There are also persistent but unconfirmed rumors that Wyatt Earp may have frequented the establishment when his family ranched in the area.

The expansive Marine Corps Logistics Base, a key component of America's battle in the Pacific Theater during World War II, necessitates a short detour onto I-40 at Daggett, to the Nebo Street exit. The Route 66 odyssey resumes at the East Main Street exit in Barstow.

Like Needles, it is obvious that Barstow has witnessed better times, and there seems little hope for a return to the good old days. Lining the highway corridor are colorful murals, generic fast food and motel offerings, empty and

DAGGETT

Even Route 66 enthusiasts skip through the dusty desert hamlet of Daggett. The only lure is the Desert Market—known as Ryerson's General Store when it opened in 1908—with signs promoting cold drinks.

Daggett, however, is a fascinating old town with a colorful history and interesting landmarks. Officially, its origins date to establishment of a railroad siding here in 1884, but settlement at the site precedes this by several years because of mining in the immediate area.

Named for John Daggett (the lieutenant governor of California from 1883 to 1887, who platted the town site), the town of Daggett flourished as it straddled the railroad in the center of the burgeoning silver-mining operations in the Calico Mountains. The development of borax mining north of the Calico Mountains, construction of a ten stamp mill, and construction of the Daggett-Calico spur line ensured years of prosperity even with the collapse of silver prices in the 1890s.

Then it was traffic on the National Old Trails Highway, and later Route 66, that supplanted borax mining as the town's financial foundation. Still, by 1946 the community had faded from prominence, and Jack Rittenhouse noted that this was "a tree shaded little old town that was formerly the location of smelters which handled ore brought down from the nearby mountains. Some of the old buildings remain, but the town is now quiet."

In addition to the Desert Market, many remnants from the town's glory days remain. One of these—Alf's Garage, built in 1894—handled construction of the legendary twenty-mule-team borax wagons before meeting the needs of travelers on the National Old Trails Highway and Route 66.

tarnished roadside gems, cafes, and old signs that no longer light the desert sky.

The highlight here is the old Casa Del Desierto, now known as the Harvey House Railroad Depot. Built in 1911, replacing an earlier structure that had burned, the former Harvey House was purchased by the City of Barstow in 1990 and currently houses city offices, a wonderful railroad museum, and an exceptional Route 66 Museum. It also serves as an Amtrak stop. You can access the complex by driving north on First Street (the former course of the National Old Trails Highway), crossing a picturesque railroad bridge that spans the massive old rail yard, and then swinging into the complex.

Before 1925, the Casa Del Desierto was located in the heart of the community. With the dramatic expansion of the rail yard by the Atchison, Topeka and Santa Fe Railroad in 1925, almost the entire community vanished to reappear along the current Main Street corridor.

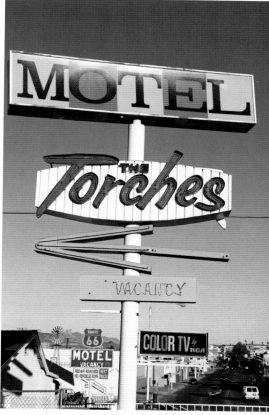

The Torches Motel, Barstow. *iStockphoto*

From Barstow south to the Cajon Pass, which serves as the gateway to the Los Angeles basin, you have two options. One is to follow I-15, formerly a four-lane section of Route 66, or you can use the older two-lane highway into Victorville. My suggestion is to go with the older alignment.

The old course of Route 66 from Barstow follows that of the National Old Trails Highway, also the general course of the historic Mojave Road, the Mormon Trail, and the Spanish Trail. All these historic roads follow the gentle curves of the Mojave River.

History permeates the air along this segment of highway, even though the tangible traces of that history are sparse. The towns of Lenwood, Hodge, Helendale, and Oro Grande closely resemble their appearance on maps: dots along the highway. The vast desert plains—broken by the occasional farm, the

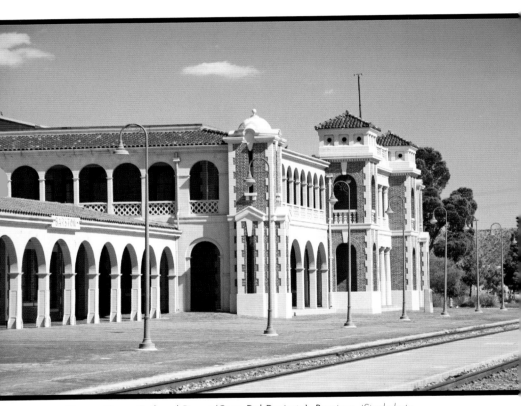

Harvey House Railroad Depot (Casa Del Desierto), Barstow. *iStockphoto*

Emma Jean's Holland Burger, Victorville. *Judy Hinckley*

railroad, and the faint green ribbon that marks the course of the river—frame the remaining links to previous eras. Oro Grande is where legendary cowboy crooner and film star Roy Rogers established his Double R Bar Ranch.

The highway crosses the river over a picturesque 1930 truss bridge, which has many of its ornate guardrails still intact, and enters Victorville, bordered by a massive old cement plant that leaves everything in the area coated with a layer of powder, and by Emma Jean's Holland Burger. The latter is a vintage truck stop café still serving hearty meals at reasonable prices in a building little changed, inside or out, since the early 1950s.

Route 66 in Victorville follows D Street past the California Route 66 Museum, and then turns sharply onto 7th Street. The course of the highway now carries a familiar theme: the roadside begins with faded neighborhoods, empty lots where thriving businesses once stood, and a few landmarks in various states of preservation. And then, as the highway again nears the interstate, the hustle and bustle of the modern era intervenes.

VICTORVILLE

Vast landscapes with high desert flora, fauna, and twisted spires of stone framed by often-snow-covered peaks made the area of Victorville a favored film location for many early Hollywood studios shooting westerns. As a result, during the 1930s, 1940s, and 1950s, the town became a miniature Hollywood and a haven for the rich and famous.

Filming for episodes of *The Cisco Kid* and *Zorro* occurred west of town. At the Green Spot Motel, once part of a resort complex and now used as low-rent apartments, Herman Mankiewicz and John Houseman wrote the first drafts of the script for *Citizen Kane* in 1940.

Dude ranches and resorts intermingled with real ranches along the Mojave River as celebrities such as Roy Rogers began calling the area home. One of these complexes, located in nearby Apple Valley along Route 66, has a rather unique claim to fame and film history association.

In 1926, an era of segregation, Nollie B. Murray, a prominent African American businessman in Los Angeles, purchased a forty-acre parcel of land to create a resort for African Americans. As Murray's Dude Ranch developed in the following decades, it became a favored vacation destination for African-American celebrities, including Joe Louis and Pearl Bailey.

During the 1930s, the ranch served as the set for a series of African American westerns starring Herbert Jefferies. With the onslaught of World War II, Murray's Dude Ranch became a center of recreation and USO tours for soldiers assigned to guard posts in the area at various military installations.

Pearl Bailey and her husband, Louis Bellson, acquired the property in 1954. But the glory days of the ranch had passed, and they sold it ten years later. Periods of abandonment followed. In 1988, the Apple Valley Fire Department used the complex as a training exercise.

Green Spot Motel. *Judy Hinckley*

INTO THE METROPOLIS AND ON TO THE END OF THE ROAD

From Victorville to Devore near San Bernardino, the interstate highway is your only option. The Route 66 experience here is limited to short segments accessed from the freeway and the knowledge that much of I-15 rests upon the course of the later four-lane alignment of Route 66.

To steel yourself for the Cajon Pass, you may want to stop first at the Old Outpost Café (at the US 395 exit) or the Summit Inn (just off the Oak Hill exit). Both are venerable Route 66 institutions, and the Summit Inn is a true icon with origins dating to 1952.

The Cajon Pass contrasts scenic beauty and a rich history with a high-speed traffic flow that seems to be a cross between demolition derby, racetrack, and carefully choreographed disaster. Depending on weather conditions, driving the Cajon Pass is an exhilarating experience interspersed with the excitement of discovery.

Summit Inn interior. *Judy Hinckley*

CAJON PASS

Vintage postcard of Cajon Pass.
Courtesy of Steve Rider

Connecting the urban sprawl of the Los Angeles metropolitan area with the Mojave Desert is the Cajon Pass between the San Gabriel Mountains and San Bernardino Mountains. For centuries, the pass has served as a primary transportation corridor.

A Native American trade route linking coastal tribes with the Zuni pueblos in New Mexico and the Hopi villages in Arizona used the pass and its dependable springs. So did Spanish explorers charting the course of the Spanish Trail linking the presidio of Albuquerque with the mission village of Los Angeles.

The Americanization of the area did nothing to diminish the importance of the pass. The Mojave Road and Mormon Trail both followed the pass from the desert to the sea. So did the railroad, the National Old Trails Highway, Route 66, and now I-15.

Vestiges of each of these trails and trade routes remain in the pass, creating an almost palpable sense of history, even though the crush of high-speed traffic makes it difficult to enjoy that history.

Cajon Pass at I-15, 2013. *Judy Hinckley*

Glimpses of the various alignments of Route 66, as well as the various roads and trails that preceded it, are scattered all through the picturesque but rugged topography cleaved into a canyon by the San Andreas Fault. A tangible link to the rich history of the pass and Route 66, as well as an opportunity to escape the traffic and take in the sights, is located at the highway 138 exit. A short drive south on the frontage road on the east side of the interstate will take you to a Mormon Trail Marker and some interesting views.

At the Cleghorn Road exit, you'll find your next opportunity to escape the modern hustle and bustle. This short section of the early four-lane US 66 features original bridges and, scattered among the brush and rocks, snippets of earlier alignments.

All too soon, you'll need to rejoin the herd on I-15, but this journey is a short one. At the Devore Road Exit, your Route 66 adventure continues uninterrupted with an almost 100-mile-long string of traffic lights and intense urban driving. The old highway follows Cajon Boulevard into San Bernardino, and then turns south along Mount Vernon Avenue before resuming its westward trek on Foothill Boulevard into Rialto. Tarnished roadside gems abound, but a few have thrived as portals to an earlier time. Weary travelers have found hearty meals waiting at Mitla Café on Mount Vernon Avenue since 1937.

Nestled just inside the Rialto city limits is the fully refurbished Wigwam Motel—one part icon, one part time capsule, and two parts fun. The vast orange groves that once embraced the motel may be ancient history, but the

Wigwam Motel, Rialto

essence of Route 66 encapsulated by the snow-covered peaks to the north, the laughter of guests around the pool, and the friendliness of the owners is alive and well here.

Along the Route 66 corridor of Foothill Boulevard west from Rialto, the landscape is dominated by an endless string of strip malls, traffic lights, old garages, converted cafés, historic wineries, and vintage motels shorn of their neon and now serving as apartments.

The transition from one community to the next is almost seamless: Rialto blends into Fontana, Fontana blends into Rancho Cucamonga, and Rancho Cucamonga blends into Upland. Repeat for Claremont, La Verne, San Dimas, Glendora, Azusa, Irwindale, Duarte, Monrovia, Arcadia, and into Pasadena.

Scattered among the flotsam of the modern era's strip malls, auto dealerships, and mini-marts are landmarks of every description. At 15395 Foothill Boulevard in Fontana is Bono's Restaurant, a treasure that dates to 1935. In Rancho Cucamonga at 8318 Foothill Boulevard you'll find the Sycamore Inn, with roots stretching to 1848, and at 8189 Foothill Boulevard, the 1957 Magic Lamp Inn is famous for its ornate décor.

In Upland, landmarks of note include the Madonna of the Trail Statue (at the corner of Euclid and Foothill Boulevard) and the Buffalo Inn (1814 West Foothill Boulevard) that dates to 1929 and is famous for its buffalo burgers. Claremont's landmark is the Wolfe's Market, established by the Wolfe family in 1917 and relocated to Foothill Boulevard in 1935.

From Upland west, new stores and service stations designed to mimic those of an earlier age are intermixed with symbols of modern urban sprawl, along with sections of tree-lined road. This blend gives you an odd sense of slipping between the past and present as you motor west.

In Glendora, the primary course of the highway (the later alignment), follows Alosta Avenue to reconnect with Foothill Boulevard in Azusa. The earliest alignment can be accessed by following Amelia Street north to Foothill Boulevard, and it feels surprisingly rural.

After Duarte, the course of Route 66 becomes quite interesting. Through Monrovia and into Arcadia, the highway followed several distinctly different corridors. In Irwindale, Foothill Boulevard becomes Huntington Drive, a transition that continues into Monrovia and Arcadia before the highway merges with Colorado Place, which in turn transitions into Colorado Street. The earlier alignment, in Monrovia, follows Shamrock north to Foothill Boulevard from Huntington Drive, and then doglegs to Santa Anita before continuing west on Colorado Boulevard to Colorado Street.

ARCADIA

Named for the Arcadia region of Greece, popularized in poetry as a place of natural beauty and rural simplicity, Arcadia was initially a community of orchards, farms, and ranches. It remained so until the late 1930s and the establishment of the Rancho Anita subdivision, a precursor to the suburbia that would transform the entire Los Angeles basin in postwar years.

Since 1904, the city has been associated with the Santa Anita Race Track established by Elias "Lucky" Baldwin, a colorful developer of the early twentieth century. However, both the racetrack and the bucolic peace and serenity associated with Arcadia were blighted during World War II. Under a decree authorizing relocation and internment of Japanese citizens, Arcadia's storied racetrack underwent extensive renovation and served as an internment camp for the remainder of the war.

Santa Anita Race Track, circa 1908. *Library of Congress Prints and Photographs Division*

In Pasadena, at various times, Route 66 utilized the Arroyo Parkway, Colorado Boulevard, and Fair Oaks Avenue. The course into Los Angeles proper is even more confusing: Huntington Drive to Mission Road and then onto Broadway, Figueroa and the Arroyo Seco Parkway.

Colorado Bridge, Pasadena. *Judy Hinckley*

LOS ANGELES

As you crawl along Route 66 through the vast Los Angeles metropolitan area, it is difficult to think that this was once an agricultural paradise. It may be even more difficult to imagine it as a sleepy Spanish mission settlement on the edge of a vast frontier.

The first European association with the site of modern-day Los Angles dates to an entry in the journals of the Portales expedition, which camped on the banks of the river here in 1769. Establishment of a rancheria (small, rural settlement) occurred shortly after, and a report dated December 27, 1779, noted "the founding of a town with the name Queen of the Angeles on the river of the Porciuncula."

On August 26, 1781, Governor Felip de Neve issued the final decree for establishment, and the official founding of the town took place on September 4, 1781. With American acquisition in the late 1840s, pronunciation difficulties resulted in a confusing array of names for the little farming village.

In one report dated January 11, 1847, the name Ciudad de los Angeles is used. A few months later, another report used the name City of Angeles. The abbreviated version, Los Angeles, became the official designation with incorporation on April 4, 1850.

The corner of 7th Street and Broadway in the heart of downtown Los Angeles marked the western terminus of Route 66 until 1936. After this date, the western terminus became the intersection of Lincoln and Olympic Boulevards in Santa Monica, mere blocks from the ocean, and Route 66 followed Sunset Boulevard through Hollywood and Santa Monica Boulevard to this end.

If the western terminus of legendary Route 66 seems a bit anticlimactic, do not despair. This is but the official end of Route 66, not the traditional end of the road. That is found a few blocks away at a beautiful park overlooking the sea and Santa Monica Pier, a landmark for more than a century.

Fostering the illusion that Route 66 ends at the ocean is a monument in Palisades Park dedicated to Will Rogers and proclaiming Route 66 as the Will Rogers Highway. The dedication was the culmination of a promotional

End of the Trail, Santa Monica Pier. *Judy Hinckley*

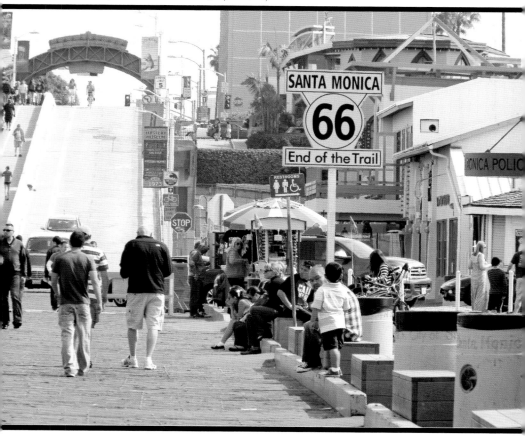

convoy in 1952 sponsored in part by the U.S. Highway 66 Association to capitalize on the publicity generated by the release of *The Will Rogers Story*, starring Will Rogers Jr. and Jane Wyman.

Additionally, in the 1930s, a movie company posted a sign on Santa Monica Pier proclaiming "Route 66 End of the Trail" as a promotional stunt. Several years ago, Dan Rice, owner of 66-to-Cali, a shop on the pier, spearheaded efforts to have a re-creation of the sign placed on the pier.

On Route 66, reality constantly fights a losing battle with illusion. So it seems rather fitting that the recently refurbished pier—with its colorful shops, restaurants, Pacific Palisades Amusement Park, historic carousel, and vibrant carnival atmosphere—is viewed as the end of the road, rather than the nondescript intersection that really *is* the end of the road.

Attractions and historic sites abound along the Route 66 corridor between San Bernardino and Santa Monica, or are easily accessed from it. This is no surprise in a string of communities that are part of the nation's largest metropolis. A person could spend a dozen vacations exploring the treasures awaiting discovery along Route 66 in these final miles.

And so ends the beginning of many grand adventures on America's most famous highway.

Santa Monica Pier and amusement park at dusk. *David Pruter/Shutterstock.com*

DON'T MISS

Attractions to enjoy, sites to see, and places not to forget near the end of the road in the **Los Angeles** area:

- The McDonald's Museum, on the corner of E Street and 14th Street in San Bernardino, site of the world's first McDonald's (1948)—privately owned by Albert Okura, founder of Juan Pollo Chicken restaurants and owner of Amboy, California;

- The Justice Brothers Racing Museum at 2734 East Huntington Drive in Duarte, housing a wide array of historically significant racing vehicles;

- The stunning Aztec Hotel (1925) at 311 West Foothill Boulevard in Monrovia, an ornately designed hotel on the National Register of Historic Places and reflecting Mayan and Aztec architectural elements;

- Fair Oaks Pharmacy at 1526 Mission Street in South Pasadena, complete with soda fountain, operating since 1915;

- The Rialto Theater at 1023 Fair Oaks Avenue in South Pasadena, built in 1925 and listed on the National Register of Historic Places in 1978—one of the few remaining single-screen theaters operating in Los Angeles County, and possibly haunted;

- The ornate Colorado Street Bridge spanning Arroyo Seco in Pasadena, built in 1913 and carrying Route 66 traffic until 1940— the bridge reopened in 1993 after a $27 million-dollar renovation;

- The nine-mile Arroyo Seco Parkway, completed in 1940 and renamed the Pasadena Freeway in 1954, California's first modern limited-access freeway and the only National Scenic Byway fully encompassed by a metropolitan area—from January 1, 1964, to December 31, 1974, the intersection of Colorado Street and Arroyo Parkway served as the western terminus of Route 66;

- The Figueroa Street Tunnels, now designated a National Scenic Byway and considered an engineering marvel at the time of their construction (between 1931and 1936)—realignment of Route 66 in the summer of 1936 made the tunnels the primary corridor into Los Angeles;

- The historic 1924 Highland Theaters at 5604 North Figueroa Street in the Highland Park section of Los Angeles, with restored rooftop signage, the centerpiece of the historic district;

- Barney's Beanery at 8447 Santa Monica Boulevard in West Hollywood, an icon for fans of Route 66—as well as movie and music history—that has operated at the same location since 1927.

INDEX